Books by Jacques Maritain

THE PERSON AND THE COMMON GOOD

THE RANGE OF REASON

ON THE PHILOSOPHY OF HISTORY

REFLECTIONS ON AMERICA

THE DEGREES OF KNOWLEDGE, *a new translation*

THE RESPONSIBILITY OF THE ARTIST

THE SOCIAL AND POLITICAL PHILOSOPHY OF
JACQUES MARITAIN
(*edited by* Joseph W. Evans *and* Leo R. Ward)

Published by Charles Scribner's Sons

Jacques Maritain *1882-*

ART AND SCHOLASTICISM

and

THE FRONTIERS OF POETRY

Translated by Joseph W. Evans

New York

Charles Scribner's Sons

Table of Contents

Art and Scholasticism 3

The Frontiers of Poetry 119

Notes 153

Index 231

Translator's Note

This new translation of *Art and Scholasticism* was undertaken at Professor Maritain's suggestion, and is made from the third and final edition (1935) of *Art et Scolastique*. The "The Frontiers of Poetry" essay, which was added as a supplement in the second edition (1927), is again included, as in the 1930 translation, but it is now given, as Professor Maritain desired, equal prominence with "Art and Scholasticism"; it is translated from the revised version presented in *Frontières de la poésie et autres essais* (1935). The "Appendices" have had restored to them here their original status as addenda to "Art and Scholasticism"; two of them—"The 'Triomphe de Saint Thomas' at the Theatre" and "Apropos an Article by Montgomery Belgion"—are new to this edition. Finally, the "Notes" contain some minor revisions and a considerable number of additions.

I wish to thank Professor Maritain for the privilege of translating this work. Also, I am grateful to Professor Wilfred Quinn for reading the manuscript and making a number of suggestions, and for checking some of the bibliographical detail.

JOSEPH W. EVANS

Notre Dame, Indiana

vi

ART AND SCHOLASTICISM

1

The Schoolmen and the Theory of Art

The Schoolmen did not write a special treatise entitled *Philosophy of Art*. This was no doubt due to the strict pedagogical discipline to which the philosophers of the Middle Ages were subjected; occupied in sifting and probing the problems of the School in all directions, they cared little that they left unworked regions between the quarries they excavated. Yet we find in them a very profound theory of Art; but we must look for it in austere treatises on some problem of logic—"is Logic a liberal art?"—or of moral theology— "how is the virtue of Prudence, a virtue at once *intellectual and moral,* to be distinguished from Art, which is an *intellectual* virtue?"

In these treatises, in which the nature of art is studied only incidentally, art in general is the subject of debate, from the art of the shipbuilder to the art of the grammarian and the logician, not the fine arts in particular, the consideration of which has no "formal" bearing on the matter under discussion. We must go to the Metaphysics of the ancients to discover what their views were concerning the Beautiful, and then proceed to meet Art and see what comes of the junction of these two terms. If such a procedure disconcerts us, it at least affords us a useful lesson, by making clear to us the error of the "Aesthetics" of modern philosophers, which,

3

considering in art only the fine arts, and treating the beautiful only with regard to art, runs the risk of vitiating both the notion of Art and the notion of the Beautiful.

Thus one could, by gathering together and reworking the materials prepared by the Schoolmen, compose from them a rich and complete theory of Art. I should like only to indicate here some of the features of such a theory. I apologize for the peremptory tone thus imposed on my essay, and I hope that despite their insufficiency these reflections on maxims of the Schoolmen will draw attention to the usefulness of having recourse to the wisdom of the ancients, as also to the possible interest of a conversation between philosophers and artists, at a time when all feel the necessity of escaping from the immense intellectual disorder inherited from the nineteenth century, and of finding once more the spiritual conditions of *honest* work.

II

The Speculative Order and

the Practical Order

There are in the intellect virtues whose *sole end* is *to know*. They belong to the *speculative* order.

Such are: the Understanding of first principles, which, once we have drawn from our sense-experience the ideas of Being, of Cause, of End, etc., enables us to see immediately— through the power of the active light which is in us by nature —the self-evident truths on which all our knowledge depends; Science, which enables us to know by demonstration, assigning causes; Wisdom,[1] which enables us to contemplate the first causes, and in which the mind holds all things in the superior unity of a simple glance.

These speculative virtues perfect the intellect in its most proper function, in the activity in which it is purely itself; for the intellect as such aims only to know. The intellect acts, indeed its act is, absolutely speaking, life *par excellence;* but its act is an *immanent* act which remains wholly within the intellect to perfect it, and through which the intellect, with a limitless voracity, seizes being and draws it into itself—it eats being and drinks being—so as "itself to become, in a certain fashion, all things." Thus the speculative order is its

proper order; it is at home there. The good or the evil of the subject, the needs and conveniences of the subject, matter little to it; it enjoys being and has eyes only for being.

The *practical* order is opposed to the speculative order because there man tends to something other than knowledge only. If he knows, it is no longer to rest in the truth, and to enjoy it (*frui*); it is to use (*uti*) his knowledge, with a view to some work or some action.[2]

Art belongs to the practical order. It is turned towards action, not towards the pure interiority of knowledge.

There are, it is true, speculative arts, which are at the same time sciences, as, for instance, logic. These scientific arts perfect the speculative intellect, not the practical intellect; but such sciences retain in their *mode* something of the practical, and are arts only because they imply the *making of a work*—this time a work wholly within the mind, and whose sole object is the achievement of knowledge, a work which consists for instance in setting our concepts in order, in framing a proposition or in constructing a reasoning.[3] The fact remains, therefore, that wherever we find *art* we find some productive operation to be contrived, some work to be made.

III

Making and Doing

The intelligence is a faculty perfectly one in its being, but it works in entirely different ways according as it knows for the sake of knowledge or knows for the sake of action.

The speculative intellect will have its perfect and infinitely superabundant joy only in the intuitive vision of the Divine Essence; it is through it that man will then possess beatitude: *gaudium de Veritate*. It is very rarely exercised in absolute liberty on this earth, save in the Man of Wisdom, theologian or metaphysician, or in the pure scientist. In the great majority of cases reason works in the practical order, and for the diverse ends of human actions.

But the practical order itself is divided into two entirely distinct spheres, which the ancients called the sphere of Doing (*agibile*, πρακτόν) and the sphere of Making (*factibile*, ποιητόν).

Doing, in the restricted sense in which the Schoolmen understood this word, consists in *the free use, precisely as free,* of our faculties, or in the exercise of our free will considered not with regard to the things themselves or to the works which we produce, but merely with regard to the use which we make of our freedom.

This use depends on our specifically human appetite, on our Will, which of itself does not tend to the true, but solely and jealously to the good of man—for that alone exists for appe-

7

tite which fulfills desire or love and which increases the being of the subject, or which is to the subject as the subject is to itself. This use is good if it is in conformity with the law of human acts, and with the true end of the whole of human life; and if it is good, the man acting is himself good—purely and simply good.

Thus Doing is ordered to the common end of the whole of human life, and it concerns the proper perfection of the human being. The sphere of Doing is the sphere of Morality, or of the human good as such. Prudence, the virtue of the practical intellect which rules Doing, stands entirely in the human sphere. Queen of the moral virtues, noble and born to command, because it measures our acts with regard to an ultimate end which is God Himself sovereignly loved, Prudence nevertheless retains a taste of misery, because it has for its matter the multitude of needs and circumstances and traffickings in which human anxiety flounders about, and because it imbues with humanity all that it touches.

In contradistinction to Doing, the Schoolmen defined Making as *productive action,* considered not with regard to the use which we therein make of our freedom, but merely *with regard to the thing produced* or with regard to the work taken in itself.

This action is what it ought to be, it is good in its own sphere, if it is in conformity with the rules and with the proper end of the work to be produced; and the result to which it tends if it is good, is that this work be good in itself. Thus Making is ordered to this or that particular end, taken in itself and self-sufficing, not to the common end of human life; and it relates to the good or to the proper perfection, not of the man making, but of the work produced.

The sphere of Making is the sphere of Art, in the most universal sense of this word.

Art, which rules Making and not Doing, stands therefore outside the human sphere; it has an end, rules, values, which are not those of man, but those of the work to be produced. This work is everything for Art; there is for Art but one law —the exigencies and the good of the work.

Hence the tyrannical and absorbing power of Art, and also its astonishing power of soothing; it delivers one from the human; it establishes the *artifex*—artist or artisan—in a world apart, closed, limited, absolute, in which he puts the energy and intelligence of his manhood at the service of a thing which he makes. This is true of all art; the ennui of living and willing ceases at the door of every workshop.

But if art is not human in the end that it pursues, it is human, essentially human, in its mode of operating. It's a work of man that has to be made; it must have on it the mark of man: *animal rationale*.

The work of art has been thought before being made, it has been kneaded and prepared, formed, brooded over, ripened in a mind before passing into matter. And in matter it will always retain the color and savor of the spirit. Its *formal* element, what constitutes it in its species and makes it what it is, is its being ruled by the intellect.[4] If this formal element diminishes ever so little, to the same extent the reality of art vanishes. The *work to be made* is only the matter of art, its form is *undeviating reason. Recta ratio factibilium:* let us say, in order to try to translate this Aristotelian and Scholastic definition, that art is the *undeviating determination of works to be made.*[5]

IV

Art an Intellectual Virtue

Let us sum up now what the Schoolmen taught about art in general, considered in the artist or artisan and as something of himself.

1. Art, first of all, is of the intellectual order, its action consists in imprinting an idea in some matter: it is therefore in the intelligence of the *artifex* that it resides, or, as is said, this intelligence is the subject in which it inheres. It is a certain *quality* of this intelligence.

2. The ancients termed *habitus* (ἕξις) qualities of a class apart, qualities which are essentially stable dispositions perfecting in the line of its own nature the subject in which they exist.[6] Health, beauty are *habitus* of the body; sanctifying grace is a *habitus* (supernatural) of the soul.[7] Other *habitus* have for their subject the faculties or powers of the soul, and as the nature of these faculties or powers is to tend to action, the *habitus* which inhere in them perfect them in their very dynamism, are *operative habitus:* such are the intellectual virtues and the moral virtues.

We acquire this last kind of *habitus* through exercise and use; [8] but we must not for this reason confuse *habitus* with habit in the modern sense of this word, that is to say, with

10

mere mechanical bent and routine; *habitus* is exactly the contrary of habit in this sense.[9] Habit, which attests the weight of matter, resides in the nerve centers. Operative *habitus,* which attests the activity of the spirit, resides principally in an immaterial faculty, in the intelligence or the will. When, for example, the intellect, at first indifferent to knowing this rather than that, demonstrates a truth to itself, it disposes its own activity in a certain manner, thus giving birth within itself to a quality which proportions it to, and makes it commensurate with, such or such an object of speculation, a quality which elevates it and fixes it as regards this object; it acquires the *habitus* of a science. *Habitus* are intrinsic super-elevations of living spontaneity, vital developments which render the soul better in a given order and which fill it with an active sap: *turgentia ubera animae,* as John of Saint Thomas calls them. And only the living (that is to say, intellectual beings, who alone are perfectly alive) can acquire them, because only they are capable of elevating the level of their being by their very activity: they have thus, in their enriched faculties, secondary principles of action which they use when they wish and which make easy and delightful for them what of itself is difficult.

Habitus are, as it were, metaphysical titles of nobility, and as much as innate gifts they make for inequality among men. The man who possesses a *habitus* has within him a quality which nothing can pay for or replace; others are naked, he is armed with steel: but it is a case of a living and spiritual armor.

Finally, *habitus,* properly speaking, is stable and permanent (*difficile mobilis*) *by very reason of the object* which specifies it; it is thus to be distinguished from simple disposition, as for example opinion.[10] The object with regard to which it perfects the subject is itself immutable—such as the

infallible truth of demonstration for the *habitus* of Science —and it is upon this object that the quality developed in the subject *takes hold*. Hence the force and the rigidity of *habitus;* hence their irritability—all that deviates from the straight line of their object galls them; hence their intransigence—what concession could they admit of? They are fixed in an absolute; hence their inconvenience in the social order. Men of the world, polished on all sides, do not like the man of *habitus,* with his asperities.

Art is a *habitus* of the practical intellect.

3. This *habitus* is a *virtue,* that is to say, a quality which, triumphing over the original indetermination of the intellectual faculty, at once sharpening and tempering the point of its activity, draws it, with reference to a definite object, *to a certain maximum of perfection and thus of operative efficiency.* Every virtue being thus determined to the ultimate of which the power is capable,[11] and every evil being a lack and an infirmity, virtue can tend only to the good: impossible to use a virtue to do evil; it is essentially a *habitus operative of good.*[12]

The existence of such a virtue in the workman is necessary for the good of the work, for *the manner of action follows the disposition of the agent, and, as a man is, so are his works.*[13] To the work-to-be-made, if it is to turn out well, there must correspond in the soul of the workman a disposition which creates between the one and the other that kind of conformity and intimate proportion which the Schoolmen called "connaturality"; Logic, Music and Architecture respectively graft the syllogism in the logician, harmony in the musician, equilibrium of masses in the architect. Through the virtue of Art present in them, they in some way are their work before making it; they are conformed to it, so as to be able to form it.

But if art is a *virtue of the practical intellect,* and if every virtue tends exclusively to the good (that is, to the *true* in the case of a virtue of the intellect), we must conclude from this that Art as such (I say Art and not the artist, who often acts contrary to his art) is never mistaken, and that it implies an *infallible rectitude.* Otherwise it would not be a *habitus* properly speaking, stable of its very nature.

The Schoolmen discussed at length this infallible rectitude of art, and more generally of the virtues of the practical intellect (Prudence in the order of Doing, Art in the order of Making). How can the intellect be rendered infallibly true in the domain of the individual and the contingent? They replied with the fundamental distinction between the *truth of the speculative intellect,* which consists in *knowing,* in conformity with what is, and the *truth of the practical intellect,* which consists in *directing,* in conformity with what ought to be according to the rule and the measure of the thing to be effected.[14] If there is *science* only of the necessary, if there is no infallible truth in *knowing* in regard to what can be otherwise than it is, there can be infallible truth in *directing,* there can be *art,* as there is *prudence,* in regard to the contingent.

But this infallibility of art concerns only the formal element of the operation, that is to say, the regulation of the work by the mind. Let the hand of the artist falter, let his instrument betray him, let the matter give way, the defect thus introduced into the result, into the *eventus,* in no way affects the art itself and does not prove that the artist is wanting in his art. From the moment that the artist, in the act of judgment brought by his intellect, imposed the rule and the measure which suited the given case, there was no error *in him,* that is to say, no false direction. The artist who has the *habitus* of art and a trembling hand,

C'ha l'habito de l'arte e man che trema,

produces an imperfect work, but retains a faultless virtue. Likewise in the moral order, though the event can fail, the act posited according to the rules of prudence will nonetheless have been infallibly correct. Although extrinsically and on the part of the matter art implies contingency and fallibility, nevertheless art in itself, that is to say, on the part of the form, and of the regulation which comes from the mind, is not fluctuating like opinion, but it is planted in certitude.

It follows from this that manual skill is no part of art; it is but a material and extrinsic condition of it. The labor through which the zither player acquires nimbleness of finger does not increase his art as such nor does it engender any special art; it simply removes a physical impediment to the exercise of the art: *non generat novam artem, sed tollit impedimentum exercitii ejus:*[15] art stands entirely on the side of the mind.

4. In order to determine more precisely the nature of Art, the ancients compared it with Prudence, which is also a virtue of the practical intellect. In thus distinguishing and contrasting Art and Prudence, they put their finger on a vital point in the psychology of human acts.

Art, we have already said, is in the sphere of Making, Prudence in the sphere of Doing. Prudence discerns and applies the means of arriving at our moral ends, which are themselves subordinate to the ultimate end of the whole of human life, that is to say, to God. Metaphorically, Prudence is, if you will, an art, but it is the art of the *totum bene vivere,*[16] of the good life absolutely, an art which the Saints alone possess fully,[17] together with supernatural Prudence, and above all with the Gifts of the Holy Spirit, which move them

to divine things according to a divine *manner,* and cause them to act under the very guidance of the Spirit of God and of His loving Art, by giving them eagle wings to help them walk on earth: *they shall take wings as eagles, they shall run and not be weary, they shall walk and not faint.*[18] Art is not concerned with our life, but only with such or such particular and extra-human ends which are an ultimate end in relation to it.

Prudence works for the good of the one acting, *ad bonum operantis;* Art works for the good of the work made, *ad bonum operis,* and all that turns it from this end perverts it and diminishes it. From the moment that the artist works well —as from the moment that the geometrician demonstrates— "it matters little whether he be in good humor or angry." [19] If he is angry or jealous, he sins as a man, he does not sin as an artist.[20] Art in no way tends to the artist's being good in his own action as a man; it would tend rather to the work produced—if that were possible—itself making in its own line a perfect use of its activity.[21] But human art does not produce works which move to action of themselves: God alone makes works of this kind, and thus the Saints are truly and literally His masterpiece as Master-artisan.

Consequently, since the artist is a man before being an artist,* it is easy to see the conflicts which will set at logger-heads within him Art and Prudence, his virtue as Maker and his virtue as Man. No doubt Prudence itself, which judges in everything according to the particular cases, will not apply to him the same rules as it will to the farmer or the merchant, and will not ask of a Rembrandt or a Léon Bloy that they make works *that pay,* so as to ensure the material comforts

* And he must be a man also in order to be an artist. In this respect —but by reason of subjective causality—art itself is in a vital relation with the morality of the artist. Cf. further on, pp. 89–90, 91–98; and *Frontières de la Poésie et autres essais* ("Dialogues").

of their family. But the artist will need a certain heroism in order to keep himself always on the straight path of Doing, and in order not to sacrifice his immortal substance to the devouring idol that he has in his soul. In truth, such conflicts can be abolished only if a profound humility renders the artist, so to speak, unconscious of his art, or if the all-powerful unction of wisdom gives to all that is in him the sleep and the peace of love. Doubtless Fra Angelico did not experience these interior conflicts.

The fact remains that the pure artist abstractly taken as such, *reduplicative ut sic,* is something entirely amoral.

Prudence perfects the intellect only presupposing that the will is straight in its own line as human appetite, that is to say, with regard to its own proper good, which is the good of the whole man: [22] in reality it concerns itself only with determining the *means* in relation to such or such concrete human ends already willed, and therefore it presupposes that the appetite is rightly disposed with reference to these ends.

Art, on the contrary, perfects the intellect without presupposing the rectitude of the will in its own line as human appetite, for the ends at which it aims are outside the sphere of the human good. Hence "the movement of the appetite which corrupts the judgment of prudence, does not corrupt the judgment of art, any more than it does that of geometry." [23] Since the act of *using* our faculties (*usus*) depends on the will in its proper dynamism as human appetite,[24] one can understand that art gives only the power of making well (*facultas boni operis*), and not the *use* itself of making well. The artist may choose not to use his art, or he may use it badly, just as the grammarian, if he wishes, may commit a barbarism, and yet the virtue of art in him is not for all that any the less perfect. According to the celebrated saying of

Aristotle,[25] who no doubt would have liked the fantasies *
of Erik Satie, the artist who sins against his art is not blamed
if he sins willing it as he would be if he sinned without willing
it; whereas the man who sins against prudence or against
justice is blamed more if he sins willing it than if he sins with-
out willing it. In this connection the ancients observed that
both Art and Prudence have first to *judge* and then to *com-
mand,* but that the principal act of art is merely to judge,
whereas the principal act of prudence is to command. *Per-
fectio artis consistit in judicando.*[26]

Finally, since Prudence has for its matter, not a thing-to-
be-made, an object determined in being, but the pure use
that the subject makes of his freedom, it has no certain and
determined ways or fixed rules. Its fixed point is the true end
to which the moral virtues tend, and in relation to which it
has to determine the just means. But for attaining this end,
and for applying the universal principles of moral science,
precepts and counsels, to the particular action to be produced,
there are no ready-made rules; for this action is clothed in a
tissue of circumstances which individualize it and make of it
each time a truly new case.[27] In each of these cases † there
will be a particular manner of conforming to the end. It is
for Prudence to find this manner, using ways or rules sub-
ordinated to the will which chooses according to the occur-
rence of circumstances and occasions—ways or rules that in
themselves are contingent and not pre-determined, that will
be fixed with certitude and rendered absolutely determined

* Fantasies which are by no means barbarisms, but achievements
in modesty, evidencing the most profound care for rigor and purity.
† Especially when, for example, it is a question of determining the
exact measure of two virtues which must be practiced at the same
time—firmness and kindness, humility and magnanimity, mercy and
truth, etc.

only by the judgment or the decision of the Prudent Man, and which the Schoolmen called for this reason *regulae arbitrariae*. Particular for each particular case, the ruling of Prudence is nonetheless certain and infallible, as I have said before, because the truth of the prudential judgment depends on the right intention (*per conformitatem ad appetitum rectum*), not on the event. And supposing the return of a second case, or of an infinity of cases, *in all points identical* with a given case, *the very same ruling* as was imposed on that one would have to be imposed on all: but there will never be a single moral case which would be entirely identical with another.[28]

It is clear then that no *science* can replace prudence, for science, no matter how detailed in casuistry it may be, never has anything but general and determined rules.

It is clear also why Prudence, in order to establish its judgment, must absolutely have recourse to that groping and multiple exploration which the ancients called *consilium* (deliberation, counsel).

Art, on the contrary, which has for its matter a thing-to-be-made, proceeds by *certain and determined ways:* "Art seems to be nothing other than a certain ordination of reason, by which human acts reach a determined end through determined means."[29] The Schoolmen, following Aristotle, affirm this constantly, and they make of this possession of fixed rules an essential property of art as such. I shall present later some remarks concerning these fixed rules in the case of the fine arts. Let us recall here that the ancients treat of the virtue of Art considered in itself and in all its generality, not in any one of its particular species; so that the simplest example of art thus considered, the one in which the generic concept of art is first realized, must be sought in the mechanical arts. The art of the shipbuilder or of the clockmaker has

for its proper end something invariable and universal, determined by reason: to permit man to travel on water or to tell the time—the thing-to-be-made, ship or clock, being itself but a matter to be formed according to that end. And for that there are fixed rules, likewise determined by reason, in keeping with the end and with a certain set of conditions.

Thus the effect produced is doubtless individual, and in those cases where the matter of the art is particularly contingent and imperfect, as in Medicine, for example, or in Agriculture or in Strategy, Art will find it necessary in order to apply its fixed rules to use contingent rules (*regulae arbitrariae*) and a kind of prudence, will find it necessary also to have recourse to deliberation, to *consilium.* It is nonetheless true that of itself Art derives its stability from its rational and universal rules, not from *consilium,* and that the correctness of its judgment is not derived, as with Prudence, from the circumstances and occurrences, but rather from the certain and determined ways which are proper to it.[30] That is why the arts are at the same time practical sciences, such as Medicine or Surgery (*ars chirurgico-barbifica,* it was still called in the seventeenth century), and some can even be speculative sciences, like Logic.

5. In summary, Art is thus *more exclusively intellectual* than Prudence. Whereas Prudence has for subject the practical intellect *as presupposing right will and depending on it,*[31] Art does not concern itself with the proper good of the will, and with the ends that the will pursues in its own line as human appetite; and if it supposes a certain rectitude of the appetite,[32] this is still with regard to some properly intellectual end. Like Science, it is to an *object* that Art is riveted (an object to be made, it is true, not an object to be contemplated). It uses the roundabout way of deliberation and coun-

sel only by accident. Although it produces individual acts and
effects, it does not, except secondarily, judge according to
the contingencies of circumstance; thus it considers less than
does Prudence the individuation of actions and the *hic et
nunc*.[33] In short, if by reason of its matter, which is contin-
gent, Art accords more with Prudence than with Science,
yet *according to its formal reason and as virtue* it accords
more with Science [34] and the *habitus* of the speculative intel-
lect than with Prudence: *ars magis convenit cum habitibus
speculativis in ratione virtutis, quam cum prudentia*.[35] The
Scientist is an Intellectual who demonstrates, the Artist is an
Intellectual who makes, the Prudent Man is an intelligent
Man of Will who acts well.

Such, in its principal features, is the conception that the
Schoolmen had of art. Not in Phidias and Praxiteles only,
but in the village carpenter and blacksmith as well, they ac-
knowledged an intrinsic development of reason, a nobility
of the intellect. The virtue of the craftsman was not, in their
eyes, strength of muscle and nimbleness of fingers, or the
rapidity of the chronometered and tailored gesture; nor was
it that mere empirical activity (*experimentum*) which takes
place in the memory and in the animal (cogitative) reason,
which imitates art and which art absolutely needs,[36] but which
remains of itself extrinsic to art. It was a virtue of the intellect,
and endowed the humblest artisan with a certain perfection
of the spirit.

The artisan, in the normal type of human development and
of truly human civilizations, represents the general run of
men. If Christ willed to be an artisan in a little village, it is
because He wanted to assume the common condition of
humanity.[37]

The Doctors of the Middle Ages did not, like many of

our introspecting psychologists, study only city people, library dwellers, or academicians; they were interested in the whole mass of mankind. But even so they still studied their Master. In considering the art or the proper activity of the *artifex,* they considered the activity that Our Lord chose to exercise during all of His hidden life; they considered also, in a way, the very activity of the Father; for they knew that the virtue of Art is predicated pre-eminently of God, as are Goodness and Justice,[38] and that the Son, in plying His poor man's trade, was still the image of the Father and of His never-ceasing action: [39] *Philip, he who sees Me, sees the Father also.*

*

It is curious to note that in their classifications the ancients did not give a separate place to what we call the fine arts.[40] They divided the arts into servile arts and liberal arts, according as they required or did not require the labor of the body,[41] or rather—for this division, which goes deeper than one thinks, was taken from the very concept of art, *recta ratio factibilium*—according as the *work to be made* was in one case an effect produced in matter (*factibile* properly speaking), in the other a purely spiritual construction remaining in the soul.[42] In that case, sculpture and painting belonged to the servile arts,[43] and music to the liberal arts, where it was next to arithmetic and logic. For the musician arranges intellectually sounds in his soul, just as the arithmetician arranges numbers there, and the logician, concepts—the oral or instrumental expression, which causes to pass into the fluid successions of sonorous matter the constructions thus achieved in the spirit, being but an extrinsic consequence and a simple means for these arts.

In the powerfully social structure of mediaeval civilization,

the artist had only the rank of artisan, and every kind of anarchical development was forbidden his individualism, because a natural social discipline imposed on him from the outside certain limiting conditions.[44] He did not work for the rich and fashionable and for the merchants, but for the faithful; it was his mission to house their prayers, to instruct their intelligences, to delight their souls and their eyes. Matchless epoch, in which an ingenuous people was formed in beauty without even realizing it, just as the perfect religious ought to pray without knowing that he is praying; [45] in which Doctors and image-makers lovingly taught the poor, and the poor delighted in their teaching, because they were all of the same royal race, born of water and the Spirit!

Man created more beautiful things in those days, and he adored himself less. The blessed humility in which the artist was placed exalted his strength and his freedom. The Renaissance was to drive the artist mad, and to make of him the most miserable of men—at the very moment when the world was to become less habitable for him—by revealing to him his own peculiar grandeur, and by letting loose on him the wild beast Beauty which Faith had kept enchanted and led after it, docile.[46]

V

Art and Beauty

Saint Thomas, who was as simple as he was wise, defined the beautiful as that which, being seen, pleases: *id quod visum placet*.[47] These four words say all that is necessary: a vision, that is to say, an *intuitive knowledge,* and a *delight.* The beautiful is what gives delight—not just any delight, but delight in knowing; not the delight peculiar to the act of knowing, but a delight which superabounds and overflows from this act because of the object known. If a thing exalts and delights the soul by the very fact that it is given to the soul's intuition, it is good to apprehend, it is beautiful.[48]

Beauty is essentially an object of *intelligence,* for that which *knows* in the full sense of the word is intelligence, which alone is open to the infinity of being. The natural place of beauty is the intelligible world, it is from there that it descends. But it also, in a way, falls under the grasp of the senses, in so far as in man they serve the intellect and can themselves take delight in knowing: "Among all the senses, it is to the sense of sight and the sense of hearing only that the beautiful relates, because these two senses are *maxime cognoscitivi.*" [49] The part played by the senses in the perception of beauty is even rendered enormous in us, and well-nigh indispensable, by the very fact that our intelligence is not intuitive, as is the intelligence of the angel; it sees, to be

sure, but on condition of abstracting and discoursing; only
sense knowledge possesses perfectly in man the intuitiveness
required for the perception of the beautiful. Thus man can
doubtless enjoy purely intelligible beauty, but the beautiful
that is *connatural* to man is the beautiful that delights the
intellect through the senses and through their intuition. Such
is also the beautiful that is proper to our art, which shapes
a sensible matter in order to delight the spirit. It would thus
like to believe that paradise is not lost. It has the savor of
the terrestrial paradise, because it restores, for a moment, the
peace and the simultaneous delight of the intellect and the
senses.

If beauty delights the intellect, it is because it is essentially
a certain excellence or perfection in the proportion of things
to the intellect. Hence the three conditions Saint Thomas
assigned to beauty: [50] *integrity,* because the intellect is pleased
in fullness of Being; *proportion,* because the intellect is
pleased in order and unity; finally, and above all, *radiance* or
clarity, because the intellect is pleased in light and intelligibil-
ity. A certain splendor is, in fact, according to all the ancients,
the essential characteristic of beauty—*claritas est de ratione
pulchritudinis,*[51] *lux pulchrificat, quia sine luce omnia sunt
turpia* [52]—but it is a splendor of intelligibility: *splendor veri,*
said the Platonists; *splendor ordinis,* said Saint Augustine,
adding that "unity is the form of all beauty"; [53] *splendor
formae,* said Saint Thomas in his precise metaphysician's
language: for the form, that is to say, the principle which con-
stitutes the proper perfection of all that is, which constitutes
and achieves things in their essences and qualities, which is,
finally, if one may so put it, the ontological secret that they
bear within them, their spiritual being, their operating mystery
—the form, indeed, is above all the proper principle of intel-

ligibility, the proper *clarity* of every thing. Besides, every form is a vestige or a ray of the creative Intelligence imprinted at the heart of created being. On the other hand, every order and every proportion is the work of intelligence. And so, to say with the Schoolmen that beauty is *the splendor of the form on the proportioned parts of matter,*[54] is to say that it is a flashing of intelligence on a matter intelligibly arranged. The intelligence delights in the beautiful because in the beautiful it finds itself again and recognizes itself, and makes contact with its own light. This is so true that those—such as Saint Francis of Assisi—perceive and savor more the beauty of things, who know that things come forth from an intelligence, and who relate them to their author.

Every sensible beauty implies, it is true, a certain delight of the eye itself or of the ear or the imagination: but there is beauty only if the intelligence also takes delight in some way. A beautiful color "washes the eye," just as a strong scent dilates the nostril; but of these two "forms" or qualities color only is said to be *beautiful,* because, being received, unlike the perfume, in a sense power capable of disinterested knowledge,[55] it can be, even through its purely sensible brilliance, an object of delight for the intellect. Moreover, the higher the level of man's culture, the more spiritual becomes the brilliance of the form that delights him.

It is important, however, to note that in the beautiful that we have called connatural to man, and which is proper to human art, this brilliance of the form, no matter how purely intelligible it may be in itself, is seized *in the sensible and through the sensible,* and not separately from it. The intuition of artistic beauty thus stands at the opposite extreme from the abstraction of scientific truth. For with the former it is through the very apprehension of the sense that the light of being penetrates the intelligence.

The intelligence in this case, diverted from all effort of abstraction, rejoices without work and without discourse. It is dispensed from its usual labor; it does not have to disengage an intelligible from the matter in which it is buried, in order to go over its different attributes step by step; like a stag at the gushing spring, intelligence has nothing to do but drink; it drinks the clarity of being. Caught up in the intuition of sense, it is irradiated by an intelligible light that is suddenly given to it, in the very sensible in which it glitters, and which it does not seize *sub ratione veri,* but rather *sub ratione delectabilis,* through the happy release procured for the intelligence and through the delight ensuing in the appetite, which leaps at every good of the soul as at its proper object. Only afterwards will it be able to reflect more or less successfully upon the causes of this delight.[56]

Thus, although the beautiful borders on the metaphysical *true,* in the sense that every splendor of intelligibility in things implies some conformity with the Intelligence that is the cause of things, nevertheless the beautiful is not a kind of truth, but a kind of good; [57] the perception of the beautiful relates to knowledge, but by way of addition, *comme à la jeunesse s'ajoute sa fleur;* it is not so much a kind of knowledge as a kind of delight.

The beautiful is essentially delightful. This is why, of its very nature and precisely as beautiful, it stirs desire and produces love, whereas the true as such only illumines. *"Omnibus igitur est pulchrum et bonum desiderabile et amabile et diligibile."* [58] It is for its beauty that Wisdom is loved.[59] And it is for itself that every beauty is first loved, even if afterwards the too weak flesh is caught in the trap. Love in its turn produces ecstasy, that is to say, it puts the lover outside of himself; ec-stasy, of which the soul experiences a diminished

form when it is seized by the beauty of the work of art, and
the fullness when it is absorbed, like the dew, by the beauty
of God.

And of God Himself, according to Denis the Areopagite,[60]
we must be so bold as to say that He suffers in some way
ecstasy of love, because of the abundance of His goodness
which leads Him to diffuse in all things a participation of His
splendor. But God's love causes the beauty of what He loves,
whereas our love is caused by the beauty of what we love.

<div align="center">*</div>

The speculations of the ancients concerning the beautiful
must be taken in the most formal sense; we must avoid ma-
terializing their thought in any too narrow specification. There
is not just one way but a thousand or ten thousand ways in
which the notion of *integrity* or perfection or completion can
be realized. The lack of a head or an arm is quite a consider-
able lack of integrity in a woman but of very little account
in a statue—whatever disappointment M. Ravaisson may
have felt at not being able to *complete* the Venus de Milo.
The least sketch of da Vinci's or even of Rodin's is more com-
plete than the most perfect Bouguereau. And if it pleases a
futurist to give the lady he is painting only one eye, or a
quarter of an eye, no one denies him the right to do this: one
asks only—here is the whole problem—that this quarter of
an eye be precisely all the eye this lady needs *in the given case.*

It is the same with proportion, fitness and harmony. They
are diversified according to the objects and according to the
ends. The good proportion of a man is not the good propor-
tion of a child. Figures constructed according to the Greek
or the Egyptian canons are perfectly proportioned in their
genre; but Rouault's clowns are also perfectly proportioned,
in their genre. Integrity and proportion have no absolute

signification,[61] and must be understood solely *in relation* to
the end of the work, which is to make a form shine on matter.

Finally, and above all, this radiance itself of the form,
which is the main thing in beauty, has an infinity of diverse
ways of shining on matter.* There is the sensible radiance of

* By "radiance of the form" must be understood an *ontological*
splendor which is in one way or another revealed to our mind, not a
conceptual clarity. We must avoid all misunderstanding here: the
words *clarity, intelligibility, light,* which we use to characterize the
role of "form" at the heart of things, do not necessarily designate
something clear and intelligible *for us,* but rather something clear and
luminous *in itself,* intelligible *in itself,* and which often remains ob-
scure to our eyes, either because of the matter in which the form in
question is buried, or because of the transcendence of the form itself
in the things of the spirit. The more substantial and the more pro-
found this secret sense is, the more hidden it is for us; so that, in
truth, to say with the Schoolmen that the form is in things the proper
principle of *intelligibility,* is to say at the same time that it is the
proper principle of *mystery.* (There is in fact no mystery where there
is *nothing to know:* mystery exists where there is *more to be known*
than is given to our comprehension.) To define the beautiful by the
radiance of the form is in reality to define it by the radiance of a
mystery.

It is a Cartesian misconception to reduce clarity *in itself* to clarity
for us. In art this misconception produces *academicism,* and condemns
us to a beauty so meagre that it can radiate in the soul only the most
paltry of delights.

If it be a question of the "legibility" of the work, I would add that
if the *radiance of form* can appear in an "obscure" work as well as in
a "clear" work, the *radiance of mystery* can appear in a "clear" work
as well as in an "obscure" work. From this point of view neither
"obscurity" nor "clarity" enjoys any privilege. [1927]

Moreover, it is natural that every really new work appear obscure
at first. Time will decant the judgment. "They say," Hopkins wrote
to Bridges apropos the poem *The Wreck of the Deutschland,* "that
vessels sailing from the port of London will take (perhaps it should
be / used once to take) Thames water for the voyage: it was foul
and stunk at first as the ship worked but by degrees casting its filth
was in a few days very pure and sweet and wholesome and better
than any water in the world. However that may be, it is true to my
purpose. When a new thing, such as my ventures in the Deutschland
are, is presented us our first criticisms are not our truest, best, most
homefelt, or most lasting but what come easiest on the instant. They
are barbarous and like what the ignorant and the ruck say. This was
so with you. The Deutschland on her first run worked very much and

color or tone; there is the intelligible clarity of an arabesque, of a rhythm or an harmonious balance, of an activity or a movement; there is the reflection upon things of a human or divine thought; [62] there is, above all, the deep-seated splendor one glimpses of the soul, of the soul principle of life and animal energy, or principle of spiritual life, of pain and passion. And there is a still more exalted splendor, the splendor of Grace, which the Greeks did not know.

Beauty, therefore, is not conformity to a certain ideal and immutable type, in the sense in which they understand it who, confusing the true and the beautiful, knowledge and delight, would have it that in order to perceive beauty man discover "by the vision of ideas," "through the material envelope," "the invisible essence of things" and their "necessary type." [63] Saint Thomas was as far removed from this pseudo-Platonism as he was from the idealist bazaar of Winckelmann and David. There is beauty for him the moment the shining of any form on a suitably proportioned matter succeeds in pleasing the intellect, and he takes care to warn us that beauty is in some way *relative*—relative not to the dispositions of the subject, in the sense in which the moderns understand the word relative, but to the proper nature and end of the thing, and to the formal conditions under which it is taken. *"Pulchritudo quodammodo dicitur per respectum ad aliquid. . . ."* [64] *"Alia enim est pulchritudo spiritus et alia corporis, atque alia hujus et illius corporis."* [65] And however beautiful a created thing

unsettled you, thickening and clouding your mind with vulgar mud-bottom and common sewage (I see that I am going it with the image) and just then you *drew off* your criticisms all stinking (a necessity now of the image) and bilgy, whereas if you had let your thoughts cast themselves they would have been clearer in themselves and more to my taste too." Letter of May 13, 1878, in *The Letters of Gerard Manley Hopkins to Robert Bridges,* edited with notes and an introduction by Claude Colleer Abbott (London: Oxford University Press, 1935), pp. 50–51.

may be, it can appear beautiful to some and not to others, because it is beautiful only under certain aspects, which some discern and others do not: it is thus "beautiful in one place and not beautiful in another."

*

If this is so, it is because the beautiful belongs to the order of the *transcendentals,* that is to say, objects of thought which transcend every limit of genus or category, and which do not allow themselves to be enclosed in any class, because they imbue everything and are to be found everywhere.[66] Like the one, the true and the good, the beautiful is *being* itself considered from a certain aspect; it is a property of being. It is not an accident superadded to being, it adds to being only a relation of reason: it is being considered as delighting, by the mere intuition of it, an intellectual nature. Thus everything is beautiful, just as everything is good, at least in a certain relation. And as being is everywhere present and everywhere varied the beautiful likewise is diffused everywhere and is everywhere varied. Like being and the other transcendentals, it is essentially *analogous,* that is to say, it is predicated for diverse reasons, *sub diversa ratione,* of the diverse subjects of which it is predicated: each kind of being *is* in its own way, is *good* in its own way, is *beautiful* in its own way.

Analogous concepts are predicated of God pre-eminently; in Him the perfection they designate exists in a "formal-eminent" manner, in the pure and infinite state. God is their "sovereign analogue," [67] and they are to be met with again in things only as a dispersed and prismatized reflection of the countenance of God.[68] Thus Beauty is one of the divine names.

God is beautiful. He is the most beautiful of beings, be-

cause, as Denis the Areopagite and Saint Thomas explain,[69] His beauty is without alteration or vicissitude, without increase or diminution; and because it is not as the beauty of things, all of which have a particularized beauty, *particulatam pulchritudinem, sicut et particulatam naturam.* He is beautiful through Himself and in Himself, beautiful absolutely.

He is beautiful to the extreme (*superpulcher*), because in the perfectly simple unity of His nature there pre-exists in a super-excellent manner the fountain of all beauty.

He is beauty itself, because He gives beauty to all created beings, according to the particular nature of each, and because He is the cause of all consonance and all brightness. Every form indeed, that is to say, every light, is "a certain irradiation proceeding from the first brightness," "a participation in the divine brightness." And every consonance or every harmony, every concord, every friendship and every union whatsoever among beings proceeds from the divine beauty, the primordial and super-eminent type of all consonance, which gathers all things together and which calls them all to itself, meriting well in this "the name χαλός, which derives from 'to call.'" Thus "the beauty of anything created is nothing else than a similitude of divine beauty participated in by things," and, on the other hand, as every form is a principle of being and as every consonance or every harmony is preservative of being, it must be said that divine beauty is the cause of the being of all that is. *Ex divina pulchritudine esse omnium derivatur.*[70]

In the Trinity, Saint Thomas adds,[71] the name Beauty is attributed most fittingly to the Son. As for integrity or perfection, He has truly and perfectly in Himself, without the least diminution, the nature of the Father. As for due proportion or consonance, He is the express and perfect image of the Father: and it is proportion which befits the image as such.

As for radiance, finally, He is the Word, the light and the splendor of the intellect, "perfect Word to Whom nothing is lacking, and, so to speak, art of Almighty God." [72]

Beauty, therefore, belongs to the transcendental and metaphysical order. This is why it tends of itself to draw the soul beyond the created. Speaking of the instinct for beauty, Baudelaire, the *poète maudit* to whom modern art owes its renewed awareness of the theological quality and tyrannical spirituality of beauty, writes: ". . . it is this immortal instinct for the beautiful which makes us consider the earth and its various spectacles as a sketch of, as a *correspondence* with, Heaven. . . . It is at once through poetry and *across* poetry, through and *across* music, that the soul glimpses the splendors situated beyond the grave; and when an exquisite poem brings tears to the eyes, these tears are not proof of an excess of joy, they are rather the testimony of an irritated melancholy, a demand of the nerves, of a nature exiled in the imperfect and desiring to take possession immediately, even on this earth, of a revealed paradise." [73]

*

The moment one touches a transcendental, one touches being itself, a likeness of God, an absolute, that which ennobles and delights our life; one enters into the domain of the spirit. It is remarkable that men really communicate with one another only by passing through being or one of its properties. Only in this way do they escape from the individuality in which matter encloses them. If they remain in the world of their sense needs and of their sentimental egos, in vain do they tell their stories to one another, they do not understand each other. They observe each other without seeing each other, each one of them infinitely alone, even though work

or sense pleasures bind them together. But let one touch the good and Love, like the saints, the true, like an Aristotle, the beautiful, like a Dante or a Bach or a Giotto, then contact is made, souls communicate. Men are really united only by the spirit; light alone brings them together, *intellectualia et rationalia omnia congregans, et indestructibilia faciens.*[74]

Art in general tends to make a work. But certain arts tend to make a *beautiful* work, and in this they differ essentially from all the others. The work to which all the other arts tend is itself ordered to the service of man, and is therefore a simple means; and it is entirely enclosed in a determined material genus. The work to which the fine arts tend is ordered to beauty; as beautiful, it is an end, an absolute, it suffices of itself; and if, as work-to-be-made, it is material and enclosed in a genus, as beautiful it belongs to the kingdom of the spirit and plunges deep into the transcendence and the infinity of being.

The fine arts thus stand out in the *genus* art as man stands out in the *genus* animal. And like man himself they are like a horizon where matter and spirit meet. They have a spiritual soul. Hence they possess many distinctive properties. Their contact with the beautiful modifies in them certain characteristics of art in general, notably, as I shall try to show, with respect to the rules of art; on the other hand, this contact discloses and carries to a sort of excess other generic characteristics of the virtue of art, above all its intellectual character and its resemblance to the speculative virtues.

There is a curious analogy between the fine arts and wisdom. Like wisdom, they are ordered to an object which transcends man and which is of value in itself, and whose amplitude is limitless, for beauty, like being, is infinite. They are disinterested, desired for themselves, truly noble because

their work taken in itself is not made in order that one may use it as a means, but in order that one may enjoy it as an end, being a true *fruit, aliquid ultimum et delectabile*. Their whole value is spiritual, and their mode of being is contemplative. For if contemplation is not their act, as it is the act of wisdom, nevertheless they aim at producing an intellectual delight, that is to say, a kind of contemplation; and they also presuppose in the artist a kind of contemplation, from which the beauty of the work must overflow. That is why we may apply to them, with due allowance, what Saint Thomas says of wisdom when he compares it to play: [75] "The contemplation of wisdom is rightly compared to play, because of two things that one finds in play. The first is that play is delightful, and the contemplation of wisdom has the greatest delight, according to what Wisdom says of itself in Ecclesiasticus: *my spirit is sweet above honey*. The second is that the movements of play are not ordered to anything else, but are sought for themselves. And it is the same with the delights of wisdom. . . . That is why divine Wisdom compares its delight to play: *I was delighted every day, playing before him in the world.*[76] "

But Art remains, nevertheless, in the order of Making, and it is by drudgery upon some matter that it aims at delighting the spirit. Hence for the artist a strange and saddening condition, image itself of man's condition in the world, where he must wear himself out among bodies and live with the spirits. Though reproaching the old poets for holding Divinity to be jealous, Aristotle acknowledges that they were right in saying that the possession of wisdom is in the strict sense reserved to Divinity alone: "It is not a human possession, for human nature is a slave in so many ways." [77] To produce beauty likewise belongs to God alone in the strict sense. And if the condition of the artist is more human and less exalted

than that of the wise man, it is also more discordant and more painful, because his activity does not remain wholly within the pure immanence of spiritual operations, and does not in itself consist in contemplating, but in making. Without enjoying the substance and the peace of wisdom, he is caught up in the hard exigencies of the intellect and the speculative life, and he is condemned to all the servile miseries of practice and of temporal production.

*

"Dear Brother Leo, God's little beast, even if a Friar Minor spoke the language of the angels and raised to life a man dead for four days, note it well that it is not therein that perfect joy is found. . . ."

Even if the artist were to encompass in his work all the light of heaven and all the grace of the first garden, he would not have perfect joy, because he is following wisdom's footsteps and running by the scent of its perfumes, but does not possess it. Even if the philosopher were to know all the intelligible reasons and all the properties of being, he would not have perfect joy, because his wisdom is human. Even if the theologian were to know all the analogies of the divine processions and all the whys and the wherefores of Christ's actions, he would not have perfect joy, because his wisdom has a divine origin but a human mode, and a human voice.

Ah! les voix, mourez donc, mourantes que vous êtes!

The Poor and the Peaceful alone have perfect joy because they possess wisdom and contemplation *par excellence,* in the silence of creatures and in the voice of Love; united without intermediary to subsisting Truth, they know "the sweetness that God gives and the delicious taste of the Holy Spirit." [78] This is what prompted Saint Thomas, a short time

before his death, to say of his unfinished *Summa:* "It seems to me as so much straw"—*mihi videtur ut palea.* Human straw: the Parthenon and Notre-Dame de Chartres, the Sistine Chapel and the Mass in D—and which will be burned on the last day! "Creatures have no savor." *

The Middle Ages knew this order. The Renaissance shattered it. After three centuries of infidelity, prodigal Art aspired to become the ultimate end of man, his Bread and his Wine, the consubstantial mirror of beatific Beauty. And the poet hungry for beatitude who asked of art the mystical fullness that God alone can give, has been able to open out only onto *Sigê l'abîme.* Rimbaud's silence marks perhaps the end of a secular apostasy. In any case it clearly signifies that it is folly to seek in art the words of eternal life and the repose of the human heart; and that the artist, if he is not to shatter his art or his soul, must simply be, as artist, what art wants him to be—a good workman.

And now the modern world, which had promised the artist everything, soon will scarcely leave him even the bare means of subsistence. Founded on the two *unnatural* principles of the *fecundity of money* and the *finality of the useful,* multiplying needs and servitude without the possibility of there ever being a limit, destroying the leisure of the soul, withdrawing the material *factibile* from the control which proportioned it to the ends of the human being, and imposing on man the

* I feel today that I must apologize for the sort of thoughtlessness with which I adopted this phrase here. One must have little experience of created things, or much experience of divine things, in order to be able to speak in this way. In general, formulas of contempt with regard to created things belong to a conventional literature that is difficult to endure. The creature is deserving of compassion, not contempt; it exists only because it is loved. It is deceptive because it has too much savor, and because this savor is nothing in comparison with the being of God. [1935]

panting of the machine and the accelerated movement of matter, the system of *nothing but the earth* is imprinting on human activity a truly inhuman mode and a diabolical direction, for the final end of all this frenzy is to prevent man from resembling God,

> *dum nil perenne cogitat,*
> *seseque culpis illigat.*

Consequently he must, if he is to be logical, treat as useless, and therefore as rejected, all that by any grounds bears the mark of the spirit.

Or it will even be necessary that heroism, truth, virtue, beauty become *useful* values—the best, the most loyal instruments of propaganda and of control of temporal powers.

Persecuted like the wise man and almost like the saint, the artist will perhaps recognize his brothers at last and discover his true vocation again: for in a way he is not of this world, being, from the moment that he works for beauty, on the path which leads upright souls to God and manifests to them the invisible things by the visible. However rare may be at such a time those who will not want to please the Beast and to turn with the wind, it is in them, by the very fact that they will exercise a *disinterested* activity, that the human race will live.

The Rules of Art

The whole formal element of art consists in the *regulation* which it imprints on matter. Moreover it is of the essence of art, according to the ancients, to have fixed rules, *viae certae et determinatae.*

This expression "fixed rules" conjures up some bad memories: we think of the three unities, and of "Aristotle's rules." But it is from the Renaissance with its superstitious reverence for antiquity and its stuffed Aristotle, not from the Christian Aristotle of our Doctors, that the starched rules of the grammarians of the *grand siècle* derive. The fixed rules of which the Schoolmen spoke are not conventional imperatives imposed on art from without, but the ways of operation peculiar to art itself, the ways of working reason, ways high and hidden.[79] And every artist knows well that without this intellectual form ruling the matter, his art would be but sensual slush.[80] Some explanations however seem to be necessary at this point.

*

First, with regard to art in general, the mechanical or servile arts as well as the fine arts and the liberal arts, it is important to understand that the rules in question are nothing, in actual fact, if they are not in a vital and spiritual state in a *habitus*

or a virtue of the intellect, which is precisely the virtue of art.

Through the *habitus* or virtue of art superelevating his mind from within, the artist is a ruler who *uses* rules according to his ends; it is as senseless to conceive of him as the slave of the rules as to consider the worker the slave of his tools. Properly speaking, he possesses them and is not possessed by them: he is not *held* by them, it is he who *holds*—through them—matter and the real; and sometimes, in those superior moments where the working of genius resembles in art the miracles of God in nature, he will act, not against the rules, but outside of and above them, in conformity with a higher rule and a more hidden order. Let us understand in this manner the words of Pascal: "True eloquence makes fun of eloquence, true morality makes fun of morality, to make fun of philosophy is to philosophize truly," to which the most tyrannical and the most radical of academy heads adds this savory gloss: "Unless you don't care a rap about painting, painting won't care a rap about you." [81]

There is, as I noted earlier, a fundamental incompatibility between *habitus* and egalitarianism. The modern world has a horror of *habitus,* whatever ones they may be, and one could write a very strange *History of the Progressive Expulsion of Habitus by Modern Civilization.* This history would go back quite far into the past. We would see—"a fish always rots by the head first"—theologians like Scotus, then Occam, and even Suarez, ill-treat, to begin with, the most aristocratic of these strange beings, namely the gifts of the Holy Spirit—not to mention the infused moral virtues. Soon the theological virtues and sanctifying grace will be filed and planed away by Luther, then by the Cartesian theologians. Meanwhile, natural *habitus* have their turn; Descartes, with his passion for levelling, attacks even the *genus generalissimum* to which the

wretches belong, and denies the real existence of qualities and accidents. The whole world at the time is agog with excitement over calculating machines; everybody dreams only of method. And Descartes conceives method as an infallible and easy means of bringing to the truth "those who have not studied" and society people.[82] Leibniz finally invents a logic and a language whose most wonderful characteristic is that it *dispenses from thinking*.[83] And then comes the taste, the charming curiosity, the spiritual acephaly of the Enlightenment.

Thus *method* or *rules, regarded as an ensemble of formulas and processes that work of themselves and serve the mind as orthopedic and mechanical armature,* tend everywhere in the modern world to replace *habitus,* because method is for all whereas *habitus* are only for some. Now it cannot be admitted that access to the highest activities depend on a virtue that some possess and others do not; consequently beautiful things must be made easy.

Χαλεπὰ τὰ καλά. The ancients thought that truth is difficult, that beauty is difficult, and that the way is narrow; and that to conquer the difficulty and the loftiness of the object, it is absolutely necessary that an intrinsic force and elevation— that is to say, a *habitus*—be developed in the subject. The modern conception of method and rules would therefore have seemed to them a gross absurdity. According to their principles, rules are of the essence of art, but on condition that the *habitus,* a living rule, be formed; without it, rules are nothing. Plaster the perfect theoretical knowledge of all the rules of an art onto an energetic laureate who works fifteen hours a day but in whom the *habitus* is not sprouting, and you will never make an artist of him; he will always remain infinitely farther removed from the art than the child or the savage equipped with a simple natural gift: this said by way

of excusing the too naive or too subtle adorers of Negro art.

The problem is posed for the modern artist in an insane manner, as a choice between the senility of academic rules and the primitiveness of natural gift: with the latter, art does not yet exist, except in potentiality; with the former, it has ceased to exist at all. Art exists only in the living intellectuality of the *habitus*.

*

In our day *natural gift* is lightly taken for art itself, especially if it is covered over with facile faking and a voluptuous medley of colors. However, natural gift is only a prerequisite condition for art, or again a rough outline (*inchoatio naturalis*) of the artistic *habitus*. This inborn disposition is clearly indispensable; but without cultivation and a discipline which the ancients held should be long and patient and honest, it will never develop into art properly speaking. Thus art, like love, proceeds from a spontaneous instinct, and it must be cultivated like friendship; for it is a virtue like friendship.

Saint Thomas points out that the natural dispositions through which one individual differs from another have their root in the physical disposition of the body; [84] they concern our sense faculties, in particular the imagination, the chief purveyor of art—which thus appears as the *gift* par excellence by which the artist is born—and which the poets gladly make their main faculty, because it is so intimately bound up with the activity of the creative intellect that it is difficult in the concrete to distinguish the one from the other. But the virtue of art involves an improvement of the mind; moreover, it imprints on the human being an incomparably deeper quality than do the natural dispositions.

Besides, the manner in which education cultivates the natural dispositions may atrophy the spontaneous gift instead of

developing the *habitus,* especially if this manner is material and rotten with recipes and clever devices—or again if it is theoretical and speculative instead of being operative, for the practical intellect, on which the rules of the arts depend, proceeds by positing an effect in being, not by proving or demonstrating; and often those who best possess the rules of an art are the least capable of formulating them. From this point of view one must deplore the substitution (begun by Colbert, completed by the Revolution) of the academic teaching of the schools for corporate apprenticeship.[85] By the very fact that art is a virtue of the practical intellect, the mode of teaching that by nature belongs to it is apprenticeship-education, the working-novitiate under a master and in the presence of the real, not lessons distributed by professors; and, to tell the truth, the very notion of a *School of Fine Arts,* especially in the sense in which the modern body politic understands this phrase, conceals as deep a misunderstanding of things as the notion, for instance, of an *Advanced Course in Virtue.* Hence the revolts of a Cézanne against the Academy and against the professors, revolts directed, in reality, chiefly against a barbarous conception of artistic education.

The fact remains that art, being an intellectual *habitus,* presupposes necessarily and always a *formation* of the mind, which puts the artist in possession of fixed rules of operation. No doubt, in certain exceptional cases, the individual effort of the artist, of a Giotto,[86] for example, or a Moussorgsky, can suffice by itself alone to procure this formation of the mind. And indeed, since what is most spiritual in art—the synthetic intuition, the conception of the work-to-be-made—depends on the *via inventionis* or the effort of discovery, which requires solitude and is not learned from others, it may even be said that the artist, as far as the fine point and the highest

life of his art are concerned, forms and elevates himself single-handed. The closer one approaches this spiritual point of the art, the more the *viae determinatae* with which one will have to deal will be adapted and personal to the artist, and designed to disclose themselves to one man only.[87] In this respect it may be that in our time, when we are experiencing so grievously all the evils of anarchy, we run the risk of deceiving ourselves as to the nature and extent of the results that can be expected from a return to the craft traditions.

Still, for the immense amount of rational and discursive work that art involves, the tradition of a discipline and an education by masters and the continuity in time of human collaboration, in short, the *via disciplinae,* is absolutely necessary, whether it is a question of technique properly speaking and of material means, or of all the conceptual and rational replenishing which certain arts (above all in classical times) require and carry along—or, finally, of the indispensable maintenance of a sufficiently high level of culture in the average run of artists and artisans, each one of whom it is absurd to ask to be an "original genius." [88]

Let us add, in order to have the thought of Saint Thomas in its entirety,[89] that in every discipline and in all teaching the master only assists from the outside the principle of immanent activity which is within the pupil. From this point of view, teaching relates to the great notion of *ars cooperativa naturae.* Whereas certain arts apply themselves to their matter in order to dominate it, and to impose on it a form which it has only to receive—such as the art of a Michelangelo torturing marble like a tyrant—others, because they have for matter nature itself, apply themselves to their matter in order to serve it, and to help it to attain a form or a perfection which can be acquired only through the activity of an interior principle; such are the arts which "cooperate with nature,"

as, for instance, medicine, with corporeal nature, or teaching (as also the art of directing souls), with spiritual nature. These arts operate only by furnishing the interior principle within the subject with the means and the assistance it avails itself of in order to produce its effect. It is the *interior principle,* the intellectual light present in the pupil, which is, in the acquisition of science and art, the *principal cause* or *principal agent.*

*

If it be a question now of the fine arts in particular, their contact with being and the transcendentals creates for them, as regards the rules of art, an altogether special condition.

And straightway they are subject to a law of renewal, and therefore of change, which the other arts do not acknowledge or at least do not acknowledge for the same reason.

Beauty, like being, has an infinite amplitude. But the work as such, realized in matter, exists in a certain genus, *in aliquo genere.* And it is impossible for a genus to exhaust a transcendental. Outside the artistic genre to which this work belongs, there is always an infinity of ways of being a *beautiful* work.

A sort of conflict may therefore be observed between the transcendence of beauty and the material narrowness of the work to be made, between, on the one hand, the formal *ratio* of beauty, the splendor of being and of all the transcendentals combined, and, on the other hand, the formal *ratio* of art, undeviating ingenuity in the realm of works-to-be-made. No form of art, however perfect, can encompass beauty within its limits, as the Virgin contained her Creator. The artist is faced with an immense and lonely sea,

> . . . *sans mâts, sans mâts, ni fertiles îlots,*

and the mirror he holds up to it is no bigger than his own heart.

The creator in art is he who discovers a *new analogate* [90] of the beautiful, a new way in which the radiance of form can shine on matter. The work that he makes, and which as such exists in a certain genus, is from then onwards in a new genus and requires new rules—I mean a new adaptation of the fundamental and perennial rules,[91] and even the use of *viae certae et determinatae* not hitherto employed and which at first disconcert people.

At that moment the contemplative activity in contact with the transcendental, which constitutes the proper life of the fine arts and of their rules, is clearly predominant. But almost inevitably talent, cleverness, pure technique, the merely operative activity that pertains to the *genus* art, will little by little get the upper hand, at the moment when one no longer exerts oneself except to exploit what was once discovered; then the rules formerly living and spiritual become materialized, and this form of art finally exhausts itself. A renewal will be necessary. Please God that a genius be found to bring it about! Even so the change will perhaps lower the general level of art; and yet change is the very condition of art's life and of the flowering of great works.[92] We may believe that from Bach to Beethoven and from Beethoven to Wagner art declined in quality, in spirituality, and in purity. But who would be bold enough to say that one of these three men was less necessary than the other? If they load their art with exotic riches too heavy for any but themselves to bear, it happens that the most powerful ones are the most dangerous. Rembrandt is a bad master; but who would refuse him one's affection? Even though painting was to be wounded for it, it is better that he should have played and won, made his miraculous breach in the invisible world. It is indeed true that there is no necessary progress in art, that tradition and discipline are the true nurses of originality; and it is likewise true that

the feverish acceleration which modern individualism, with
its mania for revolution in mediocrity, imposes on the suc-
cession of art forms, abortive schools, and puerile fashions,
is the symptom of wide-spread intellectual and social poverty.
And yet the fact remains that art has a fundamental need of
novelty: like nature, it goes in seasons.

Unlike Prudence, Art does not presuppose straightness of
the appetite, that is to say, of the power of willing and lov-
ing, in relation to the end of man or in the line of morality.[93]
It nevertheless presupposes, as Cajetan explains,[94] that the
appetite tend straightly *to the proper end of the art,* so that
the principle: "the truth of the practical intellect does not
consist in conformity with the thing, but in conformity with
the straight appetite," rules the sphere of Making as well as
that of Doing.

In the fine arts the general end of art is beauty. But in their
case the work-to-be-made is not a simple matter to be or-
dered to this end, like a clock one makes for the purpose
of telling time or a boat one builds for the purpose of
travelling on water. As an individual and original realiza-
tion of beauty, the work which the artist is about to make
is for him an end in itself: not the general end of his art,
but the particular end which rules his present activity and
in relation to which all the means must be ruled. Now, in
order to *judge* suitably concerning this individual end, that is
to say, in order to conceive the work-to-be-made,[95] reason
alone is not enough, a *good disposition of the appetite* is neces-
sary, for everyone judges of his own ends in accordance with
what he himself actually is: "As everyone is, so does the end
appear to him." [96] Let us conclude therefore that in the painter,
poet, and musician, the virtue of art, which resides in the
intellect, must not only overflow into the sense faculties and

the imagination, but it requires also that the whole appetitive power of the artist, his passions and will, tend straightly to the end of his art. If all of the artist's powers of desire and emotion are not fundamentally straight and exalted in the line of beauty, whose transcendence and immateriality are superhuman, then human life and the humdrum of the senses, and the routine of art itself, will degrade his conception. The artist has to love, he has to love *what he is making,* so that his virtue may truly be, in Saint Augustine's words,[97] *ordo amoris,* so that beauty may become connatural to him and inviscerate itself in him through affection, and so that his work may come forth from his heart and his bowels as well as from his lucid spirit. This undeviating love is the supreme rule.

But love presupposes intellect; without it love can do nothing, and, in tending to the beautiful, love tends to what can delight the intellect.

Finally, because in the fine arts the work-to-be-made is— precisely as beautiful—an end in itself, and because this end is something absolutely individual, something entirely unique, each occasion presents to the artist a new and unique way of striving after the end, and therefore of ruling the matter. Hence there is a remarkable analogy between the fine arts and Prudence.

No doubt art always keeps its *viae certae et determinatae,* and the proof of this is that the works of the same artist or of the same school are all stamped with the same fixed and determined characteristics. But it is with prudence, *eubulia,* good sense and perspicacity, circumspection, precaution, deliberation, industry, memory, foresight, intelligence and divination, it is by using prudential rules not fixed beforehand but determined according to the contingency of singular cases,

it is in an always new and unforeseeable manner that the artist applies the rules of his art: only on this condition is its ruling infallible. "A painting," said Degas, "is a thing which requires as much cunning, rascality and viciousness as the perpetration of a crime." [98] For different reasons, and because of the transcendence of their object, the fine arts thus partake, like hunting or the military art, in the virtues of government.

In the end, all the rules having become connatural to him, the artist seemingly has no other rule than to espouse at each moment the living contour of a unique and dominating intuitive emotion that will never recur.

This artistic prudence, this kind of spiritual sensibility in contact with matter, corresponds in the operative order to the contemplative activity and the proper life of art in contact with the beautiful. To the extent that the rules of the Academy prevail, the fine arts revert to the generic type of art and to its lower species, the mechanical arts.

VII

The Purity of Art

"What we now seek in art," Émile Clermont observed,[99] "the Greeks sought in something quite different, sometimes in wine, most often in the celebration of their mysteries: a frenzy, an intoxication. The great Bacchic madness of these mysteries corresponds to our highest point of emotion in art, which is something derived from Asia. But for the Greeks art was altogether different. . . .[100] It did not have for its purpose to convulse the soul, but to purify it, which is the exact opposite: 'art purifies the passions,' according to Aristotle's celebrated and generally misunderstood observation. And what would doubtless be a prime necessity for us, is to purify the idea of beauty. . . ."

Both with regard to *art* in general and with regard to *beauty*, the Scholastic Doctors insistently teach that the intellect has primacy in the work of art. They never stop reminding us that *the first principle of all human works is reason*.[101] Let us add that in making Logic the liberal art *par excellence*, and in a sense the prime analogate of art, they are telling us that in every art there is a sort of *lived* participation in Logic.

> *There all is ORDER and beauty,*
> *Richness, tranquillity and pleasure.*[102]

If in architecture all unnecessary veneer is ugly, it is because it is illogical; [103] if sham and illusion, always irritating, be-

49

come detestable in sacred art, it is because it is profoundly illogical that deceit should serve to decorate God's house: [104] *Deus non eget nostro mendacio.* "Everything in art," said Rodin, "is ugly which is false, which smiles without motive, everything that is senseless affectation, everything that struts and prances, everything that is but parade of beauty and grace, everything that lies." [105] "I want you," Maurice Denis adds,[106] "to paint your figures *in such a way that they have the look of being painted,* subject to the laws of painting—I don't want them to try to deceive my eye or my mind; the truth of art consists in the conformity of the work with its means and its end." Which is to say with the ancients that the truth of art is taken *per ordinem et conformitatem ad regulas artis,*[107] and that every work of art must be logical. Therein lies its truth. It must be steeped in logic: not in the pseudo-logic of clear ideas,[108] and not in the logic of knowledge and demonstration, but in working logic, always mysterious and disconcerting, the logic of the structure of the living and of the intimate geometry of nature. Notre-Dame de Chartres is as much a marvel of logic as Saint Thomas' *Summa;* flamboyant Gothic itself remains averse to veneer, and the extravagance in which it exhausts itself is that of the elaborate and tortuous syllogisms of the logicians of the period. Virgil, Racine, Poussin, are logical. Chateaubriand is not.*—The

* Is this so very certain? I fear that Chateaubriand may have been inserted there to balance the sentence or because of some old prejudice. I should have said, and of this I feel sure: Mallarmé also is logical, and Claudel is logical (and even formidably rational). And in an order which no longer contains anything rational, from which the idea is deliberately ousted to make room for the sole architecture of dream, Pierre Reverdy also is logical, with a nocturnal logic unconscious of itself, incarnate in the spontaneity of feeling. The poems of a Paul Éluard obey the same law, as do the "surrealist themes" when they have poetic value. Chance itself is logical in the heart of a poet. (Is that any reason to abandon oneself to it? Let us not take for the normal conditions of poetry the experiences which strive to

architects of the Middle Ages did not restore "in the style," like Viollet-le-Duc. If the choir of a Romanesque church was destroyed by fire, they rebuilt it in Gothic, without further thought. But observe in Le Mans Cathedral the joints and the transitions, the sudden and self-assured arcing in splendor: there you have living logic, like the logic of the orogeny of the Alps or of the anatomy of man.

*

The perfection of the virtue of art consists according to Saint Thomas in the act of judging.[109] As for manual dexterity, that is a requisite condition, but extrinsic to art. It even represents—at the same time that it is a necessity—a perpetual menace to art, inasmuch as it runs the risk of substituting the guidance of muscular habit for the guidance of the intellectual *habitus,* and of having the work escape the influx of art. For there is an influx of art which, *per physicam et realem impressionem usque ad ipsam facultatem motivam membrorum,* proceeds, from the intellect where art resides, to move the hand and to cause an artistic "formality" to "shine" in the work.[110] A spiritual virtue may thus pass into a clumsy stroke.

Hence the charm one finds in the clumsiness of the primitives. In itself clumsiness has nothing charming about it; it has no attraction where poetry is lacking, and it even becomes downright obnoxious whenever it is—however so little—willed for itself or imitated. But in the primitives it was a sacred weakness through which the subtle intellectuality of art revealed itself.[111]

Man lives so much *in sensibus,* he has so much trouble maintaining himself at the level of the intellect, that one may

reduce it to the impossible in order to test its resistance, leaving to survive only a final germ gleaming on the threshold of death.) [1927]

well wonder whether—in art as well as in social life—progress
in material means and in scientific technique, good as it is in
itself, is not an evil in actual fact, so far as the average state
of art and civilization is concerned. In this category, and be-
yond a certain limit, whatever removes a constraint removes
a source of strength, and whatever removes a difficulty re-
moves a source of grandeur.

When on visiting an art gallery one passes from the rooms
of the primitives to those in which the glories of oil painting
and of a much more considerable material science are dis-
played, the foot takes a step on the floor but the soul takes
a steep fall. It had been taking the air on the everlasting hills:
it now finds itself on the floor of a theatre—a magnificent
theatre. With the sixteenth century the lie installed itself in
painting, which began to love science for its own sake, en-
deavoring to give the *illusion* of nature and to make us be-
lieve that in the presence of a painting we are in the presence
of the scene or the subject painted, not in the presence of a
painting.

The great classicists from Raphael to Greco, to Zurbaran,
Lorrain, and Watteau, succeeded in purifying art of this lie;
realism, and, in a sense, impressionism, delighted in it. Does
Cubism in our day, despite its enormous deficiencies, repre-
sent the still groping and noisy childhood of an art once again
pure? The barbarous dogmatism of its theorists compels one
to doubt this very much, and to fear that the new school may
be endeavoring to free itself radically from naturalist imita-
tion only to immobilize itself in *stultae quaestiones*,[112] by
denying the primary conditions which essentially distinguish
Painting from the other arts, from Poetry, for instance, or
from Logic.*

* Or rather by denying the conditions which distinguish Painting
from Art taken in its generic concept only. I wrote these lines almost

We observe, however, in a few of the artists—painters, poets, and musicians—whom Criticism only recently lodged at the Sign of the Cube (an astonishingly expandable cube), the most noteworthy effort towards the logical coherence and the simplicity and purity of means that properly constitute the veracity of art. These days, all *the best people* want the classical.[113] I know nothing in contemporary production more sincerely *classical* than the music of Satie. "Never any sorcery, repetitions, suspicious caresses, fevers, or miasmas. Never does Satie 'stir the pool.' It is the poetry of childhood relived by a master technician." [114]

*

Cubism has rather violently posed the question of *imitation* in art. Art, as such, does not consist in imitating, but in making, in composing or constructing, in accordance with the laws of the very object to be posited in being (ship, house, carpet, colored canvas or hewn block). This exigency of its generic concept takes precedence over everything else; and to make the representation of the real its essential end is to destroy it. Plato, with his theory of imitation in its several degrees [115] and of poetry as a conjurer, misconceives, like all exaggerated intellectualists, the proper nature of art; whence his contempt for poetry. It is obvious that if art were a *means of science,* it would be tremendously inferior to geometry.[116]

But if art, as art, is a stranger to imitation, the fine arts, insofar as they are ordered to Beauty, have a certain relation to imitation, and one that is quite difficult to define.

When Aristotle wrote, apropos the first causes of poetry:

ten years ago. Today there is no longer a Cubist school, but the results have not been lost; whatever the theories, the Cubist reaction, by recalling painting to the essential exigencies of art in general, did in fact render the immense service of recalling painting to itself. [1927]

"To imitate is natural to men from childhood, . . . man is
the most imitative of the animals: he acquires his first knowl-
edge through imitation, and everybody delights in imitations.
We find a sign of this latter in works of art: for of the very
things that we look at with uneasiness we rejoice to behold
the most exact images, such as the forms of the vilest beasts
and of corpses. The explanation is that to learn is the greatest
of pleasures not only for philosophers but also for other
men . . ." [117]—when Aristotle wrote these words, he enun-
ciated a specific condition imposed on the fine arts, a condi-
tion grasped from their earliest origin. But Aristotle is to be
understood here in the most *formal* sense. If, following his
usual method, the Philosopher goes straight to the primitive
case, it would be an utter mistake for us to stop there and
always to limit the word "imitation" to its everyday meaning
of *exact reproduction or representation of a given reality.*
When the man of the reindeer age traced the forms of animals
on the walls of caves, he was no doubt prompted above all by
the pleasure of reproducing an object with exactness.[118] But
since that time the *joy of imitation* has been remarkably
purified. Let us try to make this idea of imitation in art more
precise.

The fine arts seek to produce, by the object they make, the
joy or delight of the intellect through the intuition of the
sense: the aim of painting, said Poussin, is delight. This delight
is not the delight of the very act of knowing, the delight of
the possession of knowledge, the delight of the true. It is a
delight that overflows from this act, when the object upon
which it bears is well proportioned for the intellect.

Thus this delight presupposes knowledge, and the more
knowledge there is, or the more things given to the intellect,
the greater is the possibility of delight. This is why art as

ordered to beauty refuses—at least when its object permits
it—to stop at forms or colors, or sounds or words grasped
in themselves and *as things* (they must first be grasped in
this manner—that is the first condition), but it grasps them
also as making known something other than themselves, that
is to say, *as signs*. And the thing signified can be a sign in its
turn, and the more the object of art is laden with significa-
tion (but with spontaneous and intuitively grasped significa-
tion, not with hieroglyphic signification), the greater and
richer and higher will be the possibility of delight and beauty.
The beauty of a painting or a statue is thus incomparably
richer than the beauty of a carpet, a Venetian glass, or an am-
phora.

It is in this sense that Painting, Sculpture, Poetry, Music,
and even the Dance, are imitative arts, that is, arts which
effect the beauty of the work and procure the delight of the
soul by making use of imitation, or by rendering, through
certain sensible signs, something other than these signs spon-
taneously present to the spirit. Painting *imitates* with colors
and plane forms things given outside of us, Music *imitates*
with sounds and rhythms—and the Dance with rhythm only
—the "characters," as Aristotle says,[119] and the movements
of the soul, the invisible world which stirs within us. Allow-
ing for this difference as regards the object signified, Painting
is no more imitative than Music and Music is no less imi-
tative than Painting, if "imitation" is understood precisely
in the sense just defined.

But since the delight procured by the beautiful does not
consist formally in the act itself of knowing the real, or in the
act of conformity with what is, it does not at all depend on
the perfection of imitation as reproduction of the real, or on
the exactness of the representation. Imitation as reproduction
or representation of the real—in other words, imitation *ma-*

terially taken—is but a means, not an end; along with manual
dexterity, it relates to artistic activity, but no more than
manual dexterity does it constitute it. And the things rendered
present to the soul by the sensible signs of art—by the rhythms,
sounds, lines, colors, forms, masses, words, metres, rhymes,
images, the *proximate matter* of art—are themselves but a
material element of the beauty of the work, just like the signs
in question; they are a *remote matter,* so to speak, which the
artist arranges and on which he must make shine the radiance
of a form, the light of being. To propose to oneself as an end
the perfection of imitation understood materially, would there-
fore be to direct oneself to what is purely material in the work
of art, and to imitate slavishly; this servile imitation is abso-
lutely foreign to art.[120]

What is required is not that the representation exactly con-
form to a given reality, but that through the material elements
of the beauty of the work there truly pass, sovereign and
whole, the radiance of a form *—of a form, and therefore of

* I specified in the note to p. 28 the sense in which this "radiance
of a form" is to be understood. It is not a question of the clarity or
facility with which the work evokes objects already known, ideas,
feelings—*things.* The very things evoked, the feelings, ideas and rep-
resentations, are for the artist but materials and means, signs still.
To insist on explaining the power of poetry by the musicality of the
sounds is to exhibit a very crude hedonism. A beautiful verse takes
hold of the soul by the spiritual correspondences, inexpressible in
themselves, that a birth truly free of the work of words uncovers.
Whether it be "obscure" or "clear" is therefore secondary.

Nor should it be forgotten that "the obscurity of a passage is the
product of two factors: the matter read and the one doing the read-
ing. It is rare that the latter accuses himself." (Paul Valéry, in
Frédéric Lefèvre, *Entretiens avec Paul Valéry,* Paris, La Livre, 1926.)
Few great artists have escaped being accused of obscurity by their con-
temporaries. Many minor ones, it is true, make themselves obscure to
compel esteem. In any case, if "Hamletian" subjectivism has more
devotees today than when Max Jacob wrote his *Art Poétique,* the
fact remains that in its deepest tendency modern poetry, far from
seeking obscurity for itself, "fumes," on the contrary, "at not being
understood." [1927]

a truth: in this sense the great phrase of the Platonists, *splendor veri,* always remains. But if the delight in the beautiful work comes from *a truth,* it does not come from the truth of *imitation as reproduction of things,* it comes from the perfection with which the work expresses or manifests the form, in the metaphysical sense of this word,[121] it comes from the truth of *imitation as manifestation of a form.* Here we have the *formal element* of imitation in art: the expression or manifestation, in a work suitably proportioned, of some secret principle of intelligibility which shines forth. It is upon this that the *joy of imitation* bears in art. It is also what gives art its value of *universality.*

What constitutes the rigor of the true classical, is such a subordination of the matter to the light of the form thus manifested, that no material element issuing from things or from the subject is admitted into the work which is not strictly required as support for or vehicle of this light, and which would dull or "debauch" [122] the eye, ear, or spirit. Compare, from this point of view, Gregorian melody or the music of Bach with the music of Wagner or Stravinsky.*

In the presence of a beautiful work, as I have already pointed out, the intellect rejoices without discourse. If therefore art manifests or expresses *in matter* a certain radiance of being, a certain form, a certain soul, a certain truth—"Oh!

* I am sorry to have spoken in this way of Stravinsky. I knew as yet only the *Sacre du Printemps,* but I should have already seen that Stravinsky was turning his back on all that shocks us in Wagner. Since then he has shown that genius preserves and increases its strength by renewing it in the light. Exuberant with truth, his admirably disciplined work affords the best lesson of any today in grandeur and creative force, and best comes up to the strict classical rigor of which we are speaking. His purity, his authenticity, his glorious spiritual vigor, are to the gigantism of Parsifal and the Tetralogy as a miracle of Moses is to the enchantments of the Egyptians. [1927]

you'll *confess* in the end," Carrière once said to one whose
portrait he was painting—it does not give a conceptual and
discursive expression of it in the soul. It is thus that it sug-
gests without properly making known, and that it expresses
that which our ideas cannot signify. *A, a, a,* exclaims Jeremias,
Domine Deus, ecce nescio loqui.[123] But where speech leaves
off, song begins—*exsultatio mentis prorumpens in vocem.*[124]

Let us add that in the case of the arts which address them-
selves to sight (painting, sculpture), or to the intellect (po-
etry), a stricter necessity of imitation or signification imposes
itself extrinsically on art, because of the faculty involved. For
this faculty must rejoice—above all, if it is the intellect, sec-
ondarily and instrumentally if it is sight.[125] Now sight and
intellect, being the most cognitive of the powers of knowing
and the ones most drawn to the object, cannot experience
complete joy if they do not know, in a sufficiently lively man-
ner, some object—doubtless a sign itself in its turn—which
is signified to them by mass, color, or words. The eye there-
fore and the intellect need to perceive or to recognize in the
work some element that is legible. And no doubt it is a ques-
tion here only of a condition extrinsic to art itself formally
considered *—an obscure poem can be better than a clear
poem; nevertheless, the poetic value being equal, the soul will
derive more enjoyment from the clear poem, and if the ob-
scurity becomes too great, if the signs are no longer but enig-
mas, the nature of our faculties protests. In some degree the
artist always does violence to nature, and yet if he did not
take account of this exigency, he would sin, by a kind of ideal-
ist vertigo, against the *material* or *subjective* conditions which
art is humanly obliged to satisfy. Therein lies the danger of
the foolhardy voyages, however noble in other respects, to the

* A condition affecting what we called above the *remote matter* of
art.

Cap de Bonne Espérance, and of a poetry which "teases eternity" by voluntarily obscuring the idea under films of images arranged with an exquisite sense. When a Cubist, in his horror of impressionism or naturalism, declares that a picture, like a cushion, should remain just as *beautiful* when turned upside down, he affirms a very curious return—and a very useful one, if properly understood—to the laws of absolute constructive coherence of *art* in general; [126] but he forgets both the subjective conditions and the particular exigencies of the beautiful which is proper to painting.

Nevertheless the fact remains that if "imitation" were understood in the sense of *exact reproduction or copy of the real*,[127] it would have to be said that except for the art of the cartographer or of the draftsman of anatomical plates there is no imitative art. In this sense, and however deplorable his writings may be in other respects, Gauguin, in affirming that it was necessary to renounce *making what one sees,* formulated a primary truth which the masters have practiced from the very beginning.[128] Cézanne's well-known remark expressed the same truth: "What is required is that we re-create Poussin by painting from nature. Everything is there." [129] The imitative arts aim neither at copying the appearances of nature, nor at depicting the "ideal," but at making an object beautiful by manifesting a *form* with the help of sensible signs.

The human artist or poet, whose intellect is not the cause of things, as is the Divine Intellect, cannot draw this form entirely from his creative spirit: he goes and imbibes it first and above all in the immense treasure-house of created things, of sensible nature as also of the world of souls, and of the interior world of his own soul. From this point of view he is first and foremost a man who sees more deeply than other men, and who discloses in the real spiritual radiances which

others cannot discern.[130] But to make these radiances shine
in his work, and therefore to be truly docile and faithful to
the invisible spirit that plays in things, he can, and he even
must, distort in some measure, reconstruct, transfigure the
material appearances of nature. Even in a portrait that is "a
perfect likeness"—in Holbein's drawings, for instance—the
work always expresses a form engendered in the spirit of the
artist and truly born in that spirit, true portraits being nothing
other than "the ideal reconstruction of individuals." [131]

Art, then, remains fundamentally inventive and creative.
It is the faculty of producing, not of course *ex nihilo,* but
from a pre-existing matter, a new creature, an original being,
capable of stirring in turn a human soul. This new creature is
the fruit of a spiritual marriage which joins the activity of the
artist to the passivity of a given matter.

Hence in the artist the feeling of his peculiar dignity. He
is as it were an associate of God in the making of beautiful
works; by developing the powers placed in him by the Creator
—for "every perfect gift is from above, coming down from
the Father of lights"—and by making use of created matter,
he creates, so to speak, at second remove. *Operatio artis
fundatur super operationem naturae, et haec super crea-
tionem.*[132]

Artistic creation does not copy God's creation, it continues
it. And just as the trace and the image of God appear in His
creatures, so the human stamp is imprinted on the work of
art—the full stamp, sensitive and spiritual, not only that of
the hands, but of the whole soul. Before the work of art passes
from art into the matter, by a transitive action, the very con-
ception of the art has had to emerge from within the soul, by
an immanent and vital action, like the emergence of the mental
word. *Processus artis est duplex, scilicet artis a corde artificis,
et artificiatorum ab arte.*[133]

If the artist studies and cherishes nature as much as and a great deal more than the works of the masters, it is not in order to copy it, but in order to *base himself* on it; and it is because it is not enough for him to be the pupil of the masters: he must be the pupil of God, for God knows the rules governing the making of beautiful works.[134] Nature is essentially of concern to the artist only because it is a derivation of the divine art in things, *ratio artis divinae indita rebus.* The artist, whether he knows it or not, consults God in looking at things.

They exist but for a moment, but all the same it was fine!
He were ignorant of his art who found a flaw in Thine.[135]

Nature is thus the first exciter and the first guide of the artist, and not an example to be copied slavishly. Ask the true painters what their need of nature is. They fear her and revere her, but with a chaste fear, not with a slavish one. They imitate her, but with an imitation that is truly filial, and according to the creative agility of the spirit, not with a literal and servile imitation. One day, after a walk in the wintertime, Rouault told me he had just discovered, by looking at snow-clad fields in the sunshine, how to paint the white trees of spring. "The model," said Renoir [136] for his part, "is there only to set me on fire, to enable me to dare things that I could not invent without it. . . . And it makes me come a cropper if I throw myself too much into it." Such is the liberty of the sons of the Creator.

*

Art has not to defend itself only against the allurements of manual dexterity (or of that other cleverness which is *taste* [137]) and against slavish imitation. Other foreign elements also threaten its purity. For example, the beauty to which it tends produces a delight, but it is the high delight of

the spirit, which is the exact contrary of what is called pleasure, or the pleasant tickling of the sensibility; and if art seeks to please, it betrays, and becomes deceitful. Similarly, its *effect* is to produce emotion, but if it *aims* at emotion, at affecting the appetites or arousing the passions, it falsifies itself, and thus another element of lie enters into it.[138]

This is as true of music as it is of the other arts. Music no doubt has this peculiarity that, signifying with its rhythms and its sounds the very movements of the soul—*cantare amantis est*—it produces, in producing emotion, precisely what it signifies. But this production is not what it aims at, any more than a representation or a description of the emotions is. The emotions which it makes present to the soul by sounds and by rhythms, are the *matter* through which it must give us the felt joy of a spiritual form, of a transcendent order, of the radiance of being. Thus music, like tragedy, purifies the passions,[139] by developing them within the limits and in the order of beauty, by harmonizing them with the intellect, in a harmony that fallen nature experiences nowhere else.

Let us designate as *thesis* every intention extrinsic to the work itself, when the thought animated by this intention does not act on the work through the artistic *habitus* moved instrumentally, but juxtaposes itself to this *habitus* in order itself to act directly on the work; in that case, the work is not produced wholly by the artistic *habitus* and wholly by the thought thus animated, but partly by the one and partly by the other, like a boat pulled by two men. In this sense every thesis, whether it claims to demonstrate some truth or to touch the heart, is for art a foreign importation, hence an impurity. It imposes on art, in art's own sphere, that is to say in the very production of the work, a rule and an end which

is not the end or rule of the production; it prevents the work of art from springing from the heart of the artist spontaneously like a ripened fruit; it betrays a calculation, a duality between the intellect of the artist and his sensibility, which two, art, as it happens, wants to see united.

I willingly accept the ascendancy of the *object* which the artist has conceived and which he lays before my eyes; I then abandon myself unreservedly to the emotion which in him and in me springs from a same beauty, from a same transcendental in which we communicate. But I refuse to accept the ascendancy of an art which contrives suggestive means by which to seduce my subconscious, I resist an emotion which the will of a man seeks to impose upon me. The artist must be as objective as the man of science, in the sense that he must think of the spectator only in order to present him with the beautiful, or the *well-made,* just as the man of science thinks of his listener only in order to present him with the true. The cathedral builders did not harbor any sort of thesis. They were, in Dulac's fine phrase, "men unaware of themselves." [140] They neither wished to demonstrate the propriety of Christian dogma nor to suggest by some artifice a *Christian emotion.* They even thought a great deal less of making a beautiful work than of doing good work. They were men of Faith, and as they were, so they worked. Their work revealed the truth of God, but without *doing it intentionally,* and because of not doing it intentionally.

VIII

Christian Art

By the words "Christian art" I do not mean *Church art,* art specified by an object, an end, and determined rules, and which is but a particular—and eminent—point of application of art.* I mean Christian art in the sense of art which bears within it the character of Christianity. In this sense Christian art is not a species of the genus art: one does not say "Chris-

* The distinction between *Church art* or *sacred art* and an art that is religious not by virtue of its intended purpose but only by virtue of the character and the inspiration of the work, is only too evident, for what is most lacking nowadays in a great number of works of sacred art is just precisely a truly religious character. But it is the practical importance of this distinction that I should like to point out here. The public—lay and cleric—too often overlook it. Hence the deplorable habit of evaluating every work of religious inspiration by "situating" it as if it had to decorate a church or serve some pious use. Yet many works of religious inspiration do not necessarily have this intended purpose, even when their subject matter is a religious one, and are made to be seen or heard elsewhere than in temples and for another end than the devotion of the faithful. This is precisely the case—and for reasons it is not difficult to perceive—with some of the most beautiful modern works which originate in a sincere and sometimes profound religious feeling, and which do not satisfy the proper conditions and proper decorum of sacred art. One would spare oneself many rash judgments and sometimes unnecessary indignation by not considering these works from the viewpoint of a religious use for which they are not intended. Conversely, it is not because a work of art with a religious subject possesses an extraordinary artistic merit and has been executed with faith, that it necessarily satisfies all the exigencies of sacred art and can serve the use of the faithful. [1935]

64

tian art" as one says "pictorial" or "poetic" art, "Gothic" or
"Byzantine" art. A young man does not say to himself "I am
going in for Christian art," as he might say "I am going in
for agriculture." There is no school where one learns Chris-
tian art.[141] Christian art is defined by the one in whom it
exists and by the spirit from which it issues: one says "Christian
art" or the "art of a Christian," as one says the "art of the
bee" or the "art of man." It is the art of redeemed humanity.
It is planted in the Christian soul, by the side of the running
waters, under the sky of the theological virtues, amidst the
breezes of the seven gifts of the Spirit. It is natural that it
should bear Christian fruit.

Everything belongs to it, the sacred as well as the profane.
It is at home wherever the ingenuity and the joy of man ex-
tend. Symphony or ballet, film or novel, landscape or still-
life, puppet-show libretto or opera, it can just as well appear
in any of these as in the stained-glass windows and statues of
churches.

But, it may be objected, is not this Christian art a myth?
Can one even conceive of it? Is not art pagan by birth and
tied to sin—just as man is a sinner by birth? But grace heals
wounded nature. Do not say that a Christian art is impossi-
ble.[142] Say rather that it is difficult, doubly difficult—fourfold
difficult, because it is difficult to be an artist and very dif-
ficult to be a Christian, and because the total difficulty is not
simply the sum but the product of these two difficulties multi-
plied by one another: for it is a question of harmonizing two
absolutes. Say that the difficulty becomes tremendous when
the entire age lives far from Christ, for the artist is greatly
dependent upon the spirit of his time. But has courage ever
been lacking on earth?

Besides, wherever art—Egyptian, Greek or Chinese—has
known a certain degree of grandeur and purity, it is already

Christian, Christian in hope, because every spiritual radiance is a promise and a symbol of the divine harmonies of the Gospel.

Inspiration is not a mere mythological accessory. There exists a real inspiration, coming not from the Muses, but from the living God, a special movement of the natural order,[143] by which the first Intelligence, when It pleases, gives the artist a creative movement superior to the yardstick of reason, and which uses, in superelevating them, all the rational energies of art; and whose impulse, moreover, man is free to follow or to vitiate. This inspiration descending from God the author of nature is, as it were, a symbol of supernatural inspiration. In order for an art to arise that is Christian not only in hope but in fact, and truly liberated by grace, both forms of inspiration must be joined at its most secret source.

If you want to make a Christian work, then *be* Christian, and simply try to make a beautiful work, into which your heart will pass; do not try to "make Christian."

Do not make the absurd attempt to dissociate in yourself the artist and the Christian. They are one, if you *are* truly Christian, and if your art is not isolated from your soul by some system of aesthetics. But apply only the artist to the work; precisely because the artist and the Christian are one, the work will derive wholly from each of them.

Do not *separate* your art from your faith. But leave *distinct* what is distinct. Do not try to blend by force what life unites so well. If you were to make of your aesthetic an article of faith, you would spoil your faith. If you were to make of your devotion a rule of artistic activity, or if you were to turn desire to edify into a method of your art, you would spoil your art.

The entire soul of the artist reaches and rules his work, but it must reach it and rule it only *through the artistic habitus.* Art tolerates no division here. It will not allow any foreign element, juxtaposing itself to it, to mingle, in the production of the work, its regulation with art's own. Tame it, and it will do all that you want it to do. Use violence, and it will accomplish nothing good. Christian work would have the artist, as artist, free.

Nevertheless art will be Christian, and will reveal in its beauty the interior reflection of the radiance of grace, only if it overflows from a heart suffused by grace. For the virtue of art which reaches it and rules it directly, presupposes that the appetite is rightly disposed with regard to the beauty of the work. And if the beauty of the work is Christian, it is because the appetite of the artist is rightly disposed with regard to such a beauty, and because in the soul of the artist Christ is present through love. The quality of the work is here the reflection of the love from which it issues, and which moves the virtue of art instrumentally. Thus it is by reason of an intrinsic superelevation that art is Christian, and it is through love that this superelevation takes place.

It follows from this that the work will be Christian in the exact degree in which love is vibrant. Let's make no mistake about it: what is required is the very actuality of love, contemplation in charity. Christian work would have the artist, as man, a saint.

It would have him possessed by love. Let him then make what he wishes. If the work conveys a note less purely Christian, it is because something was lacking in the purity of the love.[144] *Art requires much calm,* said Fra Angelico, *and to paint the things of Christ one must live with Christ;* it is the only saying that we have of his, and how little systematic . . .

It would therefore be futile to try to find a technique, a style, a system of rules or a way of working which would be those of Christian art. The art which germinates and grows in Christian man can admit of an infinity of them. But these forms of art will all have a family likeness, and all of them will differ substantially from non-Christian forms of art; as the flora of the mountains differs from the flora of the plains. Consider the liturgy: it is the transcendent and supereminent type of the forms of Christian art; the Spirit of God in Person fashioned it, so as to be able to delight in it.[145]

But the liturgy is not entirely immutable, it suffers the passage of time; eternity rejuvenates itself in it. And the Maronite or Pravoslav liturgy is not the Roman liturgy: there are many mansions in Heaven. Nothing is more beautiful than a High Mass—a dance before the Ark in slow motion, more majestic than the advance of the heavenly hosts. And yet in it the Church is not seeking for beauty, nor for decorative motifs, nor to touch the heart. Her sole aim is to adore, and to unite herself with the Savior; and from this loving adoration beauty, too, overflows.

Beautiful things are rare. What exceptional conditions must be presupposed for a civilization to unite, and in the same men, art and contemplation! Under the burden of a nature always resisting and ceaselessly falling, Christianity has spread its sap everywhere, in art and in the world; but except for the Middle Ages, and then only amid formidable difficulties and deficiencies, it has not succeeded in shaping an art and a world all its own—and this is not surprising. Classical art produced many Christian works, and admirable ones at that. But can it be said that taken in itself this form of art has the original savor of the Christian climate? It is a form born in another land, and then transplanted.

If in the midst of the unspeakable catastrophes which the modern world invites, a moment is to come, however brief, of pure Christian springtime—a Palm Sunday for the Church, a brief Hosanna from poor earth to the Son of David—one may expect for these years, together with a lively intellectual and spiritual vigor, the regermination of a truly Christian art, to the delight of men and the angels. Even now this art seems to herald itself in the individual effort of certain artists and poets over the past fifty years, some of whom are to be reckoned among the greatest. We must above all be careful not to disengage and isolate it prematurely, and by an academic effort, from the great movement of contemporary art.[146] It will emerge and assert itself only if it springs spontaneously from a common renewal of art and sanctity in the world.

*

Christianity does not make art *easy*. It deprives it of many facile means, it bars its course at many places, but in order to raise its level. At the same time that Christianity creates these salutary difficulties, it superelevates art from within, reveals to it a hidden beauty which is more delicious than light, and gives it what the artist has need of most—simplicity, the peace of awe and of love, the innocence which renders matter docile to men and fraternal.

Art and Morality

The artistic *habitus* is intent only on the work to be made. No doubt it permits the consideration of the objective conditions (practical use, intended purpose, etc.) which the work must satisfy—a statue made to be prayed before, is different from a statue for a garden. But this is because such a consideration has to do with the very beauty of the work: a work which would not be adapted to these conditions would thereby be lacking in proportion, and therefore in beauty. Art has for sole end the work itself and its beauty.

But for the man working, the work-to-be-made enters—itself—into the line of morality,[147] and on this ground it is only a means. If the artist took the end of his art or the beauty of the work for the ultimate end of his operation and therefore for beatitude, he would be but an idolater.[148] It is absolutely necessary therefore that the artist, *qua* man, work for something other than his work, for something better loved. God is infinitely more lovable than art.

God is jealous. "The rule of divine love is without mercy," said Mélanie de la Salette. "Love is a true sacrificer: it desires the death of all that is not it." Unhappy the artist with a divided heart! The blessed Angelico was willing to put down his painting without a murmur and go and tend geese if obedi-

ence had required this of him. Consequently a creative stream gushed from his tranquil heart. God left him that, because he had renounced it.

Art has no right against God. There is no good opposed to God or the ultimate Good of human life. Art in its own domain is sovereign like wisdom; through its object it is subordinate neither to wisdom nor to prudence nor to any other virtue. But by the subject in which it exists, by man and in man it is subordinate—extrinsically subordinate—to the good of the subject; insofar as it finds itself in man and insofar as the liberty of man makes use of it, it is subordinate to the end of man and to the human virtues. Therefore "if an art produces objects which men cannot use without sinning, the artist who makes such works himself commits sin, because he directly offers to others the occasion of sin; as if someone were to make idols for idolatry. As to the arts of works which men can put to a good or bad use, they are permissible; and yet if there are some of them whose works are employed *in the greatest number of cases* for a bad use, they must, although permissible in themselves, be banished from the city by the office of the Prince, *secundum documenta Platonis*." [149] Fortunately for the rights of man, our fine cities have no Prince, and all that works for idolatry and lechery, in dressmaking or in literature, is not thwarted by Plato.

Because it exists in man and because its good is not the good of man, art is subject in its exercise to an extrinsic control, imposed in the name of a higher end which is the very beatitude of the living being in whom it resides. But in the Christian this control proceeds without constraint, because the immanent order of charity renders it connatural to him, and because the law has become his own interior inclination: *spiritualis homo non est sub lege*. It is to him that one can say: *ama, et fac quod vis;* if you love, you can do what you

wish, you will never offend love. A work of art which offends God offends the Christian too, and, no longer having anything with which to delight, it immediately loses for him any claim to beauty.

*

There is according to Aristotle [150] a twofold good of the multitude, for example, of an army: one which is in the multitude itself, and such is the order of the army; the other separate from the multitude, and such is the good of the Commander. And this latter good is the nobler of the two, because it is to it that the other one is ordered—the order of the army being for the realization of the good of the Commander, that is to say, the will of the Commander in the obtaining of victory.[151] We can conclude from this that the contemplative, being ordered directly to the "separate common good" of the whole universe, that is to say, to God, serves better than any other the common good of the human multitude; for the "intrinsic common good" of this multitude, the social common good, depends on the "separate common good," which is superior to it. It is the same, analogically and all allowances being made, with all those, metaphysicians or artists, whose activity touches the transcendental order of truth or beauty, and who have some part in wisdom if only natural wisdom. Leave, then, the artist to his art: he serves the community better than the engineer or the tradesman.

This does not mean that he must ignore the city, either as a man—this is obvious—or even as an artist. The question for him is not whether he ought to open his work to all the human currents flowing into his heart, and to pursue, in making it, this or that particular human aim: the individual case is sole master here, and all prejudgment would be improper.

The sole question for the artist is not to be a weakling; it is to have an art which is robust enough and undeviating enough to dominate at all events his matter without losing anything of its loftiness and purity, and to aim, in the very act of making, at the sole good of the work, without being turned aside or distracted by the human ends pursued.

To tell the truth, art took to enclosing itself in its famous ivory tower, in the XIX century, only because of the disheartening degradation of its environment. But the normal condition of art is altogether different. Aeschylus, Dante, or Cervantes did not write in a vacuum bell. Moreover, there cannot in fact be any purely "gratuitous" work of art—the universe excepted. Not only is our act of artistic creation ordered to an ultimate end, true God or false God, but it is impossible that it not regard, because of the environment in which it steeps, certain proximate ends that concern the human order. The workman works for his wages, and the most disincarnate artist has some concern to act on souls and to serve an idea, be it only an aesthetic idea. What is required is the perfect practical discrimination between the aim of the workman (*finis operantis,* as the Schoolmen put it) and the aim of the work (*finis operis*): so that the workman should work for his wages, but the work should be ruled and shaped and brought into being only with regard to its own good and in nowise with regard to the wages. Thus the artist may work for any and every human intention he likes, but the work taken in itself must be made and constructed only for its own beauty.

It is the idlest fancy to think that the *ingenuousness* or the purity of the work of art depends on a break with the animating and motive principles of the human being, on a line drawn

between art and desire or love. It depends rather on the *force* of the principle that generates the work, or on the *force* of the virtue of art.

There was a tree that said: "I want to be tree only and nothing else, and to bear fruit which will be pure fruit. That is why I do not want to grow in earth which is not tree, nor in a climate which is climate of Provence or of Vendée, and not tree-climate. Shelter me from the air."

It would simplify many questions to make a distinction between art itself and its material or subjective conditions. Art being of man, how could it not depend on the pre-existing structures and inclinations of the subject in which it dwells? They remain extrinsic to art, but they influence it.

Art as such, for instance, transcends, like the spirit, every frontier of space or time, every historical or national boundary; it has its bounds only in the infinite amplitude of beauty. Like science, philosophy and civilization, by its very nature and object it is universal.

But art does not reside in an angelic mind; it resides in a soul which animates a living body, and which, by the natural necessity in which it finds itself of learning, and progressing little by little and with the assistance of others, makes the rational animal a naturally social animal. Art is therefore basically dependent upon everything which the human community, spiritual tradition and history transmit to the body and mind of man. By its human subject and its human roots, art belongs to a time and a country.

That is why the most universal and the most human works are those which bear most openly the mark of their country.[152] The century of Pascal and Bossuet was a century of vigorous nationalism. At the time of the great tranquil victories of Cluny, and at the time of Saint Louis, a French—but, above

all, Catholic—intellectual radiation was exerted on Christendom, and it was then that the world experienced the purest and the freest "international" of the spirit, and the most universal culture.

It thus appears that attachment to the natural environment, *political and territorial,* of a nation is one of the conditions of the proper life and therefore of the very universality of the intellect and of art; whereas a *metaphysical and religious* cult of the nation, which would seek to enslave the intellect to the physiology of a race or to the interests of a State, exposes art and every virtue of the spirit to mortal danger.

*

All our values depend on the nature of our God.

Now God is Spirit. To progress—which means for any nature, to tend toward its Principle [153]—is therefore to pass from the sensible to the rational and from the rational to the spiritual and from the less spiritual to the more spiritual; to civilize is to spiritualize.

Material progress may contribute, to the extent that it allows man leisure of soul. But if such progress is employed only to serve the will to power and to gratify a cupidity which opens *infinite* jaws—*concupiscentia est infinita* [154]—it leads the world back to chaos at an accelerated speed; that is its way of tending toward the principle.

There is a fundamental need of art in the human community: "Nobody," says Saint Thomas following Aristotle, "can do without delectation for long. That is why he who is deprived of spiritual delectations goes over to the carnal." [155]

Art teaches men the delectations of the spirit, and because it is itself *sensible* and adapted to their nature, it can best

lead them to what is nobler than itself. It thus plays in natural life the same role, so to speak, as the "sensible graces" in the spiritual life; and from very far, and unconsciously, it prepares the human race for contemplation (the contemplation of the saints), whose spiritual delectation exceeds all delectation,[156] and which seems to be the end of all the operations of men. For why the servile works and trade, if not in order that the body, being provided with the necessaries of life, may be in the state required for contemplation? Why the moral virtues and prudence, if not to procure the tranquillity of the passions and the interior peace that contemplation needs? Why the whole government of civil life, if not to assure the exterior peace necessary to contemplation? "So that, properly considered, all the functions of human life seem to be for the service of those who contemplate truth." [157] But contemplation itself—and all the rest—is for the sake of love.

If one tried, not, certainly, to make an impossible classification of artists and works, but to understand the normal hierarchy of the different types of art, one could do so only from this human point of view of their properly civilizing value, or of their degree of spirituality.

One would thus descend from the beauty of Holy Scripture and of the Liturgy, to that of the writings of the mystics, then to art properly so-called: the spiritual fullness of mediaeval art, the rational harmony of Greek and classical art, the pathos-laden harmony of Shakespearean art. . . . The imaginative and verbal richness of romanticism, the instinct of the heart, maintains in it, in spite of its deep-seated lack of balance and its intellectual indigence, the concept of art. With naturalism this concept disappears almost completely

—only to reappear, as one might expect, cleansed and sharpened, with new values.

*

The magnificence of Julius II and of Leo X had a great deal more to it than a noble love of glory and beauty; with whatever vanity it may have been accompanied, a ray passed through it of the Spirit which has never failed the Church.

That great Contemplative, instructed by the gift of Science, profoundly discerns all the needs of the human heart; she knows the unique value of art. That is why she has so protected it in the world. Even more, she has summoned it to the *opus Dei,* and she asks it to make precious ointments which she spreads over the head and feet of her Master. *Ut quid perditio ista?* murmur the philanthropists. She continues to embalm the body of her Beloved, whose death she proclaims every day, *donec veniat.*

Do you think that God, Who "is called *Zealot,*" says Denis the Areopagite, "because He has love and zeal for all that is," [158] is scornful of artists and of the fragile beauty which issues from their hands? Remember what He says of the men whom He Himself assigned to sacred art: "Behold, the Lord hath called by name Beseleel, the son of Uri, the son of Hur, of the tribe of Juda, and hath filled him with the spirit of God, with wisdom and understanding and knowledge and all learning to devise and to work in gold and silver and brass, and in engraving stones, and in carpenter's work. Whatsoever can be devised artificially He hath given in his heart: Ooliab also, the son of Achisameck of the tribe of Dan: both of them hath he instructed with wisdom, to do carpenter's work, and tapestry, and embroidery in blue and purple, and scarlet twice-

dyed, and fine linen, and to weave all things, and to invent all
new things." [159]

*

We have already noted the general opposition between
Art and Prudence. This opposition is further aggravated in
the fine arts, by reason of the very transcendence of their
object.

The Artist is subject, in the sphere of his art, to a kind of
asceticism, which may require heroic sacrifices. He must be
thoroughly undeviating as regards the end of his art, per-
petually on guard not only against the banal attraction of easy
execution and success, but against a multitude of more subtle
temptations, and against the slightest relaxation of his in-
terior effort, for *habitus* diminish with the mere cessation
of their acts,[160] even more, with every relaxed act, every act
which is not proportionate to their intensity.[161] He must pass
through spiritual nights, purify himself without ceasing, vol-
untarily abandon fertile regions for regions that are barren
and full of insecurity. In a certain sphere and from a particular
point of view, in the sphere of the making and from the point
of view of the good of the work, he must possess humility and
magnanimity, prudence, integrity, fortitude, temperance, sim-
plicity, ingenuousness. All these virtues which the saints pos-
sess *purely and simply,* and in the line of the supreme good,
the artist must have *in a certain relation,* and in a line apart,
extra-human if not inhuman. So he easily takes on the tone
of the moralist when he speaks or writes about art, and he
knows well that he has a virtue to protect. "We shelter in our-
selves an Angel whom we constantly shock. We must be the
guardians of this angel. Shelter well your virtue. . . ." [162]

But if this analogy invests the artist with a unique nobility,
and explains the admiration he enjoys among men, it runs

the risk of leading him pitiably astray and of having him place his treasure and his heart in a phantom, *ubi aerugo et tinea demolitur.*

The Prudent Man as such, on the other hand, judging as he does all things under the angle of morality and in relation to the good of man, is absolutely ignorant of all that pertains to art. He can, no doubt, and he must, judge the work of art insofar as it concerns morality: [163] he has no right to judge it as a work of art.

The work of art is the occasion for a unique conflict of virtues. Prudence, which considers it in its relation to morality, deserves on better grounds than Art the name of virtue,[164] for, like every moral virtue, it causes the man who acts to be good—purely and simply good.

But Art, insofar as it resembles more the speculative virtues, and insofar as it thus possesses more intellectual splendor, is in itself a nobler *habitus: simply speaking, that virtue is nobler which has the nobler object.* Prudence is superior to Art in relation to man. Understood purely and simply, Art—at least the art that, aiming at Beauty, has a speculative character—is superior metaphysically to Prudence.[165]

What makes the conflict bitter is the fact that Art is not subordinate to Prudence by virtue of their respective objects, as science, for instance, is subordinate to wisdom. As concerns its own objects, everything comes under the purview of Art, and of Art alone. But as concerns the human subject, nothing comes under Art's purview. Over anything made by the hand of man Art and Prudence each claim dominion. From the point of view of poetic, or, if you will, working values, Prudence is not competent. From the point of view of human values, and of the moral regulation of the free act,

to which everything is subordinate on the side of the human subject, Prudence alone is competent, and there is no limitation upon its rights to govern. In order to form a correct judgment about the work both virtues are necessary.

When he reproves a work of art, the Prudent Man, standing squarely upon his moral virtue, has the certitude that he is defending against the Artist a sacred good, the good of man, and he looks upon the Artist as a child or a madman. Perched on his intellectual virtue, the Artist has the certitude that he is defending a no less sacred good, the good of Beauty, and he looks as though he were bearing down on the Prudent Man with the weight of Aristotle's maxim: "Life proportioned to the intellect is better than life proportioned to man." [166]

The Prudent Man and the Artist have difficulty therefore in understanding one another. But the Contemplative and the Artist, each perfected by an intellectual virtue which rivets him to the transcendental order, are naturally close. They also have the same brand of enemies. The Contemplative, who looks at the highest cause on which every being and activity depend, knows the place and the value of art, and understands the Artist. The Artist as such cannot judge the Contemplative, but he can divine his grandeur. If he truly loves beauty and if a moral vice does not hold his heart in a dazed condition, when his path crosses the Contemplative's he will recognize love and beauty.

And besides, in following the very line of his art, he tends without knowing it to pass beyond his art; just as a plant, though lacking knowledge, directs its stem towards the sun, the artist, however sordid his life, is oriented in the direction of subsisting Beauty, whose sweetness the saints enjoy in a light inaccessible to art and reason. "Neither painting nor sculpture," said Michelangelo in his old age, "will any longer

charm the soul that is turned towards that divine love which opens out its arms on the Cross to receive us."

Consider Saint Catherine of Sienna, that *apis argumentosa* who was the counsellor of a Pope and of Princes of the Church, surrounded by artists and poets whom she leads into Paradise. Perfectly prudent, but set far above Prudence, judging all things by Wisdom, which is "architectonic in regard to all the intellectual virtues," and in whose service is Prudence "as the porter in the service of the king," [167] the Saints are free like the Spirit. Like God, the wise man is interested in the effort of every form of life.

> *Delicate and not exclusive,*
> *He will be of our day;*
> *His heart, contemplative by choice,*
> *Will yet know the work of men . . .*

Thus Wisdom, placed as it is at the point of view of God, which equally commands the spheres of Doing and of Making, can alone perfectly reconcile Art and Prudence.

Adam sinned because he failed in contemplation. Ever since, the heart of man has been divided.

To turn away from Wisdom and Contemplation, and to aim lower than God, is for a Christian civilization the first cause of all disorder.[168] It is in particular the cause of that ungodly divorce between Art and Prudence which one observes in times when Christians no longer have the strength to bear the integrity of their riches. That is doubtless why Prudence was sacrificed to Art at the time of the Italian Renaissance, in a civilization which no longer tended to anything but the humanist *Virtù*, and why Art was sacrificed to Prudence, in the XIX century, in "right-thinking" circles which no longer tended to anything but Respectability.

APPENDICES

An Essay on Art

i. Dignity of Art

The philosophers tell us that art consists essentially, not in performing a moral act, but in making a thing, a work, in making an object with a view not to the human good of the agent, but to the exigencies and the proper good of the object to be made, and by employing ways of realization predetermined by the nature of the object in question.

Art thus appears as something foreign in itself to the sphere of the human good, almost as something inhuman, and whose exigencies nevertheless are absolute: for, needless to say, there are not two ways of making an object well, of realizing well the work one has conceived—there is but one way, and it must not be missed.

The philosophers go on to say that this making activity is principally and above all an intellectual activity. Art is a virtue of the intellect, of the practical intellect, and may be termed the virtue proper to working reason.

But then, you will say, if art is nothing other than an intellectual virtue of making, whence comes its dignity and its ascendancy among us? Why does this branch of our activity draw to it so much human sap? Why has one always and in all peoples admired the poet as much as the sage?

It may be answered first that to create, to produce some-

thing intellectually, to make an object *rationally constructed,* is something very great in the world: for man this alone is already a way of imitating God. And I am speaking here of art in general, such as the ancients understood it—in short, of art as the virtue of the artisan.

But where the maker of works especially becomes an imitator of God, where the virtue of art approaches the nobility of things absolute and self-sufficient, is in that family of arts which by itself alone constitutes a whole spiritual world, namely the fine arts.

There are two things to be considered here. On the one hand, whatever the nature and the utilitarian ends of the art envisaged, it participates by its object in something superhuman, since it has as its object to create beauty. Is not beauty a transcendental, a property of being, one of the Divine Names? "The being of all things derives from the Divine Beauty," says Saint Thomas. In this respect, then, the artist imitates God, Who made the world by communicating to it a likeness of His beauty.

> . . . *The architect, by the disposition he knows,*
> *Buildeth the structure of stone like a filter in the waters*
> *of the Radiance of God,*
> *And giveth the whole building its sheen as to a pearl.*

On the other hand, to create a work of beauty is to create a work on which shines the radiance or the splendor, the mystery of a *form,* in the metaphysical sense of this word, of a ray of intelligibility and truth, of an irradiation of the primal brilliance. And no doubt the artist perceives this form in the created world, whether exterior or interior: he does not discover it complete in the sole contemplation of his creative spirit, for he is not, like God, the cause of things. But it is his eye and his spirit that have perceived and uncovered it; and it must itself be alive within him, must have taken on human life in him, must live in his intelligence with an intel-

lectual life and in his heart and his flesh with a sensitive life, in order for him to be able to communicate it to matter in the work he makes.

Thus the work bears the mark of the artist; it is the off-spring of his soul and his spirit.

In this respect also human art imitates God: it realizes in the order of intellectuality, that is to say, in the highest order of nature (I do not speak of the order of charity, which is superior to it, being supernatural), it realizes in act one of the fundamental aspects of the ontological likeness of our soul with God.

For it is the aspiration and ardent desire of the intelligence, considered in the pure state, to beget a living being like unto itself. Moreover every intelligence utters a word. "To be fertile, so as to manifest that which one possesses within oneself, is a great perfection, and it essentially belongs to the intellectual nature." [169] Thus in the world of pure spirits, where there is no generation, there is the spiritual production of the mental word, in which the Angel in knowing himself expresses himself to himself, and through which he manifests what he knows to whomever it pleases him among the other pure spirits. This mental word, it is true, this spiritual utter-ance remains a quality of the subject; it is not a substance, it is a sign. In creatures, the intellect does not succeed in pro-ducing in similitude of nature another "itself"; it does not, properly speaking, engender; it utters a word, but this word is not a son. This, however, is owing to the essentially deficient condition of the creature; intelligence itself, considered in the pure state, in its pure formal line, desires to engender, to produce, in knowing itself, something which will not be merely a likeness, a sign, an idea of the thing known, but the thing known itself existing for itself.

Only in God, only in Pure Act, is intelligence, which is then subsisting Intelligence, able to realize fully the funda-mental exigencies of its nature and give birth to *another itself* substantial and personal, to a Word which is really a

Son. It is only in the Holy Trinity that we see two functions coincide which everywhere else are separate, the uttering of the word and the generation of the son, that we see intelligence issue in a subsisting term, into which passes substantially the integrity of its own nature.

Well! We too, weak though our intelligence may be (it is on the lowest rung of the ladder of spirits), must participate in the nature of the intelligence. This is why, in spite of all the deficiencies peculiar to our kind, the intelligence endeavors to engender in us, it seeks to produce: and not only the interior word, the idea which remains within us, but a work at once material and spiritual, like ourselves, and in which superabounds something of our soul.

It is because of this exigency of the intelligence that there are artists among us.

And you see that to establish fully the dignity and the nobility of art, it was necessary for us to ascend to the mystery of the Trinity itself.

It must, however, be carefully observed that our works of art are very far from being able to be truly called our children. They are inanimate; they do not proceed from us *in similitudinem naturae;* they are the result of an artificial making, not of a natural generation.

But note that, accidentally and in a certain respect, there is in the work of art something that better answers the exigencies of the idea of generation: I mean that in his work the great artist is sure to put himself really, he is sure to imprint his own likeness on it; whereas, in the child, because of matter and heredity, one cannot be sure that it is the father or the mother, rather it may be some more or less desirable ancestor who comes to life again and manifests his or her likeness. The father thinks he finds himself again in his child, but it is the grandfather or the great-grandfather, or the mother-in-law, who appears. There is in the child a terrible unknown which does not exist in the work of art. And it is understandable, not that the artist should love his works more than his

children, but at least that he should love them with a love almost as personal and, from a certain point of view, less anxious, and that he says in thinking of them: *"Not all of me will die."*

ii. Gratuitousness

All these considerations show that art is *gratuitous* or disinterested as such—that is to say, that in the production of the work the virtue of art aims only at one thing: the good of the work-to-be-made, beauty to be made to shine in matter, the creating of the thing according to its own laws, independently of all the rest; and accordingly it desires that there be nothing in the work which will escape its regulation, and that it be alone in immediately ruling the work, in moulding it and fashioning it.

There are many ways of failing in this "gratuitousness." One may think, for instance, that good moral intentions make up for the quality of the craft or the inspiration, and suffice to construct a work. Or else one may go so far as to adulterate the work itself, such as the rules and the determined ways of art would have it to be, by forcibly applying to it, in order to rule it, foreign elements—the desire to edify, or to disedify, not to shock the public, or to create scandal, to have "arrived" in society, or to cut a figure in the bars and cafés as an *artist* free and rare . . .

You see in what sense one must admit the doctrine of the gratuitousness of art: in the sense, namely, that the virtue of art which the artist uses, for whatever end it may be employed in other respects, aims by itself only at the perfection of the work, and suffers in the work no control which does not pass through it.

But this doctrine of, and the term, "gratuitousness," are often understood in a quite different and much more ambitious sense. They are then made to signify not only what I have just said, but also that art must enjoy *in man* and *among men* an absolute independence, that it must tolerate in the

artist no human interest nor any superior law, absolutely nothing outside the pure concern for artistic making: which comes to saying that the artist must be *an artist only*—and therefore must not be a man. But if there is no man, there is no artist: in devouring the humanity, art has destroyed itself. This is what Baudelaire called *The Pagan School:* "Absorbed," he wrote, "by the fierce passion for the beautiful, the droll, the pretty, the picturesque—for there are degrees —the notions of what is proper and true disappear. The frenzied passion for art is a cancer which eats up everything else. . . . Excessive specialization of a faculty ends in nothing."

*

It seems to me that this erroneous conception of the gratuitousness of art can assume two special forms.

Under a first form, on the whole in opposition to romanticism, will be found the notion of gratuitousness professed by the Parnassians, then by the Symbolists and Mallarmé, and perhaps also, in a different sphere, by the friends of Max Jacob and Erik Satie (but already some of them would no longer hold to it). The content of the work of art, the matter to be fashioned, the artistic *thing,* the lyrical and intellectual materials, all this is a constraint and a burden, an impurity that must be eliminated. In short, pure art, art about nothing, by extenuation of the subject. I call this a sin of idealism with respect to the *matter* of art: in the end, a perfect constructing, with nothing to construct.

After the exasperation of sensibility provoked by impressionism, after so many noisy claims, so many marvels, evocations, swoons, and psychological thrills, this conception of gratuitousness has been a purifying and beneficent phase, because it has reminded us that the main thing in art is the *control* that the mind imposes upon matter. It is in this sense that Georges Auric very justly observed: *"A tight-rope walker and a dancer,* these are the two beings that every artist who

moves me unites within him. Every new work is a tightrope stretched above an everlasting track. . . . Even today, you can see with what caution a Stravinsky and a Satie have to cross that wire which must be their only way." The fact remains that the theory of gratuitousness, understood in the sense that I have just emphasized—in a deliberately brutal manner—is false, because it forgets precisely the very matter which must be artistically ruled and the indispensable part that matter plays.

No doubt, if the matter is almost non-existent, the artist's task will be easier. But art, as has been sufficiently dinned into us, must not seek for facility. It needs opposition and constraint, the constraint of the rules and the opposition of matter. The more obstinate and rebellious the matter, the better will the art that triumphs over it realize its own end, which is to make a dominating intelligibility shine forth in the matter. André Gide put it very well: "Art is always the result of some constraint. To hold that it rises higher the freer it is, is to hold that what keeps the kite from climbing is the string to which it is attached. Kant's dove, which thought it would be able to fly better without the air that resisted its wings, fails to realize that in order for it to fly it needs the resistance of the air against which to lean its wings. . . . Art longs for liberty only in sick periods; it would like to exist easily. Each time it feels itself strong, it seeks for struggle and obstacles. It likes to burst its bonds, and therefore it prefers them tight."

*

But the doctrine of the gratuitousness of art can give rise to another more specious error, and this time it is Gide himself who undertakes to propose it to us. "The artist," Gide tells us, "is expected to appear after dinner. His function is not to provide food, but intoxication." And he says after Ernest Renan: "To be able to think freely, one must be certain that what one writes will be of no consequence," from

which it follows that every thinker who envisages the consequences of what he writes does not think freely. And again, in a dialogue between himself and an imaginary interlocutor:

> The interlocutor—"Are you interested in moral questions?"
> Gide—"What! The very stuff of our books!"
> The interlocutor—"But what is morality, according to you?"
> Gide—"A branch of Aesthetics."

Oscar Wilde had said, pretty much in the same sense but in a more stately formula: "The highest Art rejects the burden of the human spirit."

The point is that the doctrine of gratuitousness, in reaction against exclusively moralist or apologetic or civic preoccupations regarded as "utilitarian," requires now, no longer the extenuation of the *matter* of art, as was the case a moment ago, but the elimination of any *human end* pursued. Let the artist take for the matter and stuff of his work whatever is most profound, most exalted and most vile, the moral life of man, that heart of man which is "hollow and full of filth"—and the rarest passions, and the spiritual life itself, nay, the Gospel and sanctity, anything he wishes; but in all of that an absolute prohibition, under pain of committing a sacrilege against art, against pursuing any other end than the pure delight, order, luxury, tranquillity and rapture that the soul must enjoy in the work. It is no longer art *in nothing,* as in the doctrine of gratuitousness in its first form; it is now art *for nothing,* for nothing else but itself.

The doctrine of gratuitousness in this second form is singularly specious, because it exploits and distorts something very true concerning the nature of art, and which we must take care not to overlook. It is nevertheless a very pernicious poison, which must in the long run exercise a completely sterilizing effect upon art.

Precisely because, given this or that work-to-be-made,

there are strictly determined ways of realizing it, ways that depend on the pure exigencies of the work itself and that brook no liberties, the virtue of art, as I just indicated, does not allow the work to be interfered with or immediately ruled by anything other than itself. It insists that it alone shall touch the work in order to bring it into being. In short, art requires that nothing shall attain the work except *through art itself*. This is the element of truth in the doctrine of gratuitousness. Woe to the artist who is deficient with respect to this exigency of his art, a jealous and fierce exigency, as are all the exigencies of the intelligence and its virtues. Here again we can find in our art a vestige as it were of the Trinity. *The Word,* says Saint Augustine, *is in some way the art of Almighty God.* And it is through the Word that the whole of the divine work was made, *omnia per ipsum facta sunt.* It is through His Word and His art that God attains, rules and brings into being everything He makes. In the same way it is *through his art* that the human artist must attain, rule and bring into being all his work.

But does this imply that the work depends on art alone, and not on the entire soul of the artist; that it is made by the art alone, separate, cut off from all the rest in man, and not by man the artist with all the human purposes, desires, and longings, all the human thoughts and beliefs he has in his heart, and with all the higher laws he would have himself obey? Nonsense! It is as though, under the pretext that everything was made *per verbum,* through the Divine Word, one were to say that the world was not made by the whole undivided Trinity: gratuitously, to be sure—it is the sole example of perfectly gratuitous art—and in a manner totally free from the least interested intention, but to an end nevertheless, an end which is not simply the perfection of the work to be achieved, and which is of an order superior to art—the communication of divine goodness.

The theorists of gratuitousness overlook an elementary distinction; they fail to distinguish between *art,* which, as such,

has no other end than the good of the object to be made, and the *artist,* who, as a man performing an act, can have all the ends he pleases. And they overlook this common-sense distinction because they fail to take account of a more subtle distinction, the distinction between the "principal agent" and the "instrumental cause," between the workman and the instrument. Through the instrument wielded by the workman there passes an invisible and intangible activity, which causes the instrument to produce an effect nobler than itself and really to produce the whole work, but as subordinate agent. Thus the picture is wholly from the brush and wholly from the painter; there is nothing, absolutely nothing, in the picture that does not come to it from the brush, and there is nothing in it that does not come from the painter.

This distinction plays a role of capital importance in metaphysics; it alone enables us to understand how the free act of the creature is wholly of the creature, as second cause, and, if it is good, wholly of God, as first cause. God activates the will to act according to its own mode, that is to say, freely. The philosophers who do not make this distinction are forced to consider the divine action as inserting into human liberty some kind of foreign element, some kind of rival which would compromise its purity. André Gide makes a similar mistake. He does not see that the virtue of art, with all its perfection and peculiar exigencies, is an *instrument* in relation to the artist, the principal agent.

The soul of the artist, with all its human fullness, with all that it admires and all that it loves, with all the purposes of a non-artistic order—human, moral, religious—that it can pursue, is the principal cause which uses the virtue of art as an instrument; and thus the work is wholly of the soul and the will of the artist as principal cause, and wholly of his art as instrument, without his art losing any of its mastery over the matter or any of its rectitude, purity and ingenuousness—just as our good acts are wholly from us as second cause and

wholly from God as first cause, without on that account losing any of their freedom.

This does not mean that we have here a juxtaposition of two forces each pulling its own way. There is instrumental subordination of the virtue of art to the soul which acts through it. The greater the artist, the more vigorous is his art, not bowed over or bent, certainly, but erect and imperious—and the more the man succeeds in passing wholly into his work, through his art. Diminish the man in the artist, and you necessarily diminish the art itself, which is something of man. The doctrine of gratuitousness in its second form is another idealist heresy. It is no longer the *matter* of the work of art, it is the *human subject,* of whom the virtue of art is a quality, which is here disregarded.

If the artist has not taken sides in the great debate between the angels and men, if he is not convinced that he provides, together with delight, a food and not simply intoxication, his work will always remain deficient and paltry in some respects. The greatest poets, and the most disinterested ones, the most "gratuitous," had something to say to men. Is not this the case with Dante, Cervantes, Racine, Shakespeare, Goethe, Baudelaire, Dostoievsky? Whatever may be the latter's ideology, his heart is Christian; Gide, who could see in him only his own countenance, was strangely mistaken about Dostoievsky. How reasonable—need it be further remarked from this point of view?—and how little "immoralist," are the explanations Goethe gives us in *Dichtung und Wahrheit* as to the origin of *Werther!* And in *Mon coeur mis à nu,* what a tragically religious anxiety the dandyism of Baudelaire suddenly reveals to us!

Is not the art of La Fontaine an eminent example of *gratuitous* art? But as Henri Ghéon observed to Valéry, "if it were not lacking in a grain of spirituality, a touch of Christianity, the art of this maker of apologues would be the art of the *apologist,* the very type of *edifying* art."

Well and good, one will say. But suppose that La Fontaine had acquired this grain of spirituality the while remaining La Fontaine, the La Fontaine we know; in exercising his apologist's art, he would never have been consumed by the zeal for souls and the apostolate. "If Jammes and Claudel are Christian artists, it is not because of their manifest and distinctive devotion. The apostolate is never an aesthetic virtue." [170] More generally, does it not seem that the happiest conditions for the artist are conditions of peace and spiritual order within and around him, such that having, we certainly hope, his soul under control and turned towards its last end, he have however in addition to this no other concern than to reveal himself—such as he is—in his work, without giving a thought to anything else, without pursuing any particular and determined human end? Was not this precisely how the artists of the Middle Ages worked? Or in our day a Cézanne?

To this objection—which is not lacking in force, and which concedes the essential—I have two answers to give. First of all, if it is true that for the workman who in making his work pursues a particular and definite human end—for example, a Lucretius intending to spread the Epicurean system, a Virgil composing the *Georgics* to bring man-power back to the land, or even a Wagner seeking to glorify the Teutonic religion—if it is true, I say, that for such a workman the task is more difficult, the danger of giving way greater, nevertheless this danger is not insurmountable, this task is not impossible, as witness the names I just cited.

Secondly, and more importantly, those who wish to serve through their art the Truth that is Christ, do not pursue a particular human end, they pursue a divine end, an end as universal as God Himself. The more they live their faith, the more their inner life becomes spiritualized, the more deeply they are of the Church—the more they rise above the human limitations, conventions, opinions, and special interests of such or such a social group; so that, understanding better

the pure spirituality and universality of God's action in souls, their art and their thought are purified of all human narrowness, in order to be henceforth directed only towards the boundless Love Who is and acts on earth as in Heaven. This is what those men cannot understand who, ignorant of everything of the Faith or deceived by too many appearances, see in zeal for souls only an effort of human domination, an attempt to serve some commercial or party interest. They do not see that those who engage as Christians, because they are Christians, in the works of the mind, are not practicing a *clerical* philosophy or a *clerical* art, or a *confessional* philosophy or a *confessional* art. In this sense there is no Catholic art or Catholic philosophy, for Catholicism is not a *particular confession,* just as it is not *a* religion: it is *the* religion, confessing the unique and omnipresent Truth. Yet their art and their philosophy are catholic, that is to say, authentically universal.

May I add that one always serves some master, and that the devil is not the least exacting overlord. In forbidding man to pursue any other end than art itself, we are, whatever we may do, positively assigning to him a last end, a God: Art in person. One binds oneself to a religion, and to a religion much more tyrannical than the true religion. One delivers oneself up to aesthetic clericalism, which is assuredly one of the most pernicious forms of clericalism.

Gide strikes me as being under constant constraint, cribbed, cabined and confined by inexorable conventions, never free, never spontaneous; forever haunted by morality. A moral choice confronts him at every corner of the street, and he is compelled to make a decision: quick, should he escape? Escape through here! What torture!

The artist who consents to be a man, who has no fear of morality, who is not afraid at each moment of losing the flower of his ingenuousness—he it is that enjoys the true gratuitousness of art. He is what he is, without caring about what he

may appear to be; he asserts if he wants to assert; he be-
lieves, he loves, he chooses, he gives himself, he follows his
bent and his fancy, he recreates and amuses himself, he plays.

iii. Of a Too Human Antinomy

Truthfully, I do not believe that it is possible outside of
Catholicism to reconcile in man, without diminishing or do-
ing violence to them, the rights of morality and the claims of
intellectuality, art or science. Morality as such aims only at
the good of the human being, the supreme interests of the
Subject who acts; intellectuality as such aims only at the Ob-
ject—what it is, if it is a question of knowing it, what it ought
to be, if it is a question of making it. What a temptation for
poor human nature to be faithful to one only at the expense
of the other! It is true, we know, *haec oportebat facere, et
illa non omittere;* but how are the children of Adam to keep
the balance?

Outside the Church and her divine life it is natural that
moral and religious zeal turn man against the intelligence; and
it is natural that zeal for art or science turn man away from
the eternal laws. In one camp we have Socrates' judges,
Luther, Rousseau, Tolstoy, the Anglo-Saxon pragmatists; in
the other, Bruno, Bacon, the great pagans of the Renaissance,
and Goethe himself, and Nietzsche.

Catholicism orders our whole life to Truth itself and to
subsisting Beauty. It puts into us—above the moral virtues
and the intellectual virtues—the theological virtues, and
through them gives us peace. *Et ego si exaltatus fuero, omnia
traham ad meipsum.* Christ Crucified draws to Him all that
is in man; all things are reconciled, but at the height of His
heart.

Here is a religion whose moral exigencies are more ele-
vated than those of any other, since the heroism of sanctity
can alone fully satisfy them, and which at the same time loves
and protects the intelligence more than any other. I say that
this is a sign of the divinity of this religion. A superhuman

virtue is necessary to assure among men the free play of art and science under the rule of the divine law and the primacy of Charity, and thus to achieve the higher reconciliation of the *moral* and the *intellectual*.

(1922)

Appendix II

Some Reflections on Religious Art*

Allow me to put before you today some very brief and very simple reflections. You will, no doubt, consider them too simple, but still I hope that they are inspired by good sense.

What I should like to examine with you very rapidly is the present state of relations between Catholic artists and the Catholic public. We must observe right off that in general they are not very satisfied with one another. And as in family quarrels, we must no doubt say here too that there are "faults on both sides," and that each side has some good reasons for complaining.

Just about everything has been said about what is called the *art of Saint-Sulpice*—an ill-chosen phrase, it must be said, and one that is very insulting to an estimable Parisian parish, the more so because the scourge in question is world-wide in scope; about the diabolical ugliness, offensive to God and much more harmful than is generally believed to the spread of religion, of the majority of the objects turned out by modern manufacture for the decoration of churches; about the kind of bitter contempt that still reigns in some "respect-

* It is clear that I am concerned in this lecture with art that is religious *by virtue of its intended purpose,* in other words, with sacred art or Church art. On the important distinction that must be made here, see above, note to p. 64.

able" circles with regard to artists and poets; lastly about the absence of taste and artistic formation that makes so greatly to be desired the establishment in seminaries of courses in aesthetics or the history of art such as Pius XI, before his elevation to the Pontificate, organized at Milan.

Yes, indeed; but on the other hand there are a great many parish priests who ardently desire to fulfill the wish of Pius X, "to have their people pray before beauty," and who are trying to rid their churches of the products belched forth from the cellars of religious mercantilism. Yet many of these, we must candidly confess, are not satisfied with what is proposed to them in the name of modern Art. I am clearly not referring to a few superior works, but to the *average* run of works produced these last few years. Our affection for our friends must not prevent us—rather the contrary—from stating what may still be lacking in an effort that in other respects commands our heartiest admiration. And I say that often these parish priests are right, for their office, let's make no mistake about it, is not to encourage the fine arts, but to give the faithful that which answers their spiritual needs, that which can truly *serve* the religious life of a Christian community. One sometimes sees them driven to fall back in despair upon the art of Saint-Sulpice. Why? Because these products of commercial manufacture, when they are not too disgusting, have at least the advantage of being perfectly indeterminate, so neutral, so empty that we can look at them without seeing them, and thus project onto them our own sentiments; whereas certain modern works, and the most agitated and impassioned among them, seek to impose on us by violence the individual emotions, exactly as they are—in the brute state, and with all that they have of the most subjective—of the artist himself. And in praying, instead of finding oneself before a representation of Our Lord or some Saint it is an unbearable torture to receive full in the chest, like a blow of the fist, the religious sensibility of Mr. So-and-So.

The present difficulties, to tell the truth, stem from deep-seated causes, and in the end from the crisis of our whole civilization. Religious art is not a thing that can be isolated from art itself, from the general movement of the art of an age: isolate it, and it grows corrupt, becomes dead letter. But on the other hand the art of a period carries with it all the intellectual and spiritual stuff that constitutes the life of this period; and notwithstanding all the rare and superior qualities contemporary art may possess in the order of sensibility, quality and invention, the spirituality it conveys is often quite mediocre and sometimes quite corrupt.

This is why Christian artists find themselves faced with very grave difficulties. On the one hand, they have to reaccustom to beauty the faithful, whose taste has been spoiled for more than a century past—and we must not forget that, given the purpose for which it is intended, religious art, as prescribed by Urban VIII on March 15, 1642, and by the Council of Trent, must not have an "unfamiliar" character—and so it is a question of destroying bad aesthetic habits while restoring a good one: no easy task. On the other hand, in order to recover a truly living religious art, they must lift up, spiritualize, and bring to the feet of God all of modern art: no easy task either. It is true that by this very fact the Christian artist, if he has the genius, is in a privileged position to profit from the whole modern effort.

What follows from all of this? It is only too evident that the Catholic public would fail in an essential and particularly urgent duty if it failed to understand the capital importance of the task undertaken with admirable generosity by so many artists who are working to reintroduce sensible beauty into the house of God, if it did not effectively support them, and if, even when it does not approve of this or that work in particular, it did not surround them with a fraternal sympathy. But it is also clear that Catholic artists for their part must make every effort to understand the legitimate needs of the faithful, for whose common good they are working, and to

ascertain, courageously, the proper conditions and exigencies of the task to which they are devoting themselves.

*

But, it may be asked, cannot certain of these conditions be stated? I think, in any case, that a few elementary truths which force themselves upon us concerning religious art can be disengaged, which, if they were universally recognized, would doubtless facilitate concord between the public and artists. Allow me to attempt to formulate some of them, ones on which, I believe, all of us here are agreed, and which correspond to the common sentiment of all our friends.

First Observation. There is no style *reserved* to religious art, there is no *religious technique.* Anyone who believes in the existence of a religious technique is on the high road to Beuron. If it is true that not every style is equally suited to sacred art, it is still more true that sacred art, as I said a moment ago, cannot be isolated, that it must, in each period, following the example of God Himself who speaks the language of men, assume, while superelevating them from within, all the means and all the technical vitality, so to speak, that the contemporary generation puts at its disposal. (From this point of view, let us observe parenthetically, it does not seem at all necessary that Christian artists, particularly those who have not come into full possession of their craft, should work exclusively in sacred art. Let them begin with still-lifes, let them accustom themselves to discovering a religious sense in the inevitable apples, fruit-dish, pipe and guitar.)

There are, however, it seems to me, in the technical order, two requisite conditions for religious art as such, granted its special object and the purpose for which it is intended.

1. It must be *legible.* For it is there above all *for the instruction of the people, it is a theology in figures.* An illegible, obscure and Mallarméan religious art is as absurd as a house without a staircase or a cathedral without a portal.

2. The work must be *finished*. I do not mean finished in the academic sense, but in the most material and humble meaning of this word. It is supremely fitting that nothing enter the house of God but work that is well made, complete, proper, durable, honest. *This must clearly be understood according to the mode peculiar to the style and the means adopted,* but the facility with which in our day one is satisfied with oneself makes it necessary to insist on this point.

Second Observation. Sacred art is in absolute dependence upon theological wisdom. In the signs it presents to our eyes something infinitely superior to all our human art is manifested, divine Truth itself, the treasure of light that was purchased for us by the blood of Christ. It is above all for this reason, because the sovereign interests of the Faith are at stake in the matter, that the Church exercises her authority and magisterium over sacred art. I recalled a moment ago the decree of Urban VIII of March 15, 1642, and the prescript of the 25th session of the Council of Trent. There are other instances. On June 11, 1623, the Congregation of Rites proscribed crucifixes representing Christ with arms updrawn. On September 11, 1670, a decree of the Holy Office forbade the making of crucifixes "in a form so coarse and artless, in an attitude so indecent, with features so distorted by grief that they provoke disgust rather than pious attention." And you know that in March, 1921, the Holy Office forbade the exhibition in churches of certain works of the Flemish painter Servaes.

Here is a point that merits all our attention. Servaes is a painter of great talent, a Christian full of faith, and one can only speak of his person with respect and affection; I am happy to bear testimony to him here. The *Stations of the Cross* which raised such violent commotion in Belgium gave birth to deep religious emotions in certain souls, nay more, brought about conversions. Nevertheless the Church condemned it, and it is never difficult, even when the appear-

ances and the human procedures disconcert us, to understand the wisdom and justice of the Church's decisions. In spite of himself, assuredly, and not in his soul but in his work, the painter, fascinated by the *Ego sum vermis et non homo* of Isaias and conceiving his *Stations* as a pure vertigo of grief, happened to be false to certain theological truths of capital importance—above all the truth that the sufferings as well as the death of Our Lord were essentially voluntary, and that it was a divine Person who suffered the most appalling human suffering: the pain and agony of His Humanity were handled by the Word as the tool with which He performed His great work. At the same time, for those who cannot harmonize the poor figurations that art places before their eyes and the pure image living in our hearts of the most beautiful of the children of men (in Him, as in His Mother, as Cajetan reminds us in his treatise *De Spasmo beatae Virginis,* the supreme torments of Calvary, though piercing the mind still more cruelly than the body, left reason intact under the Cross, in full exercise of its dominion over the sensitive part)—for these, I say, certain plastic deformations, a certain degenerate aspect of the contour, take on the value of an offense against the Humanity of the Savior, and, as it were, of a doctrinal misapprehension of the sovereign dignity of His soul and body.

At a time when the truth of the Faith is threatened on all sides, why be surprised that the Church is more concerned than ever about the doctrinal distortions that can be implied in certain works of art intended for the faithful, whatever may be in other respects their aesthetic value and the salutary emotions they may here or there excite, and whatever may be the piety, faith, depth of spiritual life, and uprightness of intention of the artist who produced them?

May I be permitted however to add that from this same point of view of dogma the base sentimentality of so many commercial products must equally vex sound theology, and is doubtless tolerated only as one of those abuses to which we

resign ourselves for a time, considering human weakness and what may be called, adapting a phrase of Holy Writ, "the infinite number of Christians with bad taste."

This ultimate control by theology that I just mentioned, and which presupposes in the artist a true theological culture, clearly does not impose on sacred art any aesthetic *genre,* any style, any particular technique. We must, however, realize that it communicates to it, as it were spontaneously, certain general directions. Thus the intrinsic characteristics of the object represented have assuredly for sacred art a very special importance: not, certainly, from the point of view of the naturalist imitation of material detail and picturesque appearance, which is more out of place and execrable here than elsewhere, but from the point of view of the laws of *intellectual signification.* If one reflects on the essential deficiency of the means of expression of human art in relation to the divine mysteries to which these means are applied, on the terrible difficulty of expressing in a sensible matter truths that bridge heaven and earth and unite the most opposite realities, one is even led to think that sacred art, however rich it ought to be in sensibility and humanity, in order to attain to a certain spiritual fullness will doubtless always have to retain something of the hieratic and, so to speak, ideographic symbolism, and, in any event, of the sturdy intellectuality of its primitive traditions.

Third Observation. A last point—a very simple one—is that a work of religious art must be religious. Otherwise it is not *beautiful,* since beauty presupposes essentially the entirety of all the requisite conditions. As Paul Cazin remarked, tell an artist dealing with a religious subject "that he has produced a masterpiece, but that his masterpiece is not religious, and you will pain him greatly. . . ." And Cazin continues: "God alone can touch men's hearts with a feeling of piety before the most miserable chromolithograph or the most distressing daub, as well as before the most sublime masterpiece."

That is true, but it does not prevent the fact that normally certain works have *of themselves* a value, a radiance of religious emotion, of interior illumination, and, properly speaking, of sanctification. Nevertheless, repeating once more what Maurice Denis has said, this does not depend on the *subject* itself. Nor does it depend, I am convinced, on the recipe of a school and a particular technique. It would be a great delusion to think that clumsy angles and a humble subject matter are the necessary means of expression of a Franciscan emotion, or that a geometric stiffness and dull, austere tones are required in order to give to a work the seal of Benedictine dignity.

There are no rules for giving an art object a value of religious emotion. This depends, on the contrary, on a certain interior freedom with regard to rules. One achieves it only by not seeking it directly, and only by participating, in one manner or another, in the spiritual life of the Saints: something which the common Christian atmosphere of an era of faith made easy for artists, even when, from many points of view, they remained far from the examples of the Saints, but which, of itself and in the absence of exterior aids, requires in the soul the habitual radiance of the theological virtues and supernatural wisdom. And it is necessary, besides, that the virtue of art not remain separate, isolated from this wisdom, because of an insufficient mastery or of false academic principles, but that between the two contact be made, and that this wisdom freely use the virtue of art as a supple and infallible instrument.

(Talk to the *Journées d'Art religieux,* February 23, 1924.)

The "*Triomphe de Saint Thomas*"

at the Theatre

The best ideas are born by chance. One realizes afterwards that they were the terminus where many secret concatenations logically had to converge.

Ghéon and I were conversing at Meudon one day last September. The Dominicans of Liége and the Catholic students at the University had asked him to do a liturgical play for the feast of Saint Thomas Aquinas, a miracle play of the Blessed Sacrament, for example. What subject should he choose? But why not, instead of a particular event, Saint Thomas himself? Not his life and his history, but his thought, his mission, his *Triumph,* after the manner of those paintings by Andrea da Firenze in Santa Maria Novella in Florence, and by Francesco Traini in Saint Catherine's of Pisa? And Ghéon, in a flash, put together the plan of his trilogy: the Vocation, with the conflict of the false Virtues, and the accord of the true; the drama of Knowledge: Heraclitus and Parmenides, Plato, Aristotle, Averroës, then the composing of the *Summa,* and the ecstasy of the last days; finally, the Church's lament, and, before the final glorification of the saint, the marching past of the philosophical monsters presented to modern Man by the Devil, University professor . . . —A foolhardy enterprise, was it not, in which the

futility of the didactic genre was to be joined to the futility of allegory, and which could be directed only at the sparsest academy or college public?

Six months later, on March 6th last, I attended at Liége the first performance of *Triomphe de Saint Thomas d'Aquin,* "composed for the stage, as in days of old, in prose interspersed with verse." More than two thousand people were in attendance, among them, no doubt, few readers of the *Summa.* Everyone in the hall, with one accord, followed passionately the ideological adventures that were unfolding upon the stage. And at what moments did the audience burst out in applause? At the moment when, Averroës duly convicted of error, Aristotle and Thomas Aquinas embrace each other, and again at the moment when, at the instigation of Common Sense, Friar Thomas with a Sign of the Cross makes fall the masks of False Faith and False Reason, and when these two demons take to flight . . .

In this astonishing play, published in the issues of *La Vie spirituelle, ascétique et mystique* between the *Échelle de la Perfection* of the Carthusian Guiges du Chastel and the *Soliloque enflammé* of Gerlac Peters, and which seems to bring together all the species of paradox, the reader marvels that so exact a scholastic compendium should be disclosed to us in such a pleasing language, and that the strict rigor of the doctrine served the poet so well. Theological, hieratic, its lyricism does not weaken, but takes on a more sonorous density.

> *Moi l'Épouse, moi l'Église*
> *De la couronne promise*
> *Pour le jour du jugement,*
> *Rien ne fera que je doute,*
> *Qui déjà pend à la voûte*
> *Obscure du firmament.*
>
> *Mais le Bien-Aimé qui veille*
> *Sur les fruits de la corbeille*

Que je Lui dois présenter
Quand, debout sur les nuages,
Il viendra comme l'orage
Déchirant le sombre été,

Est digne d'une louange
Plus nombreuse que les Anges
Qui croisent dans les hauteurs,
Et d'un don plus magnifique
Que la chaîne de cantiques
Dont le ceignent les Neuf Choeurs:

Un peuple à sa ressemblance
Qui, d'entre mes bras, s'élance
Au terme fixé par Lui . . .

But what only the actual performance itself enables one to appreciate is the extraordinary quality of scenic action of this intellectual drama, as also the admirable plastic, decorative, and musical unity it is able to sustain (the students of Liége had had only a month to put on the play, and yet they gave us a spectacle of magnificent completeness). And there is also the grandeur and variety of the traditions it evokes. The sacred origins of the theatre were rejoined; Greek primitive drama met with Christian liturgical drama and mediaeval allegory—and this without the least material imitation in the means (which are akin rather to the realism of our classical theatre), but from within, and because a *spirit* had been re-discovered. Hence the intensity of the religious emotion which, during the greater part of the performance, held the people in a state of peaceful contemplation. Then, in the middle of the third part, comes the satirical drama, the ex-hibiting of false Truths, treated with drastic—and not un-justified—simplifications, which persons accustomed to a pas-sionate veneration of modern Thought will deplore, but which Ghéon has taken care to impute to the devil professor and stage-manager. There is universal Doubt with its egg-shaped

head, Pure Reason and its sister Practical Reason, huge Cubist females, all the *isms* of our masters, even Modernism as a worldly cleric—terrifying buffoonery, akin at one and the same time to Aristophanes, the revue, and the film.

"Extremes affect *me*," says André Gide. And me too, though perhaps in a different way. To bring together in a superior and perfectly *natural* unity extreme archaism and extreme modernness, the highest lyricism and the most familiar tone, the comical and the sacred, theological teaching and dramatic movement, is not only a proof of Henri Ghéon's rare mastery, a result and a confirmation of his conception of a *catholic* theatre—that is to say, universal, and in which all of the human is reconciled; it is also, for a whole category of human pursuits, in my opinion a very important sign.

Through this remarkable scholastic draft, we see what an entire *intellectualization* of drama—imposed in this case by the subject matter itself—can produce: and without departing from drama, but by being *theatre* more than ever. It is this that removes such a work as far from the "Philosophical Dramas" of Renan as from the mournful *Tentation de saint Antoine*. Shaping a matter that has the solidity of the things of the spirit, Ghéon, thanks to Intelligence and to Ideas, which, incarnate, are made the very springs of action, has achieved, together with a complete eradication of anecdote, an utmost purification of means, rendered at the same time more intense and incomparably more ample.

<center>*</center>

I have great admiration for *Les Trois Miracles de Sainte Cécile* and for *Le Pauvre sous l'Escalier*, so moving and so pure. Nevertheless I think that it is perhaps through the humility of his patronage plays, of his "jeux et miracles pour le peuple fidèle," that Henri Ghéon, by breaking with the theatre of our day and rediscovering the first conditions of a theatre genuine from the very start, assures dramatic art the most favorable chances of renewal. But the *Triomphe de*

Saint Thomas is of such a quality that one must attribute to it from this point of view a particular significance. It represents a success of greatest importance in that quest for synthesis in the theatre, in that restoration through candidness and simplicity, of which Jean Cocteau's *Antigone* and *Roméo* are, to my mind, other victories.[171]

Speaking of minds of classical formation, Cocteau, in a note in his study on Picasso, wrote: "I consider it a misfortune that they can live in ignorance of our masters and look upon Picasso, no doubt, as a barbarian. . . . At least, let these foster-brothers see in my eulogy of our times that the worship of a ruin conceals from them the inimitable sound of the impact of intelligence against beauty."

These misunderstandings, which I, too, deplore, will not last for ever. Of all the paths along which contemporary art is engaged, one is directed towards the purity of creative intelligence. It is along this path that the promise of salvation lies: beset by death, a child of genius proved this to us by a masterpiece.[172] Those who advance along this road, in sometimes very different retinues, will indeed recognize each other in the end.

(1924)

Appendix IV

Apropos an Article by Montgomery Belgion

The following lines are taken from a letter addressed to Algar
Thorold, editor of *The Dublin Review* (and published in the January–
March, 1931, issue), in answer to an article by Montgomery Belgion
("Art and Mr. Maritain," *ibid.*, October–December, 1930).

. . . Unquestionably Montgomery Belgion's point of view
and my own point of view are too different for us to be able
to enter into a useful dialogue. My honorable critic has ana-
lysed the text of *Art and Scholasticism* with a patience and
a care that I admire; the spirit of this book has unfortunately
escaped him. Mr. Belgion seems persuaded that a disciple
of the Schoolmen owes it to himself and to them to *repeat*
only what they have already written. My conception is dif-
ferent, and my avowed intention was to go a little further
than the mediaeval Schoolmen while relying on their princi-
ples. But everything that moves seems to shock Mr. Belgion.
Like that Beauty chanted by the poet whose name cited after
those of Aristotle, Plotinus, Denis the Areopogite, etc., makes
Mr. Belgion so amusingly surprised, and the quotation from
whom on p. 49 started plunging my book into the abysses
of romanticism,

> *Il hait le mouvement qui déplace les lignes.*

Certainly no one will reproach him with "shifting his
ground." As for me, whom many fickle minds accuse of giv-
ing too much credit to the Middle Ages, I find it a consola-

113

tion to be accused by a serious mind of giving too much credit to the moderns.

Would there be any point now in explaining that if Mr. Belgion had formed an accurate idea of what I conceive beauty to be, and what I meant by speaking of the *analogical* character of beauty, he would not be astonished that in my view there are for beauty, in art as well as in nature, very different ways in which it may be realized? He would understand that the religious values inherent in the tragedies of Aeschylus or in the Passions of Bach are precisely for me integral parts of the beauty peculiar to these works; and also that the intuition which begets aesthetic joy is indeed human and in no way angelic, since it comes to the mind through the medium of the senses.

I should further explain that I did not assert that the fine arts were ordered *exclusively* to beauty and that the other arts produced nothing beautiful (I even said the contrary, observing, as Mr. Belgion moreover has noted, that this division remains an "accidental" division). I think however that what distinguishes the fine arts from the other arts is not solely the social situation of the artist who practices them, it is above all the fact that in the fine arts the spiritual element introduced by the contact with beauty becomes preponderant. Besides I am persuaded that a growth in consciousness of the nature of art has taken place in the course of modern times (this I tried to show in *Frontières de la Poésie*). I find it hard not to regard it as a mark of a certain coarseness of manners to harbor the conviction that the destiny of the artist consists, as was the belief in the 17th century, in entertaining the genteel.

If this growth in consciousness was experienced by romanticism in the form of a deification of the artist and the passions, it is not the first time that something true has been conveyed and distorted by a heresy. Moreover, I regard the dispute between classicism and romanticism as outmoded. Shall I confess that despite certain defenders of the eternal

principles of classicism, I find the charms of romanticism alluring? May T. S. Eliot pardon me; I have great admiration and affection for him. Besides he knows well that it is not of him that I am thinking here.*

* Since I referred to T. S. Eliot in this letter, allow me to quote here some lines of his that I have read since then with particular pleasure: "That is one of the dangers of expressing one's meaning in terms of 'Romanticism': it is a term which is constantly changing in different contexts, and which is now limited to what appear to be purely literary and purely local problems, now expanding to cover almost the whole of the life of a time and of nearly the whole world. It has perhaps not been observed that in its more comprehensive significance 'Romanticism' comes to include nearly everything that distinguishes the last two hundred and fifty years or so from their predecessors, and includes so much that it ceases to bring with it any praise or blame." (T. S. Eliot, *The Use of Poetry and the Use of Criticism*, London, Faber and Faber, 1933, p. 128.) And again, referring to Henri Brémond's book *Prière et Poésie:* "My first qualm is over the assertion that 'the more of a poet any particular poet is, the more he is tormented by the need of communicating his experience.' This is a downright sort of statement which is very easy to accept without examination; but the matter is not so simple as all that. I should say that the poet is tormented primarily by the need to write a poem. . . ." (*Ibid.*, p. 138.)

THE FRONTIERS OF POETRY

The Frontiers of Poetry

Φεύγωμεν δὴ φίλην ἐς πατρίδα..,
Πατρὶς δὴ ἡμῖν, ὅθενπερ ἤλθομεν.
καὶ πατὴρ ἐχεῖ.
Plotinus, *Enneads,* I, 8.

This is not an essay in the genre *criticism,* whether literary criticism or art criticism. The author has too many principles in his head to be able to aspire to criticism. He is only a philosopher. Is it not a philosopher's professional duty to remain in the heaven of metaphysics, the only enduring empyrean, from which he sees in reverse the changing clouds and the diverse atmospheres of the plains? There are, it is true, other duties than one's professional duty.

In any case, *Art and Scholasticism,* far from militating for any particular school, has been well received in very different, even opposed, camps (opposed sometimes to my own personal preferences)—a sign that it is endowed with a sufficiently universal spirit. Indeed the study of first principles, in the practical as well as in the speculative order, is the special province of philosophy. But a great gulf separates these principles and the work in which they find their final application, a gulf that art alone can cross—and this by different paths, which diverge ever more and more even though they are legitimate, and which can in addition be more or less successful.[173]

119

If moreover I had attempted a synthesis of an historical and critical kind, I would have had to make use of a much richer store of erudition. But for a philosophical work, an inquiry limited to the essential, to the most accessible and most significant examples, is sufficient.[174]

This absolutely clean separation being once and for all clearly stated—and it cannot be too strongly insisted upon —between the author's philosophical point of view and the point of view of criticism, it nevertheless remains for me to note, and not without pleasure, the ease with which, in actual fact, the very ancient principles I recalled in my book unite with the deep-seated intentions of modern researches that are often regarded as foolhardy. Such meetings are instructive. I have sometimes been reproached for my fondness for these researches; I must confess that with the years it has only been confirmed. I would now like to aggravate the case against me by embarking upon some explanations of certain tendencies in contemporary art. I shall therefore take up again from a more concrete point of view some ideas expounded in another form in *Art and Scholasticism,*[175] intermingling with them some new considerations which, in order to begin philosophically, I shall base on the theory of the divine ideas.

*

God's ideas are not like our concepts, that is, representative signs drawn from things, intended to introduce into a created mind the immensity of that which is, and to render this mind consonant with existents (actual or possible) independent of it. God's ideas precede things, they create them. This is why theologians, in order to find some analogy to them here below, compare them to the artist's ideas.

Thomist theology thereupon considers the artist's idea in its proper nature and deepens the notion of it. Making or

operative idea, spiritual and immanent object born in the mind
and nourished by it, living with the mind's life, and which
is the immaterial matrix from which the work is produced in
being—this idea is *formative* of things and not *formed* by
them. Far from being measured by them, as is the speculative
concept, it is all the more independent of things the better
it realizes its own essence; subduing them to its creative im-
pregnation, it so holds them under its domination that to
give, with a John of Saint Thomas, to the word "idea" its
full force, it must be said that one truly has the idea of a thing
only when one is capable of making it.[176] It does not render
the mind consonant with the real, it renders the real con-
sonant with the mind; for there is always likeness, but this
time it is the likeness of a bit of matter to the abyss of the en-
gendering invisible germ. In us the creative idea is not a pure
intellectual form, because we are at the lowest rung among
spirits: on the contrary, the spiritual germ which fecundates
our art, operating through sense organs and floundering in
matter, is for us but a divine nothing scarcely glimpsed, ob-
scure to our own eyes, raising and irradiating the dough of
sense and the elementary spontaneities. And, above all, this
independence with regard to things, essential to art as such
and to the operative idea, is thwarted in us by our condition
—minds created in a body, placed in the world after things
had been made, and obliged to draw first from things the
forms they use.

In God only does this independence with regard to things
appear in a perfect manner. God sees in His Ideas all the
ways in which His essence can be manifested, and He pro-
duces creatures according to the model of these Ideas, thus
placing the seal of His likeness upon the whole expanse of
that which is made, detaching things from the life they had
in Him, and in which they were He, only to find again in them

a vestige of Himself. Here only, on the high summits of Divinity, does the idea as artisan-form obtain the complete fullness required of it by its very notion.

This is to say that art, like intelligence (art, for that matter, is nothing but creative intelligence), considered apart and in its pure essence, realizes all the perfection demanded by its nature only by passing to Pure Act. It is ridiculous, Aristotle observed, to attribute the civil or political virtues to God. But in the sense in which the Gospel says: *Unus est bonus, Deus,* so we may say: *Unus est artifex, Deus.*

There we have a gleam of metaphysics thrown on the movement which sustains—which yesterday sustained—our epoch in the search for *pure music, pure painting, pure theatre, pure poetry* (I use this expression in the sense in which it corresponds to the specific effort undertaken in France since Mallarmé). To command our art *to be* art in the pure state, by freeing itself in effect from all its conditions of existence in the human subject, is to wish it to usurp for itself the aseity of God. To ask it to *tend* to pure art as a curve to its asymptote,[177] without rejecting the servitudes of its human condition, but by ceaselessly overcoming them, by straining its created bonds to the extreme limit of elasticity, is to ask it to realize more fully its root spirituality. Pride, in the one case, magnanimity, in the other—both aiming at the impossible, either of folly or of heroism. A blinding moment it is when extremes of sin and virtue brush sides with each other and mingle, each in that confusion proceeding towards its appointed place, the weak one to the presumption in which it will be swallowed up, the strong one to the virtue in which it will grow stronger.

Let me be more precise. The whole issue comes down to this, that there is for art an antinomy (and art is not alone

in this) between the highest demands of the *essence* taken in itself and transcendentally, and the *conditions of existence* called for by this very essence according as it is realized here on earth.[178]

Where would the notion of "pure art" lead if pushed to its furthest logical extremes? To an art completely isolated from all that is not its own rules of operation and the object to be created as such, in other words, an art apart, freed, completely uninterested in man and things. For, of itself, art—*recta ratio factibilium*—is not human, as are the moral virtues, and does not measure itself in accordance with things, as do the speculative virtues; there it is then, if you carry it to the pure state, wholly occupied in making being, and not at all interested in beings. But then, by dint of being itself, it destroys itself, for its existence depends on man, in whom it subsists, and on things, on which it nourishes itself. Angelist suicide—through the forgetting of matter.

Remind art that "poetry is ontology"; [179] that, being *of man,* it can no more cut itself off from things than man himself can; that, being *in man,* art always ends by confessing in some way the weaknesses of man, and that if it devours the substance of the artist and the passions, options, and speculative and moral virtues which make it truly human, it devours the very subject in which it inheres; that, being in a certain way *for man* (if not in itself, at least as to the use that is made of it), it withers away in the course of time if it refuses either the constraints and limitations necessitated from without by the good of man, or the service of the common culture, which asks it to make itself legible, accessible, open, to take upon itself the heritage of reason and wisdom on which we live, to awaken in a people or in the human race a moment of unanimity—remind it of all this and you remind it of its conditions of existence, the sum of which is: humanity.

Though art be irritated (the tone in which such remonstrances are generally addressed to it is a sufficient excuse), this nevertheless remains true. As a matter of fact it can happen that a frank acceptance of these servitudes may bring about a renewal of art's own life, especially when it is a question of a condition implied in its formal object itself, as for instance regard for the *intended purpose* of the work.

The fact remains, however, that if art grows in the midst of accepted servitudes, it is by struggling against them; and that all the exigencies its conditions of existence have disclosed to us remain, as we say, on the side of "subjective" and "material" causality. Of itself—let us not forget—art is a virtue in some way inhuman; the effort towards a gratuitous creative activity, solely absorbed in its own mystery and its own operative laws, without subordinating itself either to the interests of man or to the evocation [180] of that which already exists, in short, the effort towards pure art, follows from the very essence of art, once beauty has awakened it to itself. Art cannot forgo this effort without being false to itself. A too languid resignation to its conditions of existence is also suicide for art—sin of materialism.

It may be observed from this point of view that a return to religion, to right moral life or to sound philosophy, does not at all entail by itself a simultaneous righting of art in its own sphere, but merely brings it back to normal conditions of existence—and to the normal burdens these imply. This, of course, can strengthen its vitality, and deliver it from all kinds of hindrances and obstacles (*removere prohibentia*), but it can also cause it to lose in aesthetic quality, for it is a case here only of *dispositive* causality, and everything depends on the advantage a sufficiently vigorous virtue of art will be able to draw from it.

Such, then, is the deep-seated conflict which art cannot

escape. The solution is no doubt clear to the philosopher. Art must acquire this ideal independence—the desire for which is inscribed in its nature—in regard to the material obligations involved in its conditions of existence, by turning to account these very obligations, by mastering them, by showing itself strong enough to take them upon itself without giving way; it does not acquire it by refusing them—which is to acknowledge a weakness.

But in practice, for the artist, the solution is less simple. In actual fact there will be give-and-take, it will be necessary to aim too high; and precisely the better to dominate matter and to assure oneself new holds on it one will have the appearance of repudiating it, concealing behind this weakness a new energy. Mallarmé never wished to reduce to nothing the significance of words; he was preparing on the contrary a new way of making it appear.

In any case, however useful the resistance of critical reason and of the human environment may be, it is not through them, but by the movement of invention itself, pursuing its course, that the necessary adjustments are made. Art rights itself by advancing further, not by stopping. The springs of the conditions of existence recoil spontaneously; or it comes to be perceived that a too pure effort was itself going astray and injuring a specific exigency of human art. In the changing and never-fixed life that poets carry on through the whole length of time, Mallarmé and, in another order, Rimbaud, one fine day become the past.[181] And at that moment they reveal in them something which is a stop-point, an end and not a beginning, an exhaustion of energy, against which one will have to take a stand. One will then start out again with a closer grasp on the truth.

Let us add, to bring this digression to an end, that—quite naturally—those who advance along the path of tradition,

in via disciplinae, attach themselves by preference to what in art depends on its conditions of existence; whereas those who advance along the path of invention, *in via inventionis,* attach themselves by preference to what in art depends on its pure form or essence. Thus, this distinction between essence and conditions of existence might perhaps, if it were recognized, have a chance of contributing its share to the formation of an equitable judgment on

> *Cette longue querelle de la tradition et de l'invention,*
> *De l'Ordre et de l'Aventure,*

of which Apollinaire spoke.

The problem of imitation, which, at least if imitation is properly understood, concerns the formal element in our art, is closely related to the questions I have just raised. At this point the theological consideration of the operative idea clearly shows how foreign to art is the servile imitation of the appearances of nature, since art's deepest exigency is that the work manifest not another thing already made, but the mind itself from which it proceeds. Just as God makes created participations of His essence to exist outside Himself, so the artist puts himself—not what he sees, but what he is— into what he makes. Thus anyone contemplating the myriad landscapes that God signs at each turn of the wheel of light, or any countenance at all of beast or man, clearly sees that strictly speaking they are *inimitable,* and that there is more humility in continuing in our manner the creative impulse than in striving to equal its effect in a representation.

The truth is, and it is here that the mystery becomes knotted, that we have nothing which we have not received.

In Wilde's paradoxes on the lie a great truth lies hidden, a truth which, obviously, has nothing to do with the shoddy

Hegelianism with which he decks it out. It is quite true that things are better in the mind than in themselves,[182] that they take on their full proportions only when they have been uttered by a mind, and that they themselves crave to be taken up into the heaven of thought—metaphysics or poetry—where they proceed to live above time, and with a life that is universal. What would have become of the Trojan War without Homer? Unfortunate are the adventures which are not told.

But what Wilde, suffocated by the paper roses of his aestheticism, did not understand is that our art does not draw from itself alone what it gives to things; it spreads over them a secret which it has first seized by surprise in them, in their invisible substance or in their endless exchanges and correspondences. Withdraw our art from "that blessed reality given once and for all, at the center of which we are placed," [183] and it is no longer anything. It transforms, it moves about, it brings together, it transfigures; it does not create. It is by the way in which he transforms the universe passing into his mind, in order to make a form divined in things shine on a matter, that the artist imprints his mark on his work. For each work, he recomposes, *such as into itself at last poetry changes it,*[184] a world more real than the real offered to the sense.

Thus there remains for our art—because the subject in which it inheres is the mind of man—the law of imitation, of resemblance: but in what a purified sense! It must transpose the secret rules of being in its manner of producing the work, and it must put as much fidelity and exactness into transforming the real according to the laws of the work-to-be-made, as science does in conforming itself to it. What it makes must resemble, not the material appearances of things, but some one of the hidden meanings whose iris God alone sees glittering on the neck of his creatures—and by that very fact it

will also resemble the created mind which in its own manner
discerned that invisible color. Resemblance, yes, but a *spiritual*
resemblance. Realism, if you will, but a realism of the super-
real.

This divination of the spiritual in the things of sense, and
which expresses itself in the things of sense, is precisely what
we call POETRY. Metaphysics too pursues a spiritual prey,
but in a very different manner, and with a very different formal
object. Whereas metaphysics stands in the line of *knowledge*
and of the contemplation of truth, poetry stands in the line
of *making* and of the delight procured by beauty. The differ-
ence is an all-important one, and one that it would be harmful
to disregard. Metaphysics snatches at the spiritual in an idea,
by the most abstract intellection; poetry reaches it in the
flesh, by the very point of the sense sharpened through intelli-
gence. Metaphysics enjoys its possession only in the retreats
of the eternal regions, while poetry finds its own at every
crossroad in the wanderings of the contingent and the singu-
lar. The more real than reality which both seek, metaphysics
must attain in the nature of things, while it suffices to poetry
to touch it in any sign whatsoever. Metaphysics gives chase
to essences and definitions, poetry to any flash of existence
glittering by the way, and any reflection of an invisible order.
Metaphysics isolates mystery in order to know it; poetry,
thanks to the balances it constructs, handles and utilizes mys-
tery as an unknown force.

Poetry in this sense—need it be pointed out?—is alto-
gether the opposite of LITERATURE, insofar as this word
connotes (already from the time of Verlaine) a certain
deformation of which literary men are the prime victims.
Sophistics of art, as difficult to track down as the old sophistics
detested by Plato, one can group under this word all the

counterfeits of beauty which make the work tell a lie each time the artist prefers himself to the work. This impurity is in our art the wound inflicted by original sin, and our art never ceases to bewail it. For our art is not itself a lie, under the pretext that its truth is not the truth of knowledge. It affirms outwardly the personality of the artist insofar as the artist forgets his personality in his object [185] and in the reality (interior or exterior) which it manifests the while transforming. Literature puts on the work the grimace of personality. It would fain embellish God.

Literature is to art as self-conceit is to the moral life. Poetry, I have said elsewhere, is to art what grace is to the moral life.

Poetry thus understood is clearly no longer the privilege of poets. It forces every lock, lies in wait for you where you least expected it. You can receive the little shock by which it makes its presence known, which suddenly makes the distances recede and unfurls the horizon of the heart, as much when looking at any ordinary thing or cardboard cutout, "silly pictures, panel-friezes, stage-effects, showmen's curtains, signboards," [186] as when contemplating a masterpiece.

Tu lis les prospectus, les catalogues, les affiches qui chantent
 tout haut,
Voila la poésie ce matin . . .[187]

The *fine arts,* however, and the art of the poet himself, being ordered to a transcendental world, are specially designed by nature to bring it into our midst. They aspire to capture it.[188] When they meet poetry, each rejoins the principle of its own spirituality.

I have said that in tending to *pure art,* our art, while running the risk of suicide because of the inhuman conditions

into which it enters, tends to draw closer to its principle and
to take on a higher consciousness of its spirituality. It is in-
evitable that at the same time it should become more con-
scious of its relation to poetry, that it should seek with a
more violent and more desperate desire that indefinable some-
thing from which the best of its spiritual life proceeds. The
search for the absolute purity of art will therefore be at the
same time the search for the poetic substance in the pure
state. Here, alas, it is not enough to seek, in order to find.

Today art is doing penance; it works itself to death, morti-
fies and scourges itself like an ascetic bent on destroying him-
self in order to obtain the grace of the Holy Spirit, and who
often remains devoid of that in which a child superabounds.
Rimbaud is silent. What was there in the heart of Rimbaud
if not this hunger for the poetic absolute,[189] for the pure spirit
of poetry, which breathes where it will, without any man
knowing whence it comes or whither it goes? A mysticism
of light and darkness through which poetry symbolizes the
supernatural without penetrating it, mimics it and foretells it
all at once, and with which grace can mingle its touches, but
which of itself still remains far from the mysticism of the
saints, and which, besides, is available both to Heaven and
to Hell.

The principal role played by Baudelaire and Rimbaud is
to have made modern art pass the frontiers of the spirit. But
these are regions of the direst perils, there the weightiest
metaphysical problems fall on poetry, there the battle is
waged between the good and the bad angels, and the bad
angels are disguised as messengers of light.

*

Art opened its eyes on itself at the time of the Renaissance.
It may be said that for the last half-century it has been seized
by another fit of introspection, giving rise to a revolution

every bit as important. Work such as Picasso's reveals a frightful progress in self-awareness on the part of painting. Its lesson is as instructive for the philosopher as for the artist, and therefore a philosopher may be permitted to say a few words about it from his own point of view.

In order to find a pure expression, freed even of such human interferences and *literature* as proceed from the pride of the eyes and their acquired knowledge, Picasso expends an heroic will and courageously confronts the unknown; after which painting will have advanced a step in its own mystery. At each moment he brushes against the sin of angelism; at the same heights another man would fall into it. I sometimes think that by dint of subjecting painting to itself alone and to its pure formal laws, he feels it yield under his hand; it is then that he bursts into rage, and seizes anything at all and nails it against a wall—still with an infallible sensibility. But he always saves himself because he awakens in all that he touches an incomparable poetic substance.

It is because he is pure painter that Picasso meets with poetry: in this he is in line with the Masters, and recalls to us one of their most instructive lessons. As Cocteau has rightly pointed out,[190] Picasso's works do not despise reality, they *resemble* it, with that spiritual resemblance—"superreal" resemblance, to use a word very true in itself—of which I have already spoken. Dictated by a demon or by a good angel—one hesitates at certain moments to decide which. But not only do things become transfigured in passing from his eye to his hand; at the same time there is divined another mystery: it is the painter's soul and flesh endeavoring to substitute themselves for the objects he paints, to drive out their substance, to enter in and offer themselves under the appearances of those trifling things painted on a canvas, and which live there with another life than their own.

Thus the spiritual virtue of human art, once it has attained

to a certain height in its own heaven, perceives that it trans-
lates analogously and figuratively the movement of a higher
and inaccessible sphere. Rimbaud blasphemed at not being
able to gratify that kind of eucharistic passion which he had
discovered at the heart of poetry. We cannot tell, for we have
difficulty understanding anything spiritual, to what depths—
sometimes in the inverted symbols of sin—art pursues its
analogy with the supernatural. At a certain level of relinquish-
ment and anguish, it awakens impossible desires, and the poor
human soul which has confided in it is thrown into a nameless
world, as close to, as far away from, the truth as your reflec-
tion is from your face in the deep water over which you lean.
God alone, Whom it desires without knowing it, could hence-
forth content it; it has found what it seeks, the thick surface on
which to cross, but it needs the help of Omnipotence to take
this step.

Poetry (like metaphysics) is spiritual nourishment; but of
a savor which has been created and which is insufficient.
There is but one eternal nourishment. Unhappy you who
think yourselves ambitious, and who whet your appetites for
anything less than the three Divine Persons and the humanity
of Christ.

It is a mortal error to expect from poetry the supersubstan-
tial nourishment of man.

The search for the absolute, for perfect spiritual liberty,
combined with the absence of any metaphysical and religious
certitude, has, after Rimbaud, thrown many of our contem-
poraries into this error. They expect from poetry alone—
in the midst of a despair whose sometimes tragic reality must
not be overlooked—an improbable solution of the problem
of their life, the possibility of an escape towards the super-
human. And yet, Rimbaud had said it, *la charité est cette*

clef—Charity is the key. Notwithstanding this shining phrase, he remains the great personification of the error of which I am speaking.

Let us follow our scholastic custom and proceed by sharp distinctions. We have seen that we must distinguish three terms: *poetry, art,* and *"literature."* I say that in the last analysis Rimbaud's error consists on the one hand in confusing the last two, in condemning as "literature" art properly so called,[191] on the other hand in separating the first two terms, and forcibly transferring poetry from the line of art to the line of morality: which leads to the exact opposite of Wilde's error. Wilde made life a means of poetry; now poetry is being made the means of life (and of death).

As a result, we see men gifted with the sense of poetry load poetry with burdens which are repugnant to its nature, *onera importabilia;* we see them require a picture, a piece of sculpture, or a poem to "bring about an advance in our abstract knowledge properly so-called," [192] open the heart to a metaphysic, and reveal to us sanctity. But poetry can do all this only through illusion; and once more we are confronting a mirage: intimidation, and blinding effects, resulting from the intrusion of foreign grandeurs. Thus the most strenuous search for liberation from all literature leads by the force of things to literature still. When anyone perceives this, he will raise havoc with himself. But for a new deception.

As to the order of action and human destiny, what can poetry as regulating moral and spiritual life, poetry *to be realized in conduct,* introduce into it except counterfeit? Counterfeit of the supernatural and of miracle; of grace and the heroic virtues. Disguised as an angel of counsel it will lead the human soul astray on false mystical ways; [193] its spirituality, diverted from its own path and its own place, will, under the aspect of a wholly secular interior drama,

provide a new sequel to the old heresies of the *Illuminati*.
Purity! There is no purity where the flesh is not crucified, no
liberty where there is no love. Man is called to supernatural
contemplation: to offer him another night is to rob him of his
proper possession. A revolution which does not change the
heart is a mere turning over of whitened sepulchres.

Poetry is the heaven of working reason. To put forward
the misdeeds of the spirit Poetry when it has gone astray as
a pretext for refusing to acknowledge its rights in the line of
art, to claim to bring art back to mere technique or to amuse-
ment or pleasure, would be an unpardonable mistake, and
altogether fruitless besides. It is possible that a reaction of
the kind "And now let's not budge an inch from nature" may
some day take place; I am told that there are already some
signs of it in Italy, at any rate as regards painting. Nothing
could be more in line with the trend of fashion. If such a
reaction, supposing it actually takes place, does not succeed
in integrating the spiritual values of current inquiries (as the
classical reaction, in France, succeeded in assimilating, at
least in part—a very small part—the spirit of Ronsard and
Marot), it will only be an accident of no importance. One
is always severely punished for forgetting the metaphysical
transcendence of poetry, and for forgetting that if in the work
of Creation the Word was art, the Spirit was poetry. "Because
Poetry, my God, it's you." [194]
There were times when art worked in a blessed innocence,
convinced that it was only a craft, intended for the service
or the amusement of men, and that its function was to paint
grapes which would fool the birds, to celebrate military feats,
to adorn the council chambers, and to instruct and admonish
the people. It lived then in a servile state; which does not
mean that it was enslaved. It did not deny its nature; it was

unaware of itself. Under cover of an admirable misunderstanding, its native nobility and its liberty, not proclaimed in ideas and words, in what is said, were respected in the silence of what is made: protected by its very obligations and by its own humility. Poetry came to visit it in secret; never was it happier, never more fecund.

These times are past and far past; art cannot return to ignorance of itself, cannot abandon the gains won by consciousness. If it succeeds in finding a new spiritual equilibrium, it will be, on the contrary—in this I think I agree with Valéry—by *still greater* self-knowledge.

A parenthesis: there are many references in *Art and Scholasticism* to the Middle Ages. This is legitimate, because the Middle Ages are relatively the most *spiritual* period to be found in history, and thus offer us an example very nearly realized—I do not say without vices and defects—of the principles which I hold to be true. But time is irreversible, and in this example I wish to seek only an *analogy*. It is under a mode entirely new, and difficult to foresee, that these principles have to be realized today (for there are a thousand possible historical realizations, as different as you like, of the same abstract principle). If as a result of our natural tendency to materialize everything, the spiritual analogy slipped over into the material copy, into the imitation of the particular modes of historical realization, it would be the danger of the Middle Ages which would have to be denounced. Whatever admiration I may have for Roman and Gothic architecture, I remember the delight I experienced in St. Peter's in Rome when I saw that Catholicism is not bound even to what I hold dearest. In that great rational light, most appropriate for a religion publicly revealed, even Bernini served to give me evidence of the universality of my faith. And a Grünewald, a Zurbaran, a Greco—what gratitude we owe them for having

thrust aside the barriers of extraordinary masterpieces, which
threatened to confine the signs of faith.

As for the Renaissance, my position with regard to it has
often been misunderstood. There is in this period a certain
"intentional virtue" which tends to the worship of man, and
which has become the form of the modern world. But it is in
the most immaterial order, into which metaphysics and theol-
ogy alone penetrate, that we discern it, without disregarding
on that account all the normal developments which continue
in other respects, and which the mishap that occurred in the
high places *at first* only affects in their pure spiritual signifi-
cance. To observe that there was a moment when beauty,
still retaining the fragrance of the virtues and of prayer, began
to deviate from its vows and yield to the image of terrestrial
love and of a youthful sensuality, is not to calumniate Flor-
ence. To remark that the spiritual curve of culture has been
declining since the Renaissance is not to desire that the Ren-
aissance be expunged from human history. Parallelogram of
forces: there is in the course of events a divine line to which
our infidelity adds a more or less pronounced element of devi-
ation, but which Providence does not, for all that, abandon.
If Erasmus and his friends [195] had proportioned their means
to the end they were pursuing and had realized that reason
does not suffice in order for one to be right, above all if there
had not been for so long such manifold abuses of grace in
Christendom, the Renaissance would not have deviated so
far from that line, humanism would not so quickly have
proved itself inhuman. The fact remains that God's patience
is instructive, and teaches us not to root up, even in desire,
crops overrun with cockle.

Every strong civilization imposes exterior constraints on
art, because it subjects the whole practical domain to the
primacy of the good of man and powerfully orders all things

to this good. Enough has been said of the advantages which art, if it wishes, derives from these constraints. And not only art. The pitiable state of the modern world, a mere corpse of the Christian world, makes one desire with particular intensity the re-establishment of a true civilization. If this desire however were to remain ineffectual and universal dissolution were to continue, we would still console ourselves, because, in proportion as the world unmakes itself, we see the things of the spirit gather together there where one is in the world and not of the world. Art and poetry are among these; together with metaphysics and wisdom. The charity of the saints will lead the choir. None of these has any permanent dwelling here below; each lives in some sort of casual shelter, while waiting for time to end. If the Spirit which floated over the waters must now hover over the ruins, what does it matter? It is enough that it comes. What is certain, in any case, is that we are approaching a time when every hope placed lower than the heart of Christ is doomed to disappointment.

*

Max Jacob thinks that the poetic work which is going on under the eyes of our contemporaries, and of which they are scarcely aware, is preparing the way for a renewal of art as important as the advent of Cimabue and Giotto. Indeed, it may be that such a springtime is being prepared. Our Lord exhorts us to pay attention to the budding of the fig-trees which proclaims that summer is nigh. Great things foretell nothing; it is the little things that foretell the great.

Art, understood formally, asks only to be allowed to develop in history its internal logic, in complete disregard of our human interests. In actual fact, however, that one or the other of the virtualities which struggle in it triumphs at any given moment, results for a large part from material

causality or the dispositions of the subject. It may be that art today has proceeded so far into the regions of the spirit, and is involved in such grave metaphysical problems, that it cannot escape a choice of a religious kind. The search for pure art, such as the Symbolists had attempted with such high hopes, is now, for art, entirely a thing of the past; it directs itself towards Christ or towards Antichrist,[196] towards the destruction of faith or towards faith. Do you not see all that it has of desire divide between these two ways,[197] along which it advances divided and a prey to the absolute?

I am not forgetting that by the very nature of things one of these ways is wider and easier than the other. Evil is by nature easy. Because good is a wholeness, whereas evil is a *deficiency,* and because evil does not act through itself but through the good it preys upon, it takes but a small amount of good to succeed greatly in evil, whereas it takes a great amount of good to succeed but a little in good. It is only in times especially blessed, and in a civilization such as ours is not, that the art of an epoch finds its greatest opportunities in the line of good. But I am not forgetting either that extreme anguish renders God's solicitations more perceptible and the help of the higher virtues more necessary.

That art today should in many opt for the devil is not surprising. But it is on the other hand a fact which anyone can verify that at least in a small number of men of real stature it opts for Christ. Such an impetus will not be easy to stop. From this point of view Léon Bloy and Paul Claudel have particular historical significance. Through them the absolute of the Gospel has entered into the very sap of contemporary art. In the great epochs of earlier times religion safeguarded the dignity of art, which ordinary social life in the human community would gladly compromise into a mere means of amusing or, as Gide says, *flattering* an aristocracy.[198] Now that religion

is no longer recognized by public life, it is incumbent on it to exercise a similar service in the secret and more profound sphere of intellectual life. Religion alone can help the art of our epoch to keep the best of its promises, I do not say by clothing it in a gaudy devotion or by applying it directly to the apostolate, but by putting it in a position to respect its own nature and to take its true place. For it is only in the light of theology that art today can achieve self-knowledge and cure itself of the false systems of metaphysics which plague it. By showing us where moral truth and the genuine super-natural are situate, religion saves poetry from the absurdity of believing itself destined to transform ethics and life, saves it from overweening arrogance. But in teaching man the dis-cernment of immaterial realities and the savor of the spirit, in linking poetry and art itself to God, it protects them against cowardice and self-abandonment, enables them to attain a higher and more rigorous idea of their essential spirituality, and to concentrate their inventive activity at the fine point thereof.

It is thus possible to conceive a liberation—and indeed it began a half-century ago—of the values of modern art, a renaissance, which the analogy between the operative virtues and the virtues that rule moral life entitles us to call Christian, not only in the properly religious sphere, but in the sphere of artistic creation itself.

Prudence and justice, fortitude and temperance: straight-way we would find there the cardinal virtues transposed into the order of the *factibile,* as features of the work made, for they are the analogical archetypes of the rules of every work of art. But such an art, already living in many works that we admire, would bear the imprint of many other correspond-ences. It would in its way follow the lesson of the Gospel. It would know the meaning, for a fruit born in the secret of the

soul, of humility and poverty, spiritual chastity, obedience, high regard for the works of the Fathers, miracles worked secretly, the concealment of good because of the eyes of men, the passage of light into our midst and its own receiving it not. It would understand with Saint Thomas that intelligence is the sister of mystery; and that it is as foolish to reject mystery because "stupidity is not my forte" as it is to reject intelligence because one has a liking for mystery. It would become close friends of the wisdom of the Saints, would know the value of purity of heart, would learn how love and the seven gifts of the Spirit impose on the works of man a more exalted rule than that of reason. Chaste fear, piety, fortitude, counsel, knowledge, intelligence, wisdom, "what would one say of a work in which he would recognize the traces of these gifts?" [199]

Submission to the conditions of the human state, on which the very existence of the operative virtues in the subject depends, would then—without diminution or surrender— harmonize with the movement towards pure art, which follows from the very essence of these virtues once they make contact with beauty—just as in the Saints a modest and willing sub- mission to the necessities of human nature harmonizes with an audacious movement towards pure spirit. The true equi- librium between the different mental energies which concur in the production of the work will thus be recognized. For if it is true that undeviating practical reason is the formal element of art—the element, consequently, on which the Schoolmen owed it to themselves to insist most (confirmed in this by the testimony of artists themselves, of a Delacroix no less than a Poussin)—it is equally true that without the dynamism of the imagination, and of the whole immense night of the an- imate body, this formal principle would suffice as little for art as a mortal soul is sufficient unto itself without matter.

And most certainly this vast power of the senses is the more visible. Aristotle told us long ago that the νοῦς is nothing as to mass: and yet it is what matters most.

But if the active point of the soul—that spiritual instinct in contact with the heaven of the transcendentals—on which poetry really depends is not moved in us by some special impulse springing from the first Intelligence, reason's measuring will remain paltry, and, being unable to penetrate either the profundities from above or the profundities from below, will prefer not to recognize them. Instead of the dialogue between the soul and the spirit—*spiritus vir animae*—it will be the conflict between the soul and lower reason.[200] However true the observations of Poe and Baudelaire, Wilde and Valéry, on the creative importance of the critical spirit, calculation still lets the most divine element escape; the spirit in us is placed between an obscurity from above, through an excess of transparency, and an obscurity from below, through an excess of opacity. No doubt the soul receives better than the spirit the rays from these two nights; but it is Adam who must judge all the voices that Eve hears. What some vainly seek at the farthest confines of sleep and abandonment to the unconscious, will be found at the farthest confines of vigilance. A vigilance of the spirit, so subtle and so prompt—prepared by interior silence—that it will discern at the edge of the shadow all the forms which pass under the starry canopy of the heart. *Vigilate et orate:* here too the precept is from the Gospel.

Will this new epoch live only in our desires? Everything depends on the births secretly produced in the hearts of a few privileged ones of sorrow and the spirit—and also, alas, on the general conditions of human life, for every artistic epoch is a function of the whole civilization. What is certain is that

an art submissive to the law of grace is something so difficult, requiring such rare equilibriums, that man, even Christian man, and as much of a poet as you like, is incapable of it by himself. It requires the Spirit of God.

We are so stupid—Saint Thomas says something like this —that even provided with the infused virtues, theological and moral, we would be certain to miss our salvation if the gifts of this Spirit did not come to the rescue of the feeble government of our reason. Art by itself has no need of such assistance. But the art of which I am speaking here, an art which would truly bear the traces of the seven gifts, must issue from a heart itself stirred by them. Let there be no mistake: by its height and by the obstacles it overcomes and which it presupposes, such an art would require souls completely submissive to God. This does not make things easier.

"There is but one sadness—not to be of the saints." [201] We are not equal to the task. It is when it is hardest that we are weakest—is there any weakness worse than the weakness of the men of our time? A weak and unfortunate generation again bears the weight of the future. Must we then give up the struggle?

Consider, says Our Lord, serious-minded people who undertake affairs of state. Which of you, wishing to build a tower, does not first sit down and reckon the expenses and see whether he has the wherewithal to finish it, lest after he has laid the foundation and is not able to finish it, all that see it begin to mock him, saying: this man began to build and was not able to finish? And what king, about to make war on another king, does not first sit down and reckon whether with ten thousand men he will be able to resist an aggressor coming to meet him with twenty thousand?

Which is to say: before beginning to work for God and

to fight against the devil, first determine your assets; and if
you think yourself well enough equipped to begin, you are a
fool, because the tower to be built costs an *outrageous price,*
and the enemy coming to meet you is an angel before whom
you hardly count. Understand that you are called to a task
which entirely exceeds your forces. Get to know yourself so
well that you will be unable to look at yourself without flinch-
ing. Then there will be room for hope. In the sure knowledge
that you are "obliged to do the impossible" and that you can
do the impossible in Him Who strengthens you, you are then
ready for a task which can be accomplished only through
the Cross.

I am well aware that many people understand this parable
differently. They fear God but they fear more the armies of
Satan, and in the end, after everything has been well con-
sidered, they arrive at an agreement with the adversary, send-
ing him from afar the deputation of their fears. The safest
thing is to leave him the difficult positions, poetry as well as
philosophy, and to abandon intelligence to him. They are
true Davids, advancing after every risk has been removed.

Others say, and in my opinion more wisely: we know that
it is a fearful thing to bear Christ's name before men, and
what a paradox a Christian art must realize and what perils
accompany the encounter of religion with the restless world
of art and the lying world of literature—and the very eager-
ness with which grace and despair contend for a whole gener-
ation of youth; we know that it is customary among men that
the greatest number fail in whatever is difficult, and that thus
the eventual spoiling of every enterprise of even a little eleva-
tion conforms to the customs of nature. Well! we shall rely
upon grace. If our tower should come to a standstill when
only half-finished, or if it should happen to fall on our heads,
the beginnings perhaps will have been beautiful.

Grace does not exempt the artist from his own labor: it even makes his labor more arduous, for it compels it to carry a heavier substance. Now trees laden with fruit bow down to the ground, but art must not bend under its load.

Nor does grace exempt the believer from human preparations and human effort, although it gives him, and because it gives him, both the will and the actual execution. By ourselves alone we can do nothing, i.e., increase being in any way; but by ourselves alone we can do nothingness, i.e., diminish being. When the First Cause makes use of us as instruments, it is as living and free instruments, acted upon, no doubt, but acting also. In the realm of our free acts the First Cause likewise does nothing without us. A moment of which man is master, at the most secret core of the heart, binds and looses eternity.

Mysticism is in fashion, asceticism less so. It is a grave mistake to think that one of these can be separated from the other. We cannot love Love by halves. Our epoch feels itself too forlorn not to cry towards Heaven—but sometimes as a sick man calls for morphine, not for recovery. Its cowardice creates the fear that it intends to serve two masters—resting its foolish hope in a radical division of the heart and the metaphysical annihilation of personality; as if the innumerable divisions and dissociations of the psychic structures, however profound our infirmity permits them to be in the whole order of the feelings and involuntary attractions, and of secondary choices, could affect the primitive choice of the will deciding on its ultimate good, and the metaphysical essence of personality. In the end one perceives an abominable *counterfeit,* the diabolical collusion of mysticism and sin, the Black Mass.

The world from which the Saints formerly fled into the desert was no worse than ours. To describe our time, we need to recall the first chapter of the Epistle to the Romans. We

have returned to the great night of pagan agony, in which man has no longer to cope simply with his own wretched flesh, but with a flesh scourged by the angels of Satan, and in which, for his obsessed imagination, the whole of nature clothes itself in obscene symbols. To keep pity from turning into connivance, love from turning into despair, in such a world, it is inadvisable to forget death-to-oneself and all that ensues— I mean as a condition of a strong life. And in this order of things it is often less tiring to run than to walk.

Nor would it be advisable to wait for infused knowledge instead of acquiring the knowledge which depends on us— or, what is worse, to scorn knowledge. It must be admitted that in general the youth of today, victims of the inhuman acceleration imposed on life, seem discouraged at the long preparations that intelligence requires. Nevertheless, to neglect the intelligence costs dearly. A reign of the heart which would not presuppose in the heart an absolute will to truth, a Christian renewal which would think that it could do without wisdom and theology, would be suicide in the disguise of love. The age is swarming with fools who disparage reason. First one must deserve the right to speak ill of it. Love goes beyond reason; what remains this side of reason is folly. In ecstasy and near death, Saint Thomas could say of the *Summa:* "It seems to me as so much straw." He had written it.

The simple-minded idolatry that the majority of artists bestow on their work, which becomes triply sacred once they have produced it, is proof of man's essential creative weakness. God does not adore His works. Nevertheless He knows they are good. He does not cling to them, He lets them be spoiled by man; even the gratuitous marvels of the supernatural order, charismata, prophecies, miracles, the purest gambols of His poetry, are as fires too beautiful wasted in

the night. But there is one good to which He clings: souls, the pasture of His love. Do you think that He weighs man's greatest masterpiece against the smallest amount of charity in a soul? Neither art nor poetry justifies any want of sensitivity towards Him.

Saint Paul says there are things which ought not even to be so much as named among you. This is a saying that is ordinarily misunderstood, for it affirms a rule, not of conversation, but of conduct, and signifies that morals so pure are required of Christians that they cannot have about them so much as even the shadow or the name alone of certain things.[202] As to designating these things by their name, Saint Paul does so himself immediately. There is nothing which *by its nature* is forbidden nutriment for art, such as the unclean animals for the Hebrews. From this point of view art can name all things, just as Saint Paul names avarice and lust. But on condition that, in the particular case and *in relation to the people* [203] it is aiming at and with whom it comes in contact, the work does not stain the mind and the heart. If from this point of view there are things which the artist is neither strong enough nor pure enough to name without conniving with evil, it is better for him and for others that he not name them yet. When he becomes a saint, he will be able to do what he wishes.

If he knew his own good, what thanks the artist would render to morality! In protecting his humanity, morality protects his art in a certain indirect way. For, however beautiful the work may be in other respects, it always betrays in the end, with an infallible craftiness, the blemishes of the workman.[204] No doubt the formal object of art is not subordinate in itself to the formal object of morality. Nevertheless it is not only extrinsically and for the good of the human being

that morality can influence the activity of the artist; it also concerns this activity intrinsically—in the order of *material* or *dispositive* causality. For morality is not, as Kant would have it, a world of imperatives descended from the heaven of liberty and alien to the world of being: it is rooted in reality as a whole, of which it manifests a certain category of laws; to ignore morality is to narrow the real and consequently to impoverish the materials of art. An integral *realism* is possible only for an art responsive to the whole truth of the universe of good and evil—an art pervaded by the consciousness of grace and sin and the importance of the *moment*.[205] What is most real in the world escapes the notice of a darkened soul. "Just as one can say nothing about the beauties of sense if one has no eyes to perceive them, so it is with the things of the spirit, if one cannot see how beautiful is the face of justice or temperance, and that neither the morning star nor the evening star is so beautiful. One sees them when one has a soul capable of contemplating them; and in seeing them one experiences a greater delight, surprise and consternation than in the preceding case, because now one is very close to genuine realities." [206]

There is but one way of freeing oneself from the law: to become one of the perfect whom the spirit of God moves and leads, and who are no longer under the law, doing through their own inclination what the law commands. As long as a man has not attained this goal—and when does he attain it? —as long as he is not through grace one with the rule itself, he needs, in order to keep himself upright, the restraining rules of morality. He requires this rod. And because the artist expresses and must express himself in his work according as he is—well then, if he is morally deformed, his art itself, the intellectual virtue which is perhaps what is purest in him,

runs the risk of paying the costs of this moral deformity. The conflict is inevitable. One gets out of it as best he can, rather badly than well.

What makes the condition of modern art tragic is that it must be converted if it is to find God again. And from the first conversion to the last, from baptism to the habit of virtue, there is some distance to go. Why should one not note waverings, troubles, danger zones? Those who have the care of souls naturally get frightened at times and use severity. But it is also fitting that they treat kindly the hope of future goods (and that they apply themselves more to strengthening souls and their interior capacities of vital defense, than to protecting from the outside anemic flocks lacking in virtue). If you speak with artists, tell them to make haste while they have the light, and to fear Jesus who passes and does not return. If you speak with the prudent, tell them to be patient with poets and to honor in the heart of man the long-suffering of God. But let them all hate the sniveling beast which hangs about art and poetry, that infinite self-complacency which in so many of the weak, and in so many of the strong too, causes the best gifts to stray, and which changes divine things into a sham fit to fatten fatuity.

*

Considering the human conditions which it presupposes, and the present plight of hearts, the success of the renewal I am hoping for seems strangely problematical. It is as if a rose wished to blossom not on a dead branch, but on sawdust.

I do not at all pretend to say what will be. I am not trying to know what poets or novelists will do tomorrow. I am merely attempting to indicate how certain profound desires of contemporary art move in the direction of a Christian renais-

sance. I envisage a possible future—what could be, what would be if man were not always betraying the deposits entrusted to him. It seems to me, then, that modern poetry, at least where it has not opted for despair, in the order of art proposes the very thing of which Our Lady is forever, in the order of sanctity, the perfect exemplar: to do the ordinary things in a divine way. This is precisely why "il faut être un grand poète pour être un poète moderne,"[207] one has to be a great poet to be a modern poet. On emerging from an epoch in which Nietzsche could point to "the general evolution of art in the direction of charlatanry,"[208] modern poetry is making an effort, still clumsily, to respect genuine subordinations, and to practice obedience and sacrifice.[209] After having so diligently sought false purities, it is perhaps on the way to the true. It is beginning to discover the secret significance of goodness and suffering, and that "if the world has indeed, as I have said, been built of sorrow, it has been built by the hands of love," "for the secret of life is suffering. It is what is hidden behind everything."[210] After so much sentimentalism, it wants hard contact with the real, stripped and naked. Now that so much literature and such an initially arrogant confidence in enfranchised reason and the emancipated self have ended in the disintegration manifest in Dadaism and in the free expressions of futurism (that last sigh of the past), modern poetry feels that it is incumbent upon it to reassemble—to reconcile the powers of imagination and sensibility with the powers of faith, to rediscover "the whole man in the integral and indissoluble unity of his twofold nature,"[211] spiritual and carnal, as also in the intertwining of his terrestrial life and the mystery of the operations of Heaven. Modern poetry foretells "the time of ardent grace";[212] like contemplation, it would anticipate a world transfigured:

Et que tout ait un nom nouveau.

Modern poetry is not going to free itself of language or of the work-to-be-made, but it must make transparent these intermediaries of the soul, it must make of matter, by dint of diligent attention and abnegation, a means of transmission that does not twist or mutilate its message. And it is simplicity, as Julien Lanoë has well said,[213] which will give it exactness and access to the profundities. In order to cling to its unalloyed object, it will forget the false search for an ever-trivial and insular originality; a straightforwardness, an instinct of disinterestedness, will disclose to it the mystery of universality.

Then the things of the spirit, what the tongues of men cannot utter, will find a way of expressing themselves. Art will no longer vainly attempt to violate the secret of the heart; the heart will be held in such esteem that of itself it will surrender its secret. What Rimbaud could not accomplish, love will accomplish. Where despair comes to a standstill, humility will proceed on. Where violence must be silent, charity will speak. Art will strew palms on the way of the Lord, to whom a crowd of youthful voices once sang the pious hosanna.

> *Toutes les sources sont en toi*
> *De la musique de la foi*
> *De la poésie*
>
> *La source de vie en ton sang*
> *En tes lois le fondement*
> *De toute harmonie.*[214]

NOTES

Notes

1. I am speaking here of Wisdom *by mode of knowledge,* Metaphysics and Theology. The Schoolmen distinguish a higher wisdom, wisdom by *mode of inclination* or of *connaturality with divine things.* This wisdom, which is one of the gifts of the Holy Spirit, does not stop with knowledge, but it knows in loving and in order to love. "The contemplation of the philosophers is for the perfection of the one who contemplates and consequently comes to a halt in the intellect: so that their end in this is the intellect's knowledge. But the contemplation of the saints is for the love of the one who is contemplated, namely, God: wherefore it does not stop in the intellect's knowledge as an ultimate end, but passes into the heart by love." Albert the Great (Jean de Castel), *De adhaerendo Deo,* cap. IX (Lugdunensi, 1651, T. XXI).

2. "The end of practical knowledge is some work, because although 'practical people,' that is to say, workers, aim to know what the truth is in some matters, still they do not seek it as an ultimate end. For they do not consider the truth according to itself and for its own sake, but by way of ordering it to the end of the operation or of applying it to some definite particular thing and at some definite time." Saint Thomas, *In II Metaph.,* lect. 2 (Aristotle, *Met.,* Bk. II, 995 b 21).

3. Cf. John of Saint Thomas, *Cursus Philos.,* Log. II P., q. 1; *Cursus Theol.* (Vivès, t. VI), q. 62, disp. 16, a. 4.

153

4. Artistic work is thus the properly human work, in contradistinction to the work of a beast or the work of a machine. That is why human production is in its normal state an *artisan's* production, and consequently requires individual appropriation, for the artist as such cannot be a sharer. In the line of moral aspirations the use of goods must be common, but in the line of production these same goods must be possessed as one's own: Saint Thomas encloses the social problem between the two branches of this antimony.

When work becomes *inhuman* or *sub-human,* because its artistic character is effaced and matter gains the upper hand over man, it is natural that civilization tend to communism and to a productivism forgetful of the true ends of the human being (and which *in the end* will therefore jeopardize production itself).

5. Prudence, on the contrary, is the undeviating determination of acts to be done (*recta ratio agibilium*), and Science the undeviating determination of the objects of speculation (*recta ratio speculabilium*).

6. To simplify my exposition, I am speaking here only of *habitus* which *perfect* the subject; there are also habitual dispositions (e.g., vices) which incline the subject *to evil*. The Latin word *habitus* is much less expressive than the Greek word ἕξις, but it would be pedantic to employ this latter term in general use. For this reason, and in the absence of a suitable English equivalent, I resign myself to using the word *habitus,* and beg to be excused its ponderousness.

7. These *habitus,* which perfect the essence itself, not the faculties, are called *entitative habitus.*

8. I am speaking here of *natural* habitus, not of *supernatural* habitus (infused moral virtues, theological virtues, gifts of the Holy Spirit), which are *infused* and not *acquired.*

9. It is for not having made this distinction that M. Ravaisson, in his famous thesis on Habit [*L'Habitude,* Paris, 1838], spread such dense Leibnizian fumes over the thought of Aristotle.

10. Cf. Cajetan, *In* II-II, 171, 2.

11. Aristotle, *De Coelo*, Bk. I.

12. *Summa theol.*, I-II, 55, 3.

13. *Ibid.*, a. 2, ad 1. *Unumquodque enim quale est, talia operatur.*

14. Cf. Cajetan, *In* I-II, 57, 5, ad 3; John of Saint Thomas, *Cursus Theol.*, q. 62, disp. 16, a. 4: "For it belongs to the practical intellect to measure the work-to-be-made and to rule it. And so its truth lies not in that which is, but in that which ought to be according to the rule and the measure of the thing to be effected."

15. John of Saint Thomas, *Curs. Phil.*, Log. II P., q. 1, a. 5.

16. It is thus that Saint Augustine defines virtue as *ars recte vivendi* (*De Civ. Dei*, IV, 21). Cf. on this point Aristotle, *Eth. Nic.*, VI; Saint Thomas, *Summa theol.*, II-II, 47, 2, ad 1; I-II, 21, 2, ad 2; 57, 4, ad 3.

17. "If you must have works of art, will not they be preferred to Phidias who model in human clay the likeness of the face of God?" (A. Gardeil, *Les dons du Saint-Esprit dans les Saints Dominicains.* Lecoffre, 1903. Introd., pp. 23–24).

18. Isaias, *XL*, 31. "Not without reason, then," John of Saint Thomas comments, "the wings of an eagle are promised, even though it is not mentioned that men will fly, but they will run and walk as men still living upon this earth. For although these men are impelled and moved by the wings of an eagle, which comes down from above, yet the gifts of the Holy Spirit are put into practice upon this earth, and they have their place in ordinary actions. Moreover those who are moved and regulated by a communication of superior spirits and gifts are led by the wings of an eagle and they differ in many ways from those who merely practise ordinary virtues. The latter are regulated by their own zeal and industry. With toil, they walk upon their own feet unaided. But those who are moved by the wings of an eagle are swept along in the breath of a strong wind. Without labour, they run in the way of God." John of St. Thomas, *The Gifts of the*

Holy Ghost. Translated from the Latin by Dominic Hughes, O.P. New York: Sheed and Ward, 1951, p. 30.

19. *Summa theol.,* I-II, 57, 3.

20. *Ibid.,* 21, 2, ad 2. "The fact of a man being a poisoner is nothing against his prose." Oscar Wilde, "Pen, Pencil and Poison," *Intentions* (New York: Brentano's, 1905), p. 90.

21. "And therefore art does not require that the artisan's act be a good act, but that he should make a good work. It would rather require that the thing made should act well, for example that the knife cut well or the saw saw well, if it properly belonged to these to act, and not rather to be acted on, because they do not have dominion over their actions." *Summa theol.,* I-II, 57, 5, ad 1.

When Leibniz (*Bedenken von Aufrichtung* . . . , in *Die Werke von Leibniz,* ed. O. Klopp, Hanover, 1864–1884, I, pp. 133 et seq.) contrasted the inferiority of Italian art, "which has confined itself almost exclusively to making things which are lifeless, motionless, and good to look upon from without," with the superiority of German art, which has from the beginning devoted itself to making works which move (watches, clocks, hydraulic machines, etc.), this great man, who shone in everything except aesthetics, had a presentiment of a truth, but unfortunately confused the *motus ab intrinseco* of a clock with that of a living being.

22. *Summa theol.,* I-II, 57, 4.

23. Aristotle, *Eth. Nic.,* VI. Cf. Cajetan, *In* I-II, 58, 5.

24. Cf. *Summa theol.,* I-II, 57, 1; 21, 2, ad 2.

25. *Eth. Nic.,* VI, 5.

26. "A poor master," wrote Leonardo da Vinci, "he whose work surpasses his judgment: he alone advances towards the perfection of art whose judgment surpasses his work." (*Textes choisis,* published by Péladan, Paris, 1907, § 403.)

27. "The means to the end in human matters are not fixed but are greatly diversified according to the diversity of persons and affairs." *Summa theol.,* II-II, 47, 15.

28. It goes without saying that with regard to the precepts of the moral law, all cases are identical *in this sense* that these precepts must always be obeyed. But, granted this, moral cases still differ individually as to the *modalities* of the conduct to be observed in conformity with the said precepts.

29. Saint Thomas, *In Poster. Analyt.*, lib. I, lect. 1, no. 1.

30. John of Saint Thomas, *Cursus theol.*, q. 62, disp. 16, a. 4.

31. "Intellectus practicus in ordine ad voluntatem rectam." *Summa theol.*, I-II, 56, 3.

32. Cf. Chapter VI, "The Rules of Art," pp. 46–47.

33. John of Saint Thomas, *loc. cit.*

34. In this sense a poet has been able to say: "Art is science made flesh" (Jean Cocteau, "Le Secret Professionel," in *Le Rappel à l'Ordre*, Paris, Stock, 1930); and a painter: "Art is but science humanized" (Gino Severini, *Du Cubisme au classicisme*, Paris, Povolozky, 1921). They thus rejoin the ancient notion of *scientia practica*.

35. *Summa theol.*, I-II, 57, 4, ad 2.

36. Cf. Aristotle, *Metaph.*, I, 1; Saint Thomas, lect. 1, §§ 20–22; Saint Thomas, *Summa theol.*, II-II, 47, 3, ad 3; 49, 1, ad 1; Cajetan, *In* I-II, 57, 4; *In* II-II, 47, 2.

37. "Now it is most fitting that he who associates with others should conform to their manner of living. . . . And therefore it was most fitting that Christ should conform to others in the matter of eating and drinking." *Summa theol.*, III, 40, 2.

38. *Summa contra Gent.*, I, 93.

39. And even, it may be said in a sense, of His divine humility: "There is here something else inflaming the soul to the love of God, namely the divine humility. . . . For Almighty God subjects Himself to each single Angel and every holy soul exactly as if He were the purchased slave of each, and any one of them were his own God. To make this known, going about He ministers to them, saying in Psalm LXXXI: *I have said, You are*

gods. . . . Now such humility derives from the multitude of His goodness and divine nobility, as a tree is bowed down by the multitude of its fruits. . . ." Opusc. *De Beatitudine,* ascribed to Saint Thomas, cap. II.

40. To tell the truth the division of the arts into the arts of the beautiful (the fine arts) and the useful arts, however important it may be in other respects, is not what the logicians call an "essential" division; it is taken from the end pursued, and the same art can very well pursue utility and beauty at one and the same time. Such is, above all, the case with architecture.

41. *Summa theol.,* I-II, 57, 3, ad 3.

42. John of Saint Thomas, *Curs. theol.,* q. 62, disp. 16, a. 4.

43. It is interesting to note that at the time of Leonardo da Vinci one no longer understood the reason for this classification nor for the rank thus assigned to painting. Leonardo never speaks of it without the liveliest indignation. "Painting has every right to complain at not being counted among the liberal arts, for she is a true daughter of Nature and works through the eye, the noblest of our senses." (*Textes choisis,* Paris, 1907, § 355.) Leonardo keeps returning to this question, treating its *per accidens* with a remarkably sophistic zeal and bitterly attacking the poets, insisting that their art is far inferior to that of painters, because poetry represents with words and for the ear, whereas painting represents for the eye and "by true likenesses." "Take a poet who describes the beauty of a lady to her lover and a painter who paints a picture of her, and you will see to which nature will turn the young lover." (*Ibid.,* § 368.) "Sculpture," on the contrary, "is not a science but a most mechanical art, for it brings sweat and bodily fatigue to him who works at it. . . ." "This is proved to be true, for the sculptor in producing his work does so by the force of his arm, striking the marble or other stone to remove the covering beyond the figure enclosed within it. This is a most mechanical exercise accompanied many times with a great deal of sweat, which combines with dust and turns into mud. The sculptor's face is covered with paste and all powdered with marble dust, so that he looks like a baker, and

he is covered with minute chips, so that he looks as though he had been out in the snow. His house is dirty and filled with chips and dust of stones. In speaking of excellent painters and sculptors we may say that just the opposite happens to the painter, since the well-dressed painter sits at great ease in front of his work, and moves a very light brush, which bears attractive colors, and he is adorned with such garments as he pleases. His dwelling is full of fine paintings and is clean and often filled with music, or the sound of different beautiful works being read, which are often heard with great pleasure, unmixed with the pounding of hammers or other noises." (*Ibid.*, § 379; A. Philip McMahon's translation in *Treatise on Painting,* by Leonardo da Vinci, Princeton University Press, 1956, pp. 35–37.)

In Leonardo's day, then, the "artist" marked himself off from the artisan and began to look down on him. But whereas the painter was already an "artist," the sculptor had remained an artisan—although he, too, was rapidly to attain the dignity of "artist." Colbert, in establishing finally the Royal Academy of Painting and Sculpture, was to record and consecrate officially the results of this evolution.

The word "artist," let us observe in passing, has had a most chequered career. An *artiste* or an *artien* was at first a *maître ès arts* (the *arts* comprising the liberal arts and philosophy):

"Lorsque Pantagreul et Panurge arriverent à la salle, tous ces grimaulx, artiens et intrans commencerent frapper des mains comme est leur badaude coustume." (Rabelais, *Pantagruel,* II, c. 18.)

> "Vrayement je le nye
> Que legistes ou decretistes
> Soyent plus saiges que les artistes."

("Farce de Guillerme," in *Ancien Théâtre François,* Paris, P. Jannet, 1854, Tome I, p. 329.)

Those whom today we call *artists* were then called *artisans:*

> "Les artizans bien subtilz
> Animent de leurs outilz
> L'airein, le marbre, le cuyvre."

(J. du Bellay, "Les deux Marguerites,"
in *Poésies Françaises et Latines
de Joachim du Bellay,* Paris,
Garnier Frères, 1918, Tome II,
pp. 44–45.)

"Peintre ou autre artisan."

(Montaigne, *Essais, II,* Bordeaux, 1909, p. 403.)

The word "artist" later becomes itself synonomous with artisan: "Artisan ou Artiste, artifex, opifex," Nicot has in his Dictionary. "Which all good workmen and artists in this art [of distillation] keep in mind." (Ambroise Paré, Bk. XXVI, 4, in *Oeuvres complètes . . . ,* Paris, J.-B. Baillière, 1840–41, vol. 3, p. 618.) He in particular is called "artist" who works in the great art (i.e., alchemy), or even in magic; in the edition of 1694, the Dictionary of the French Academy mentions that this word "is said particularly of those who engage in magical operations."

It is only in the 1762 edition that the word "artist" appears in the Academy Dictionary with its contemporary meaning as distinct from the word "artisan"; the breach between the fine arts and the crafts was then completed in language itself.

This breach was a consequence of the changes which had taken place in the structure of society, and in particular of the rise of the *bourgeoisie.*

44. The artisan is bound by what the French call *la commande,* the fact of his being commissioned to do a certain task; and it is by turning to account—in order to carry out this task—the conditions, limitations and obstacles imposed by it that he best manifests the excellence of his art. The modern artist, on the contrary, seems to regard the limiting conditions imposed by *la commande* as a sacrilegious attempt on his *freedom* as a maker in beauty. This incapacity to meet the fixed requirements of a work-to-be-made denotes in reality, in the artist, a weakness of Art itself considered according to what formally constitutes it; but it also appears as a price to be paid for the despotic and transcendent requirements of the Beauty which the artist has conceived in his heart. It is thus a remarkable sign of the kind

of conflict I mention later (pp. 33 and 44) between the formal perspective of Art and the formal perspective of Beauty in the fine arts. The artist needs a quite extraordinary strength to achieve perfect harmony between these two formal lines, one of which relates to the material world and the other to the metaphysical or spiritual world. From this point of view it seems that modern art, since its breach with the crafts, tends in its own way to assert the same claim to absolute independence, to *aseity,* as modern philosophy.

45. "This holy man," Cassian relates of Saint Anthony, "said of prayer these superhuman and celestial words: *there is no perfect prayer if the religious perceives that he is praying.*" Cassian, *Collationes,* IX, cap. 31 (Migne, 49, col. 807).

46. In Greece, in the heyday of classical art, it was reason alone which kept art in temperance and admirable harmony. By comparing the conditions of art in Athens and the conditions of art in the twelfth and thirteenth centuries, one can gain some idea of the difference between "natural" temperance and "infused" temperance.

47. *Summa theol.,* I, 5, 4, ad 1. Saint Thomas, it must be added, means to give here only a definition *per effectum.* It is when he assigns the three elements of the beautiful that he gives an *essential* definition of it.

48. "It is of the nature of the beautiful that by the sight or knowledge of it the appetite is allayed." *Summa theol.,* I-II, 27, 1, ad 3.

49. *Ibid.*

50. *Summa theol.,* I, 39, 8. "For beauty includes three conditions: *integrity* or *perfection,* since those things which are impaired are by that very fact ugly; due *proportion* or *harmony;* and lastly, *brightness* or *clarity,* whence things are called beautiful which have a bright color." (English translation from *Basic Writings of St. Thomas Aquinas,* edited by Anton C. Pegis. New York: Random House, 1945.)

51. Saint Thomas, *Comment. in lib. de Divin. Nomin.,* lect. 6.

52. Saint Thomas, *Comment. in Psalm.*, Ps. XXV, 5.

53. *De vera Religione*, cap. 41.

54. *Opusc. de Pulchro et Bono*, attributed to Albert the Great and sometimes to Saint Thomas. Plotinus (*Enneads,* I, 6), speaking of beauty in bodies, describes it as "something which affects one sensibly from the first impression, which the soul perceives with agreement, recognizes and welcomes, and to which it in some way accommodates itself." He goes on to say that "every thing without form and made to receive a form (μορφῆ) and an intelligible imprint (εἶδος) is ugly and outside the divine reason, so long as it does not share in such an imprint and spiritual quality (ἄμοιρον ὂν λόγου καὶ εἴδους)." And let us also retain, from this very important chapter on beauty, the remark that "the beauty of color is a simple quality which comes to it from a form dominating the obscure in matter, and from the presence of an incorporeal light which is reason and idea (λόγου καὶ εἴδους ὄντος)."

55. *Sight and hearing* SERVING REASON. (*Summa theol.*, I-II, 27, 1, ad 3).—Moreover sense itself delights in things suitably proportioned only because it is itself measure and proportion, and so finds in them a likeness of its nature: "Sense delights in things duly proportioned, as in what are like it, for sense too is a kind of reason, as is every cognitive power." *Summa theol.*, I, 5, 4, ad 1. On the expression "a kind of reason"—*ratio quaedam* (ἡ δ᾽ αἴσθησις ὁ λόγος)—cf. *Comm. in de Anima*, lib. 3, lect. 2.

It is permissible to conjecture that in glorified bodies all the senses, intellectualized, may be of use in the perception of the beautiful. Already poets are teaching us to anticipate in a way this state. Baudelaire has annexed to aesthetics the sense of smell.

56. This question of the perception of the beautiful by the intellect using the senses as instruments would deserve a careful analysis which, in my opinion, has too rarely tempted the subtlety of philosophers. Kant gave it his attention in the *Critique of Judgment.* Unfortunately the direct, interesting, and sometimes profound observations much more frequently met with in this *Critique* than in the other two are vitiated by his mania for system

and symmetry, and above all by the fundamental errors and the subjectivism of his theory of knowledge.

One definition he gives of the beautiful calls for an attentive examination. "The beautiful," says Kant, "is what gives pleasure universally *without a concept*." * Taken as such, this definition runs the risk of causing us to forget the essential relation which beauty has to the intellect. Thus it was that in Schopenhauer and his disciples it blossomed into an anti-intellectualist divinization of Music. Nevertheless, it evokes in its way the much more exact expression of Saint Thomas, *id quod visum placet,* that which, *being seen,* pleases—that is to say, *being the object of an intuition.* By virtue of this last definition, the perception of the beautiful is not, as the Leibniz-Wolff school would have it, a confused *conception* of the perfection of the thing or of its conformity with an ideal type. (Cf. *Critique of Judgment,* "Analysis of the Beautiful," § XV.)

If, owing to the nature of the intellect, it is normal that the perception of the beautiful be accompanied by the presence or the outline of a concept, however confused, and that it suggest ideas,† nevertheless, this is not what formally constitutes it: the splendor or radiance of the form glittering in the beautiful object is not presented to the mind by a concept or an idea, but rather by the sensible object intuitively grasped—in which there is transmitted, as through an instrumental cause, this radiance of a form. Thus one may say—at least this seems to me the only possible way to interpret Saint Thomas' words—that in the perception of the beautiful the intellect is, *through the means of the sensible intuition itself,* placed in the presence of a radiant intelligibility (derived, like every intelligibility, in the last analysis from the

* It must be added that the "concept" for Kant is a form imposed on the sensible datum by the judgment, and constituting this datum either as an object of science or as an object of voluntary appetition.

† Cf. on this point some very remarkable pages by Baudelaire, in *L'Art Romantique* (Calmann-Lévy edition, pp. 213 et seq.). Apropos the *reveries* evoked in him by the Overture to *Lohengrin* which startlingly coincided with those which the same piece had evoked in Liszt, as with the program directions drawn up by Wagner of which the poet was ignorant, he points out that "true music suggests similar ideas to different minds."—Whether "true music" is an "expressive" and ideological music in Wagner's sense is quite another question.

first intelligibility of the divine Ideas), which insofar as it produces the joy of the beautiful cannot be disengaged or separated from its sense matrix and consequently does not procure an intellectual knowledge expressible in a concept. Contemplating the object in the intuition which sense has of it, the intellect enjoys a presence, the radiant presence of an intelligible which does not reveal itself to its eyes such as it is. If it turns away from sense to abstract and reason, it turns away from its joy and loses contact with this radiance.

To understand this, let us recall that it is intellect and sense as forming but one, or, if one may so speak, *intelligentiated sense,* which gives rise in the heart to aesthetic joy.

It is thereby clear that the intellect does not—execpt after the event and reflexively—think of abstracting from the sensible singular in the contemplation of which it is fixed the intelligible reasons of its joy. And it is also clear that the beautiful can be a marvellous *tonic* for the intellect, and yet does not develop its power of abstraction and reasoning; and that the perception of the beautiful is accompanied by that curious feeling of intellectual fullness through which we seem to be swollen with a superior knowledge of the object contemplated, and which nevertheless leaves us powerless to express it and to possess it by our ideas and make it the object of scientific analysis. Thus music gives us enjoyment of being, more so perhaps than the other arts; but it does not give us *knowledge* of being, and it is absurd to make it a substitute for metaphysics. Thus artistic contemplation affects the heart with a joy that is above all *intellectual,* and it must even be affirmed with Aristotle (*Poetics,* IX, 3, 1451 b 6) that "poetry" is something more philosophical and of greater import than history, because poetry is concerned more with the universal and history is concerned only with the singular"; and yet the apprehension of the universal or the intelligible takes place in poetry without discourse and without any effort of abstraction.*

* The capital error in Benedetto Croce's neo-Hegelian aesthetics (Croce, too, is a victim of modern subjectivism: "Beauty is not inherent in things. . . .") is the failure to perceive that artistic contemplation, however *intuitive* it may be, is none the less and above all *intellectual.* Aesthetics must be *intellectualist* and *intuitivist* at one and the same time.

This seizure of an intelligible reality immediately "sensible to the heart," without resorting to the concept as formal means, creates, on an entirely different plane and by an entirely different psychological process, a distant analogy between aesthetic emotion and the mystical graces. [I say "by an entirely different psychological process." In reality, mystical contemplation takes place by virtue of the connaturality of love; here, on the contrary, love and affective connaturality with regard to the beautiful thing are a *consequence* or a *proper effect* of the perception or aesthetic emotion—a proper effect, moreover, which normally reverberates back on this emotion itself to intensify it, to give it content, to enrich it in a thousand ways. In his interesting essay on *Poetic Experience* (London: Sheed and Ward, 1934), Father Thomas Gilby has not, in my opinion, sufficiently stressed this difference. Cf. later on, n. 138.]

I would add that if the very act of the perception of the beautiful takes place without discourse and without any effort of abstraction, conceptual discourse can nevertheless play an immense part in the *preparation* for this act. Indeed, like the virtue of art itself, taste, or the aptitude for perceiving beauty and pronouncing a judgment on it, presupposes an innate gift, but can be developed by education and instruction, especially by the study and rational explication of works of art. All other things being equal, the better informed the mind is of the rules, the methods and the difficulties of art, and above all of the end pursued by the artist and his intentions, the better it is *prepared* to receive into it, by means of the sense's intuition, the intelligible splendor emanating from the work, and thus to perceive spontaneously, to *relish,* its beauty. So it is that the artist's friends, who know what the artist sought to accomplish—as the Angels know the Ideas of the Creator—derive far greater enjoyment from his works than the public; so it is that the beauty of certain works is a hidden beauty, accessible only to a small number.

The eye and the ear are said to accustom themselves to new relations. It is rather the intellect which accepts them, as soon as it has realized to what end and to what kind of beauty they are ordered, and so prepares itself to enjoy better the work which involves them.

We therefore see the role concepts play in the perception of

the beautiful: a *dispositive* and *material* role. I have said that this perception is normally accompanied by the presence or the outline of a concept, however confused it may be. In the simplest case, the border-line case, it might be simply the very concept of "beautiful," for the intellect, being capable of a return on itself because of its spirituality, knows (at least confusedly and *in lived act*) that it is experiencing delight when it is. In fact there is often a whole host of conceptual outlines which the mind is stimulated to produce by the fact of its being put into play, and which secretly accompany its intuitive delight. After the first shock when the tongue can find nothing to say, these will be able to spill out in exclamations: "What strength! Such solidity!" etc. Contrariwise at times a single word, a concept deposited in the mind ("You think he's a great painter? Taste is his strongest point") will be sufficient to spoil in advance and inhibit the delight one would have felt in the presence of a work. But, in all this, the role of the concepts does not go beyond the sphere of dispositive causality.

It may be further observed that Kant is right in considering *emotion* in the ordinary sense of the word ("the excitement of vital energies") as a *posterior* and *ensuing* fact in the perception of the beautiful. (*Ibid.*, § IX.) But for him the primary and essential fact is the "aesthetic judgment" (although on this point his texts seem to conflict at times); for us it is the intuitive delight of the intellect and (secondarily) of the senses: or, to put it in a less summary and more exact manner—for delight is essentially an act of the appetitive faculty (*it is of the nature of the beautiful that by the sight or knowledge of it the appetite is allayed*)— it is the quieting of our faculty of Desire which finds repose in the proper good of the cognitive faculty perfectly and harmoniously released by the intuition of the beautiful. (Cf. *Summa theol.*, I-II, 11, 1, ad 2. *The end and perfection of every other faculty is contained under the object of the appetitive faculty, as the proper is enveloped in the common.*) The beautiful goes straight to the heart, it is a ray of intelligibility which reaches it directly and sometimes brings tears to the eyes. And doubtless this delight is an "emotion," a "feeling" (*gaudium* in the "intellective appetite" or will, joy properly so called, in which "we communicate with the angels," *ibid.*, 31, 4, ad 3). However it is

a question here of an altogether special feeling, one *which depends simply on knowledge* and on the happy fullness which a sensible intuition procures for the intellect. It is a superior emotion, whose essential nucleus is spiritual in nature, although in actual fact, like every emotion in us, it sets in motion the whole domain of affectivity. Emotion in the ordinary sense of the word, biological emotion, the development of passions and feelings other than this intellectual joy, is but an effect—an absolutely normal effect—of this joy; it is posterior, if not in time, at least in the nature of things, to the perception of the beautiful, and it remains extrinsic to what formally constitutes the latter.

It is interesting to observe that the subjectivist "venom" * which has infected metaphysics in the wake of the Kantian revolution has almost inevitably compelled philosophers to seek the essence of aesthetic perception—in spite of Kant himself—in emotion (in the ordinary sense of the word). One expression of this subjectivism is Lipps' and Volkelt's ingenious but arbitrary theory of *Einfühlung,* which reduces the perception of the beautiful to a projection or infusion of our emotions and feelings into the object. (Cf. M. de Wulf, "L'Oeuvre d'art et la beauté," *Annales de l'Institut de philosophie de Louvain,* vol. IV, 1920, pp. 421 et seq.)

57. "Beauty is a certain kind of good." Cajetan, *In* I-II, 27, 1.—So it was that the Greeks used the same word καλοκἀγαθία to express both notions.

The beautiful, we have seen, directly relates to the faculty of knowing. For by definition it must procure a certain intuitive delight of the intellect (and, in our case, of the senses). But if the happy release of a faculty, of the intellect for instance, brings about the metaphysical well-being and, as it were, blossoming of this faculty, thus satisfying the *natural appetite* which is one with its essence, nevertheless this bloom of the act is properly *pleasure, joy* or *delight,* only because it is immediately seized by the subject's appetitive faculty itself, the *appetitus elicitus,* which finds therein its goal and its repose.† For, according to the text of Saint Thomas recalled in the preceding note, "the end and per-

* Cf. G. Mattiussi, "Il Veleno kantiano," in *Scuola Cattolica,* II, 1902.
† The angels delight in the beautiful because they possess intellect

fection of every other faculty is contained under the object of
the appetitive faculty, as the proper is enveloped in the com-
mon" (*Summa theol.,* I-II, 11, 1, ad 2). The beautiful therefore
is in an essential and necessary, albeit indirect, relation to the
appetite. For this reason it is "a kind of good" and must be con-
sidered, as I say in the text, as "essentially delightful." It is the
nature of beauty to gratify desire in the intellect, the faculty of
enjoyment in the faculty of knowing.

The texts of Saint Thomas on this point of doctrine need to
be carefully construed. He first wrote in the *Commentary on the
Sentences:* "Beauty has not the nature of the desirable except so
far as it assumes the nature of the good; and in this way also the
true is desirable. But of its own nature it has radiance." (*In I
Sent.,* d. 31, q. 2, a. 1, ad 4.) And then in the *De Veritate:* "If
appetite terminates in good and peace and the beautiful, this does
not mean that it terminates in different goals. By the very fact
of tending to good a thing at the same time tends to the beau-
tiful and to peace. It tends to the beautiful inasmuch as it is
proportioned and specified in itself. These notes are included in
the essential character of good, but good adds a relationship of
what is perfective in regard to other things. Whoever tends to
good, then, by that very fact tends to the beautiful. Peace, more-
over, implies the removal of disturbances or obstacles to the
obtaining of good. By the very fact that something is desired, the
removal of obstacles to it is also desired. Consequently, at the
same time and by the same appetitive tendency good, the beauti-
ful, and peace are sought." (*De Ver.,* 22, 1, ad 12; Robert W.
Schmidt's translation in: St. Thomas Aquinas, *Truth,* Chicago,

and will. A being which, against all possibility, would possess intel-
lect only, would have the perception of the beautiful *in its roots* and
in its objective conditions, but not in the delight through which alone
it succeeds in constituting itself. To give delight in knowing is not
simply a property of beauty, as Gredt teaches (*Elem. Arist.-Thom.,*
I, c. 2, § 5), but a formal constituent of it. (It is the fact of stirring
desire and awakening love which is a *propria passio* of the beautiful.)
My position differs therefore from that of Gredt, but it differs much
more still from that of Father de Munnynck, who gives the *placet*
of *"quod visum placet"* a wholly empirical and sensualist interpreta-
tion. (Cf. later, n. 66.)

Henry Regnery Company, 1954, Vol. III, p. 40. Saint Thomas is commenting here on Denis the Areopagite's axiom in Chapter IV of the *De Divinis Nominibus: pulchrum omnia appetunt,* all things seek the beautiful.)

Here finally are two texts of capital importance from the *Summa Theologiae:* "Beauty and goodness in a thing are identical fundamentally, for they are based upon the same thing, namely, the form; and this is why goodness is praised as beauty. But they differ logically, for goodness properly relates to appetite (goodness being what all things desire), and therefore it has the aspect of an end (the appetite being a kind of movement towards a thing). On the other hand, beauty relates to a cognitive power, for those things are said to be beautiful which please when seen. Hence beauty consists in due proportion, for the senses delight in things duly proportioned, as in what is like them—because the sense too is a sort of reason, as is every cognitive power. Now, since knowledge is by assimilation, and likeness relates to form, beauty properly belongs to the nature of a formal cause." (*Summa theol.,* I, 5, 4, ad 1; English translation from *Basic Writings of St. Thomas Aquinas,* edited by Anton C. Pegis. New York: Random House, 1945.)

"The beautiful is the same thing as the good, differing only logically. For since good is what all things seek, it is of the nature of the good that by it the appetite is allayed; but *it is of the nature of the beautiful that by the sight or knowledge of it the appetite is allayed.* . . . Thus it is evident that the beautiful adds to the good a relation to the cognitive faculty: so that that is called good which simply pleases the appetite; whereas *that is called beautiful whose mere apprehension gives pleasure."* (*Summa theol.,* I-II, 27, 1, ad 3.)

To reconcile these different texts, it must first be observed that there are two ways in which the beautiful can be related to the appetite: either as subsumed under the aspect of the good and as the object of an elicited desire (we love and desire a thing because it is beautiful); or as a special good delighting the appetitive faculty in the faculty of knowledge because it satisfies the latter's natural desire (we say that a thing is beautiful because the sight of it gives us pleasure). From the first standpoint

the beautiful coincides with the good only materially (*re seu subjecto*); from the second, on the contrary, it is of the very notion of the beautiful to be the special good in question.

It is from the first standpoint that the text from the *Sentences* must be considered: the beautiful is desirable only in so far as it assumes the aspect of the good (that is to say, generally speaking, of an object the possession of which appears to the subject as good and towards which he directs his desire). On these grounds the true also is desirable in the same way, and this desirability is of the very notion neither of the true nor of the beautiful, although it is an immediate property of the beautiful. But the fact remains that, from the second standpoint, to procure this special good which is delight in knowing is essential to the beautiful, implied in its very notion, and on these grounds there is no parallel between the beautiful and the true.

Likewise in the text from the *De Veritate* it is a question of the good as such, which, unlike the beautiful, is defined by the perfection it brings to the subject. The beautiful and the good coincide therefore materially, but differ in notion or idea (like the true and the good)—which does not prevent the beautiful, because it perfects the faculty of knowing as an object of delight, from including on these special grounds, in its very notion, a relation to appetite.

As for the two extremely important texts from the *Summa,* it clearly follows from the first one that if the beautiful differs—*ratione*—from the good in that it does not directly face the appetite, and belongs of itself to the sphere of formal causality, nevertheless it has in its definition to give pleasure when seen, and therefore necessarily implies a relation to appetite. The second text teaches as precisely as could be desired that this relation to the appetite, on the special grounds of its being an object whose mere apprehension gives pleasure, is of the very notion of the beautiful. So that beauty, while directly facing the faculty of knowing, by its very essence indirectly concerns the appetitive faculty, as was said above. *It is of the nature of the beautiful that by the sight or knowledge of it the appetite is allayed.*

58. Denis the Areopagite, *De Div. Nomin.,* cap. 4; Saint Thomas, lect. 9. Let us, by virtue of time-honored actual usage,

continue to call "the Areopagite" the man whom modern authorities call *the pseudo-Denis*.

59. "Her have I loved, and have sought her out from my youth, and have desired to take her for my spouse, and I became *a lover of her beauty*." Wisdom, VIII, 2.

60. *De Divin. Nomin.*, cap. 4; Saint Thomas, lect. 10.

61. Let us note that the conditions of the beautiful are much more strictly determined in nature than in art, the end of natural beings and the formal radiance which can shine in them being themselves much more strictly determined than those of works of art. In nature, for instance, there is assuredly a perfect type (whether we recognize it or not) of the proportions of the male or female body, because the natural end of the human organism is something fixed and invariably determined. But the beauty of a work of art *not being the beauty of the object represented*, painting and sculpture are in no way bound to the determined proportions and to the imitation of such a type. The art of pagan antiquity thought itself so bound because of an extrinsic condition, because it represented above all the gods of an anthropomorphic religion.

62. "Τὸν θεοειδῆ νοῦν ἐπιλάμποντα." Plotinus, *Enneads*, I, 6.

63. Cf. Lamennais, *De l'Art et du Beau* (Paris: Garnier, 1864), Ch. I.

64. "Beauty, health and the like are in a way said with respect to something else: because a certain mixture of humors produces health in a boy, but not in an old man; and what is health for a lion may mean death for a man. Health, therefore, is a proportion of humors in relation to a particular nature. In like manner beauty [of the body] consists in the proportion of its parts and colors; and so the beauty of one differs from the beauty of another." Saint Thomas, *Comment. in Psalm.*, Ps. XLIV, 2.

65. Saint Thomas, *Comment. in lib. de Divin. Nomin.*, cap. 4, lect. 5.

In an article entitled "Variations du Beau," published in the *Revue des Deux Mondes*, July 15, 1857 (*Oeuvres littéraires*, I,

Études esthétiques, Paris, Crès, 1923, pp. 37 et seq.), Eugène
Delacroix formulated from his painter's point of view some very
just observations. Philosophizing on the question with more
acumen than many professional philosophers, he had realized
that the multiplicity of the forms of the beautiful in no way im-
pairs its objectivity: "I have not said and nobody would dare to
say that it can vary in its essence, for then it would no longer
be the beautiful but mere caprice or fancy. But its character can
change; a countenance of beauty which once charmed a far-off
civilization does not astonish or please us as much as one which
is more in accord with our feelings or, if you like, our prejudices.
Nunquam in eodem statu permanet, said ancient Job of man."
Here we have, in different terms, an affirmation of the funda-
mentally *analogical* character of the idea of beauty (cf. "Projet
d'article sur le beau," *ibid.,* pp. 141 et seq.).

"We must see the beautiful where the artist has chosen to put
it," said Delacroix again ("Questions sur le Beau," *Rev. des
Deux Mondes,* July 15, 1854; *ibid.,* p. 52); and already in his
Journal (end of 1823 and beginning of 1824): "A Greek and
an Englishman are each beautiful in his own way, which has
nothing in common with the other" (*Journal,* Plon, 1893, vol. I,
p. 47).

66. In an essay published in 1923 ("L'Esthétique de saint
Thomas" in *S. Tommaso d'Aquino,* Publ. della Fac. di Filos.
dell'Univ. del Sacro Cuore, Milan, Vita et Pensiero), Father de
Munnynck endeavored to cast doubt on this point. To do so is
to conceive the *quod visum placet* and the Scholastic teaching on
the beautiful in a wholly material manner (cf. Father Wébert's
review, *Bulletin thomiste,* II Année, no. 1, Jan. 1925). The
classic table of transcendentals (*ens, res, unum, aliquid, verum,
bonum*) does not exhaust all the transcendental values, and if
the beautiful is not included, it is because it can be reduced to
one of them (to the good—for the beautiful is that which in
things faces the mind as an object of intuitive delight). Saint
Thomas constantly affirms that the beautiful and the (meta·
physical) good are the same thing in reality and differ only in
notion or idea (*pulchrum et bonum sunt idem subjecto, sola
ratione different,* I, 5, 4, ad 1). It is so with all the transcenden-

tals: they are identified in the thing, and they differ in idea.
Wherefore, *whoever tends to good, by that very fact tends to the
beautiful* (*De Ver.,* 22, 1, ad 12). If it is true that *the beautiful
is the same thing as the good, differing only in idea* (I-II, 27, 1,
ad 3), why should the beautiful not be a transcendental as well
as the good? Strictly speaking, Beauty is the radiance of all the
transcendentals united. Wherever there is anything existing, there
is being, form and proportion; and wherever there is being, form
and proportion, there is some beauty. Beauty is in the things of
sense, and it is also—and *par excellence*—in spiritual things. The
bonum honestum—good as right, the quality of an act good for
the sake of good—has a spiritual beauty: "A thing is said to be
good in itself (*honestum*) according as it has some quality of
excellence worthy of honor because of its spiritual beauty"
(II-II, 145, 3). Beauty is to be found in the contemplative life
essentially and *per se:* "Beauty consists in a certain radiance and
due proportion. . . . In the contemplative life, which consists
in the activity of reason, beauty is found *per se* and essentially"
(*ibid.,* 180, 2, ad 3). Beauty is properly (*formally-eminently*)
attributed to God, like being, unity and goodness. "Because
(divine) Beauty is in so many ways the cause of all things,"
Saint Thomas teaches (*Comment. in De Divin. Nomin.,* cap. 4,
lect. 5), "it follows that the good and the beautiful are the same;
because all things desire the beautiful and the good, as cause, in
every way; and because there is nothing which does not par-
ticipate in the beautiful and the good, since everything whatso-
ever is beautiful and good according to its own form." Likewise,
beauty is to be ascribed, in a more appropriate manner, to the
Person of the Son (*Summa theol.,* I, 39, 8).

The property of causing joy, of "giving pleasure," implicit
in the notion of the beautiful, is itself—it must be remembered
—of the transcendental and analogical sphere, and cannot with-
out serious misunderstanding be reduced to pleasure of the
senses alone or the "bonum delectabile" considered as opposed
to the other kinds of good. (*Honesta etiam sunt delectabilia,*
Saint Thomas observes, *Summa theol.,* I, 5, 6, ad 2; and II-II,
145, 3: *Honestum est naturaliter homini delectabile. . . .
Omne utile et honestum, est aliqualiter delectabile, sed non con-
vertitur.* Moreover, does not virtue have for result to make dif-

ficult things pleasing? Is not God the *supreme analogate* of all
that dispenses joy? *Intra in gaudium Domini tui.*) It is because
the delight implied by the beautiful is thus of the transcendental
and analogical sphere, that the diversity of modes of this delight,
and of the forms of beauty, in no way prevents the objectivity of
beauty. Cf. note 65.

67. The analogates (*analoga analogata*) of an analogous con-
cept (*analogum analogans*) are the diverse things in which this
concept is realized and which it fits.

68. In God alone are all these perfections identified according
to their formal reason: in Him Truth is Beauty, is Goodness, is
Unity, and they are He. In the things of this world, on the other
hand, truth, beauty, goodness, etc., are aspects of being *distinct
according to their formal reason,* and what is *true simpliciter*
(absolutely speaking) may be *good* or *beautiful* only *secundum
quid* (in a certain relation), what is *beautiful simpliciter* may be
good or *true* only *secundum quid.* . . . Wherefore beauty, truth,
goodness (especially when it is no longer a question of meta-
physical or transcendental good itself, but of moral good) com-
mand distinct spheres of human activity, of which it would be
foolish to deny *a priori* the possible conflicts, on the pretext that
the transcendentals are indissolubly bound to one another—a
perfectly true metaphysical principle, but one that needs to be
correctly understood.

69. *De Divinis Nominibus,* cap. 4; Saint Thomas' *Commen-
tary,* lessons 5 and 6.

70. Saint Thomas, *ibid.,* lect. 5.

71. *Summa theol.,* I, 39, 8.

72. Saint Augustine, *De Doctr. Christ.,* I, 5.

73. Baudelaire, *L'Art romantique* (Paris: Calmann-Lévy,
1885), p. 167. Baudelaire reproduces here a passage from his
preface to *Nouvelles Histoires Extraordinaires,* and this passage
itself was inspired by and almost a translation of a passage in
Poe's *The Poetic Principle:* "We have still a thirst unquenchable.

. . . This thirst belongs to the immortality of Man. It is at once a consequence and an indication of his perennial existence. It is the desire of the moth for the star. It is no mere appreciation of the Beauty before us, but a wild effort to reach the Beauty above. Inspired by an ecstatic prescience of the glories beyond the grave, we struggle by multiform combinations among the things and thoughts of Time to attain a portion of that Loveliness whose very elements, perhaps, appertain to eternity alone. And thus when by Poetry, or when by Music, the most entrancing of the poetic moods, we find ourselves melted into tears, we weep then, not as the Abbate Gravina supposes, through excess of pleasure, but through a certain petulant, impatient sorrow at our inability to grasp *now*, wholly, here on earth, at once and forever, those divine and rapturous joys of which *through* the poem, or *through* the music, we attain to but brief and indeterminate glimpses.

"The struggle to apprehend the supernal Loveliness—this struggle, on the part of souls fittingly constituted—has given to the world all *that* which it (the world) has ever been enabled at once to understand and *to feel* as poetic." (*The Works of Edgar Allan Poe*, New York, Funk & Wagnalls Company, 1904, Vol. I, pp. 30–31.)

It is remarkable that from a different point of view a philosopher should also write: "In the appreciation of music and of pictures we get a momentary and fleeting glimpse of the nature of that reality to a full knowledge of which the movement of life is progressing. For that moment, and for so long as the glimpse persists, we realize in anticipation and almost, as it were, illicitly, the nature of the end. We are, if I may so put it, for the moment *there*, just as a traveller may obtain a fleeting glimpse of a distant country from an eminence passed on the way, and cease for a space from his journey to enjoy the view. And since we are for the moment *there*, we experience while the moment lasts that sense of liberation from the urge and drive of life, which has been noted as one of the special characteristics of aesthetic experience." (C. E. M. Joad, "A Realist Philosophy of Life," in *Contemporary British Philosophy: Personal Statements*, Second Series. Edited by J. H. Muirhead, New York, Macmillan, 1925, p. 188.)

74. Denis the Areopagite, *De Divin. Nomin.,* cap. 4 (Saint Thomas, lect. 4).

75. Opusc. *LXVIII, in libr. Boetii de Hebdom.,* in princ.

76. Prov., VIII, 31.

77. *Metaph.,* I, 2, 982 b.

78. Ruysbroeck ("Vie de Rusbrock," in *Rusbrock l'Admirable,* Oeuvres choisies, ed. E. Hello, Paris, Perrin et Cie, 1902, p. Lii.)

79. We may call Technique the ensemble of these rules, but on condition of extending and elevating considerably the ordinary meaning of the word "technique." For it is a question not only of material processes, but also, and above all, of the means and ways of operation of the intellectual sphere which the artist uses to attain the end of his art. These ways are determined, like paths traced out in advance through a tangled thicket. But they have to be discovered. And the most elevated of them, those most closely related to the individuality of the work spiritually conceived by the artist, are strictly adapted to the latter and are discernible to one individual only.

80. "It is clear," Baudelaire wrote, "that systems of rhetoric and prosodies are not forms of tyranny arbitrarily devised, but a collection of rules required by the very organization of the spiritual being: never have prosodies and systems of rhetoric prevented originality from manifesting itself distinctly. The opposite would be far more true, that they have been a help to the blossoming forth of originality."
And again: "It would be quite a new departure in the history of the arts for a critic to turn poet, a reversal of all psychological laws, a monstrosity; on the contrary, every great poet becomes naturally, inevitably, a critic. I am sorry for poets who are guided by instinct alone; I consider them incomplete. In the spiritual life of great poets a crisis infallibly arises, in which they want to reason out their art, to discover the obscure laws by virtue of which they have produced, and to derive from such a scrutiny a set of precepts whose divine aim is infallibility in poetic production. It would be a marvel for a critic to turn poet and it is im-

possible for a poet not to contain a critic within himself." (*L'Art romantique*. Paris: Calmann-Lévy, 1885, p. 13; p. 229.)

81. A remark of the painter David.

82. Cf. the very title which Descartes first thought of giving to the treatise to which the *Discourse on Method* is the preface: "*Project of a universal Science capable of raising our nature to its highest degree of perfection.* To which is added Refraction, Meteors and Geometry, in which the most curious matters the author could choose, in order to provide proof of the universal science which he is proposing, are treated *in such a way that even those who have not studied can understand them.*" Some years later—doubtless around 1641—Descartes worked on a dialogue in French which he left unfinished, and which has as a title: "The Quest for truth by the light of Nature, which, un-sullied and *without enlisting the aid of Religion or Philosophy,* determines the opinions an honest man should have *concerning all the things which can occupy his thought, and penetrates the innermost secrets of the most curious sciences.*"

83. "So that the mind may be dispensed from the labor of having to think things out clearly and yet nonetheless all things turn out rightly." Leibniz, *Die philosophischen Schriften von Gottfried Wilhelm Leibniz,* ed. Gerhardt, Berlin, 1875–90, VII.

84. *Summa theol.,* I-II, 51, 1.

85. As is known, the Royal Academy of Painting and Sculpture was ultimately established in 1633.

I would mention here A. Vaillant's *Théorie de l'Architecture* (Paris, 1919). On the subject of academicism, as on the generic notion of art, the author's thesis, which is based on a very sincere though somewhat narrow positivism, happily coincides with the thought of the Schoolmen. "It was during the reign of Louis XIV," writes M. Vaillant, "that the teaching of the Fine Arts began to assume the scholastic character which we now know. . . . It must be admitted that academic influence was very great, but as yet in no way harmful: the reason being that the empirical methods of the Masters of apprenticeship and their ancient customs remained in full vigor down to the suppression of the

guilds. As they declined, the results of the teaching diminished too: for doctrine, which is the soul of art, was naturally contained in the traditions, in the manner in which the artist received and assimilated *la commande* and responded to it . . .

"As long as apprenticeship was the means of formation of artists and artisans, no necessity for any general theory was felt. Architects, in particular, had a method, which resulted from the example of and intimate collaboration with the professional life of the master, as Étienne Boileau's *Livre des Métiers* shows so well. When teaching was substituted for the living and highly varied action of the master, a grave error was committed.

"The academic breach with the *daubers of painting* and the *marble-stained polishers of marble* procured no advantage for art or the artist; and it deprived the workman of healthy contact with the superior and the excellent. Academicians, too, ceased to be independent and lost along with technique the rational organization of art work."

One consequence of the divorce was the disappearance of the technique of color grinding. In the course of time artists lost the feeling for the chemical reactions which colors and coloring materials undergo due to mixing, the nature of the binding material and the manner of application. "Van Eyck's pictures, five centuries old, have still their original freshness. Can modern pictures," asks M. Vaillant, "hope for such a protracted youth?" "How leaden modern painting is becoming!" replies M. Jacques Blanche, speaking of Manet. "In a few years the most sparkling picture has already become powdery and is ruined. We admire ruins, ruins dating from yesterday. You do not know what *Le Linge* was like when it first appeared! I would be ready to accuse myself or to bewail the state of my eyes, if I had not been a witness, during these last five years, of the destruction of a masterpiece, Delacroix's *Trajan* in the Rouen Gallery. I saw it become tarnished and crack, and now it is nothing but brown paste . . ." (Jacques-Émile Blanche, *Propos de peintre, de David à Degas*, Paris, 1919).

Augustin Cochin, for his part, wrote: "The academic teaching inaugurated [or better, erected into a unique and universal law] by the Encyclopedists, from Diderot to Condorcet, killed popular art in a generation, a phenomenon which is perhaps unique in

history. Teaching in school instead of forming in the studio, having someone learn lessons instead of having him practise making —explaining instead of showing and correcting—it is this that constitutes the reform conceived by the philosophers and imposed by the Revolution. Isolated artists have survived, but like rocks battered by the sea of banality and ignorance, not like great trees in the forest." ("Les Sociétés de pensée," in the *Correspondant* of February 10, 1920.)

86. "After these came Giotto the Florentine, and he—reared in mountain solitudes inhabited only by goats and such like beasts—turning straight from nature to his art, began to draw on the rocks the movements of the goats which he was tending, and so began to draw the figures of all the animals which were to be found in the country, in such a way that after much study he not only surpassed the masters of his own time but all those of many preceding centuries." (Leonardo da Vinci, *Textes choisis,* Péladan, Paris, 1907; Edward MacCurdy's translation, in *The Notebooks of Leonardo da Vinci,* New York, Reynal & Hitchcock, 1938, Vol. II, p. 276.)

In contradistinction to the case of Giotto or Moussorgsky, the case of Mozart provides us with the classic example of how fruitful can be the union of natural gift (and what a gift!) and *education*—the earliest, most perfect and most intense rational cultivation of the *habitus.*

87. This point is well expressed by Goethe in these lines of his *Wilhelm Meister's Wanderjahre (Sämtliche Werke,* Bd. 18, Stuttgart, 1894):

> Zu erfinden, zu beschliessen
> Bleibe Künstler oft allein;
> Deines Wirkens zu geniessen
> Eile freudig zum Verein!

88. Man cannot do without a master. But in the state of anarchy which characterizes the contemporary world, the power of the master, being unavowed, has merely become less profitable to the pupil and tyrannical.

"As everyone today wants to be king, nobody knows how to govern himself," wrote Baudelaire. "Now that everyone is left to his own devices, a master today has many unknown pupils for whom he is not responsible, and his power, being secret and involuntary, extends far beyond his studio into regions where his thought cannot be understood." (*Curiosités esthétiques,* Salon de 1846, in *Oeuvres complètes,* Paris, Calmann-Lévy, Vol. II.)

89. Cf. *Summa theol.,* I, 117, 1; *ibid.,* ad 1 and ad 3.

90. Cf. note 67.

91. These rules, which it is the province of the various artistic disciplines to define, are immutable only when taken *formally* and *analogically*.

"In aesthetics there is never any fundamental innovation. The laws of beauty are eternal, the most violent innovators obey them unawares: they obey them in their own way and this is what makes it so interesting." Max Jacob, *Art poétique,* Paris, 1922.

92. It follows that the philosopher and the critic can indeed and ought indeed to judge the value of artistic schools, as also the truth or falsity, the good or bad influence of their principles, but that considerations of this sort are radically insufficient to judge the artist or the poet himself. The really important thing here is to discern whether one has to do with an *artist* or a *poet,* with a man who really possesses the virtue of art, a *practical* and *operative* virtue, not a speculative one. A philosopher whose system is false is of no real account, for in such a case he cannot *say the true,* except by accident; an artist whose system is false can be of account, and of great account, for, in spite of his system and in spite of the inferiority of the form of art to which he adheres, he can *create the beautiful.* From the point of view of the work made there is more artistic truth (and therefore more of the genuine "classical") in a romantic possessing the virtue of art than in a classicist without it. When we speak of an artist or a poet, let us always be careful not to miss the virtue which may be in him, not to offend something naturally sacred.

93. Cf. pp. 16–17.

94. *In* I-II, 57, 5, ad 3.

95. The *conception* of the work is something altogether different from the simple choice of subject: the subject is nothing more than the *matter* of this conception, and there are even, for the artist or the poet, certain advantages—as Goethe explains very well—to receiving this matter from others. It is also something altogether different from an abstract *idea,* an intellectual theme or a thesis that the artist would have in mind. Goethe was asked what idea he had sought to expound in *Tasso:* "What idea?" said he. "How can I say? I had Tasso's life, I had my own life. . . . But don't think that everything would be lost, if there were no idea, no abstract thought to be discovered behind a work. You ask me what idea I endeavored to embody in *Faust.* As if I knew, as if I myself could tell! *From Heaven, through earth, down to Hell,* there's an explanation, if you want one: but that is not the idea, that's the *development of the action. . . ."* (*Conversations with Eckermann,* May 6, 1827, in *Goethes Gespräche,* Bd. 3, Leipzig, 1910.)

Finally, the conception of the work is not the elaborated schema of the work or its plan of construction (which is already a realization—in the mind). It is a simple view, although virtually very rich in multiplicity, of the work-to-be-made grasped in its individual soul, a view which is, as it were, a spiritual germ or a *seminal reason* of the work, and which depends on what Bergson calls *intuition* and *dynamic schema,* which concerns not only the intellect, but also the imagination and sensibility of the artist, which answers a certain unique shade of emotion and sympathy, and which for this reason is inexpressible in concepts. What painters call their "vision" of things plays an essential role here.

This conception of the work, which depends on the whole spiritual and sensitive being of the artist and above all on the straightness of his appetite in regard to Beauty, and which bears on the *end* of the activity, may be said to be, in relation to Art, as the intention of the ends of the moral virtues is in relation to Prudence. It belongs to another order than the *means,* the *ways* of realization, which are the proper domain of the virtue of Art, just as the means of attaining the ends of the moral virtues are the proper domain of the virtue of Prudence. And it is, in each

particular case, the fixed point to which the artist orders the means which art puts in his possession.

M. Blanche tells us that "the means are *everything* in painting" (*Propos de peintre, de David à Degas,* p. 151). Let there be no misunderstanding. The means are the proper domain of the artistic *habitus*—in this sense the dictum can be accepted. But means exist only in relation to an end, and the means which "are everything" would be *nothing* themselves without the conception or the vision which they tend to realize and on which the whole activity of the artist hinges.

Clearly, the more exalted this conception, the more the means will run the risk of being deficient. Do we not have in Cézanne an eminent example of such a deficiency of the means in relation to the loftiness of the conception? If he is great, and if he exercises such a dominant influence on contemporary art, it is because he brought a conception or a vision of a superior quality —his *little sensation,* as he used to say—which his means were inadequate to express. Hence his complaints at his incapacity *to realize:* "Don't you see, Monsieur Vollard, the outline keeps escaping me!"—and his touching regret at "not being Bouguereau," who, at any rate, did *"realize"* and did manage to "develop his personality."

96. Ὁποῖός ποθ᾽ ἕκαστός ἐστι, τοιοῦτο καὶ τὸ τέλος φαίνεται αὐτῷ. Aristotle, *Eth. Nic.,* III, 7, 1114 a 32. Cf. Saint Thomas' *Commentary,* lect. 13; *Summa theol.,* I, 83, 1, ad 5.—When Saint Thomas teaches (*Summa theol.,* I-II, 58, 5, ad 2) that "the principles of artificial objects are not judged by us as good or bad *according to the disposition of our appetite,* as are *ends* which are the principles of moral matters, but solely by the consideration of reason," he is thinking, on the one hand, of the *moral* dispositions of the appetite (cf. Cajetan, *loc. cit.*), and, on the other hand, of art insofar as "things-to-be-made are to art not as principles but solely as matter" (*ibid.,* 65, 1, ad 4), which is not the case with the fine arts (ends indeed are principles in the practical order, and the work-to-be-made has in the fine arts the dignity of a true *end*).

97. Saint Augustine, *De Moribus Ecclesiae,* cap. 15. "Virtus est ordo amoris."

98. Quoted by Étienne Charles in *Renaissance de l'Art français et des industries de luxe,* No. 2, April, 1918.

99. Louise Clermont, *Émile Clermont, sa vie, son oeuvre,* Grasset, 1919.

100. Insofar as Apollonism reigns supreme in Greek art. But let us not forget (if we may still use these words which have become commonplaces since Nietzsche) that a Dionysiac art remained in the shadows, such as that to which Goethe seems to allude in the Second Part of *Faust* with the Phorkyads and the Cabiri who struggle in the Classical Walpurgis-Night.

101. "Omnium humanorum operum principium primum ratio est." Saint Thomas, *Summa theol.,* I-II, 58, 2.
I would note here the very remarkable testimony of Eugène Delacroix: "Art, then, is not what the vulgar think, that is to say, a kind of inspiration which comes from I know not where, and which proceeds at random and presents only the picturesque exterior of things. *It is reason itself embellished by genius, but pursuing a necessary course and kept in check by superior laws.* This brings me back to the difference between Mozart and Beethoven. 'Where Beethoven is obscure,' Chopin said to me, 'and seems to be lacking in unity, the cause is not a rather wild would-be originality, for which he is honored; it's that he turns his back on eternal principles—Mozart never!' "
It goes without saying that the pre-eminence of true inspiration, concerning which we can say with Aristotle that it would not be fitting for one moved by a superior principle to be counselled according to human reason, is not therefore denied. Reason is the first principle of all human works—reason alone when it is a question of human works within the measure of man, reason superelevated by an instinct of divine origin when it is a question of human works ruled according to a higher measure (of the natural order, in matters of art or thought; of the supernatural order in the case of prophesy or the gifts of the Holy Spirit. Cf. note 143). I would add that just as the devil apes God, so seeking the law of the work (and not merely certain more or less valuable materials) in dream and in the whole organic night below the level of reason apes genuine inspiration, which is above reason.

102. Baudelaire again writes: "The construction, the armature, so to speak, is the most important guarantee of the mysterious life of the works of the mind" ("Notes Nouvelles sur Edgar Poe," preface to *Nouvelles Histoires extraordinaires* in *Oeuvres complètes,* Vol. VI). "Everything that is beautiful and noble is the result of reason and calculation." (*L'Art Romantique.*) And again: "Music gives the idea of space. So do all the arts, more or less; for the arts are *number* and number is a translation of space." (*Mon coeur mis à nu,* in *Journaux intimes,* Paris, Crès, 1919.)

103. From this point of view there is much to be retained in the ideas of Le Corbusier and in the comparisons he has drawn between the art of the architect and that of the engineer ("A house is a machine to be lived in"). It would be a mistake, however, to think that everything must be reduced under pain of sin to what performs a useful function: this would be to fall into a kind of Jansenist aesthetic. If certain mechanical constructions (an automobile, steamship, railway coach, airplane, etc.) are beautiful once their type is definitely established, and all their parts strictly conceived according to their use in the whole, it is because the law of utility here masks and embodies a more profound law, the law of mathematical harmony, and more generally of logic. It is logic which gives the useful its aesthetic value, and logic goes beyond the useful. In nature there is a multitude of characteristics of an entirely ornamental kind and of no practical utility. The patterns of a butterfly's wing *are of no use,* but everything in them is *logically necessary* (in relation to a certain idea gratuitously chosen).

Delacroix observed that in the great architect there is "an absolutely essential harmony of great good sense and great inspiration. The details of utility which constitute the starting-point of architecture, details which are of the essence, take precedence over all the adornments. The architect, nevertheless, is an artist only in so far as he *suitably* adorns this *useful* which is his theme. I say *suitably,* for even after establishing in all particulars the exact relation of his plan with the uses to which the building will be put, he can adorn his plan only in a certain way. He is not free to be lavish or stingy with the adornments. They, too, must

be suited to the plan, just as the plan was made to suit the uses."
(*Journal*, June 14, 1850.) It is in this sense that Auguste Perret
likes to say that the best treatise on architecture was written by
Fénelon in the following passage from his *Discours à l'Académie:*
"No part of a building should be there simply as adornment; but,
aiming always at beautiful proportions, one must turn into adorn-
ment all the parts necessary to support a building." (Fénelon,
Oeuvres complètes, Paris, 1850, T. VI, p. 607.)

104. Cf. Maurice Denis, "Les Nouvelles Directions de l'Art
Chrétien" (*Nouvelles Théories,* Rouart et Watelin, 1922): "Every
lie is unbearable in the temple of truth."

105. *Rodin,* Entretiens réunis par Paul Gsell, Paris, Grasset,
1911.

106. "Le Symbolisme et l'Art religieux moderne" (*op. cit.*).

107. John of Saint Thomas, *Curs. theol.,* t. VI, q. 62, disp.
16, a. 4.

108. As is known, the Parthenon is not geometrically regular.
It obeys a much higher logic and regularity, the zenithal direc-
tion of its columns and the curvature of its horizontal lines and
surfaces correcting the apparent distortions of line and plan in
the visual perception, and perhaps assuring also greater stability
against the seismic oscillations of the Attic earth.

109. See p. 17.

110. John of Saint Thomas, *ibid.*

111. Architecture also provides remarkable examples of this
primacy accorded by the art of the Middle Ages to the *intellectual
and spiritual* structure of the work, at the expense of material
correctness—in regard to which the technical equipment and the
theoretical knowledge of our ancient builders remained very in-
adequate. In the architecture of the Middle Ages, "geometrical
correctness or anything approaching it is nowhere to be found;
there is never any rectilinear alignment, never any right-angled
crossing or symmetrical counterpart—irregularities and after-
thoughts everywhere. Moreover the centering of the vaults had

to be specially prepared for each bay, even in the best-constructed buildings of mediaeval art. The curves, especially in the arches of the vaulting, are no more accurate than the alignment and the division of the bays. Nor is their symmetry of equilibrium any more accurate. The keystones are not found in the middle of the arches or the vaulting—and sometimes the disproportions are considerable. . . . The right side of a building is, so to speak, never symmetrical with the left side. . . . Everything is approximate in this art which is, however, very deliberate, but careless of exactitude. Perhaps it is to this simplicity of construction that the sincerity and naturalness of this architecture owe their remaining so full of charm . . ." (A. Vaillant, *op. cit.,* pp. 119, 364). The same author points out that since in those days building plans could not be made on paper as nowadays, and since the only drawing-material at their disposal was rare and costly vellum, which they used sparingly and washed so as to use again, "the projected work was represented in its essential elements chiefly by means of a reduced model. One worried about details only at the moment when they were about to take shape, when one knew the scale exactly—and then by using familiar rules and elements. It was on the *job* that the solution of all the building problems was considered and discovered, and the difficulties overcome. The same still holds for workmen nowadays, with this difference that they are wanting in education and apprenticeship-training and so their experience is mere gross routine.

"When one thinks of the enormous quantity of paper required by us in order to plan and prepare the erection of our modern buildings, and of the calculations indispensable to the working out of our slightest projects, one is amazed at the depth of intellectual power, the range of memory, and the positive talent of the master builders and foremen of those times, who were able to build these grandiose and magnificent monuments, inventing daily and ceaselessly perfecting. The artistic power of the Middle Ages is extraordinary, in spite of a scanty and fumbling technical knowledge."

The clumsiness of the primitive painters is not solely due to the inadequacy of their material means. It is also due to what may be called in them a kind of *intellectualist realism.* "Their clumsi-

ness," writes Maurice Denis, "consists in painting objects according to their everyday knowledge of them, instead of painting them, as do the moderns, according to a preconceived idea of the picturesque or the aesthetic. The Primitive . . . prefers reality to the appearance of reality. Rather than resign himself to distortions of perspective which have no interest for his maiden eye, *he makes the image of things conform to the notion he has of them*" (*Théories*, Paris, Rouart et Watelin, 1912). Let us say that his eye is entirely dominated by a sort of *rational instinct*.

112. These *stultae quaestiones* are those which, if raised in a certain science or discipline, would go against the first conditions implied by this very science or discipline. (Cf. Saint Thomas, *Comment. in ep. ad Titum*, III, 9; apropos Saint Paul's exhortation: *"avoid foolish questions."*)

113. Too many theories have rendered the word "classical" irritating to our ears and terribly hackneyed. The fact remains that the definitions of words are free. The important thing is to distinguish the authentic from the sham—they sometimes bear the same label—and to realize all the liberty the first requires.

As is known, Gino Severini published a significant book in 1921 entitled *Du Cubisme au Classicisme* (Paris, Povolozky), in which he invites the protractor, the compass and number to provide the means of escaping from mere expediency and good taste. Science and technique, which belong to the still material means of art, are not, to be sure, *sufficient* conditions, and it would be a great mistake to expect everything from them. But they are the first *necessary* conditions of honest art, and Severini's book is a most valuable testimony on that score.

114. Jean Cocteau, *Le Coq et l'Arlequin*, 1918 (*Le Rappel à l'Ordre*, Paris, Stock, 1926).

115. *Republic*, Bk. X.

116. And yet there is a *poetic knowledge* which is very often of greater worth than geometry (cf. note 130). But it has nothing to do with imitation.

"We have too long accustomed ourselves to consider truth in art from the sole point of view of imitation. There is no paradox

in maintaining the contrary, that imitation that would fool the eye is synonomous with lying, and lying with the intention of deceiving. A painting conforms to its truth, to truth itself, when it says well what it must say and fulfills its decorative role." Maurice Denis, *loc. cit.*

"What a mistake it is to think that drawing means accuracy! Drawing means the will to create a form: the more powerful and reasoned the will, the more beautiful the drawing. And that's all there is to it: the merit of the best Primitives lies not in their simplicity, as people keep saying, but in their concern for the whole, which is all drawing is. The best Cubists are like them" (Max Jacob, *Art poétique,* Paris, 1922). I find an interesting equivalent of the Thomist definition of art, *recta ratio factibilium,* in the following formula by the same poet: "Art is the will to exteriorize oneself by selected means" (Preface to *Cornet à dés,* Paris, Delamain et Boutelleau, 1922). What he then goes on to call "situation," and rightly distinguishes from "art" or "style," depends on the spiritual quality of the work. "Once he has *situated* his work, the author can employ all the charms—language, rhythm, music and wit. When a singer has his voice well placed he can amuse himself with trills." Let me add that if a philosophical work is "situated," the author can employ without disadvantage the special charm to be found in the barbarism of technical terms.

117. *Poet.,* IV, 1448 b 5–14.

118. Or, more probably, by the desire to signify an object by means of an ideogram, with perhaps a magical intention; for these drawings, being necessarily in darkness, could not have been made to look at. In a general way—as appears in particular from the study of the vases recently discovered at Susa, and dating, doubtless, from about 3000 B.C.—the art of drawing would seem to have begun by being a writing, and by answering hieroglyphic, ideographic, or even heraldic concerns, entirely foreign to aesthetics, the concern for beauty being introduced only much later.

119. *Poet.,* I, 1447 a 28.

120. "[Cézanne] once asked me what the connoisseurs thought of Rosa Bonheur. I told him it was generally agreed that the *Laboureur Nivernais* was stunning.—'Yes,' replied Cézanne, *'it's a horribly accurate likeness.'* " (Ambroise Vollard, *Paul Cézanne,* Paris, Crès, 1919.)

121. In a number of articles in the review *Nord-Sud* (cf. in particular June-July 1917, October 1917, March 1918), Pierre Reverdy asserted in the clearest possible way the claims of a *purely creative* aesthetic, free from all concern with evocation or imitation—claims which constituted the deep interest of the Cubist movement, but which far exceed it, for they manifest to an impossible degree one of the extreme exigencies of art.

I think that my exposition has sufficiently shown that the evocation or imitation of things is in no way the *aim* of art, but that our art nevertheless cannot recompose its own world, its autonomous "poetic reality," except by first of all discerning, in that which is, the forms that it manifests, and by thus *resembling* things in a more profound and more mysterious manner than any direct evocation possibly can.

"The image," writes Reverdy, "is a pure creation of the mind; it cannot be born from a comparison, but from the bringing together of two realities more or less remote from one another. . . . An image is not strong because it is *brutal* or *fantastic*— but because the association of ideas is remote and exact. . . . An image is not created by comparing (always weakly) two disproportionate realities. On the contrary, a strong image, new for the mind, is created by bringing together without comparison two distant realities whose relationship has been grasped by *the mind alone.*"

These lines must be kept in mind, if modern poetry and poetry in general are to be understood. The image so conceived is the opposite of *metaphor,* which compares one known thing with another known thing in order the better to *express* the former by covering it with the latter. The image *discloses* one thing with the help of another—and, at the same stroke, their likeness; it makes the unknown known. In a more general way I have already observed elsewhere (*Petite Logique,* n° 20) that "the most

striking and least expected images of the poets originate, per-
haps, in the difficulties man experiences when he wants to express
to himself and really make himself *see* even the most ordinary
things by the help of the imagery of language, difficulties which
compel him to renew this imagery." (Cf. Jean Paulhan, *Jacob
Cow, le pirate, ou Si les mots sont des signes.* Paris: Du Sans
Pareil . . . , 1921.)

Words are signs at the same time as being sounding matter;
on this ground we use them in discourse in place of things, which
cannot be made to appear themselves in our midst (Aristotle, I
Elench., 1): that is why, in language's youth, words were filled
with such a terrible, magical and magnificent power. The power-
fully metaphysical instinct of primitive man might go astray in
practical applications; it still bore witness to the nature of the sign
and to that astounding power bestowed on man of being able to
name things. But words are not pure signs ("formal signs");
they are imperfect signs which quickly become loaded with sub-
jectivity, each one dragging after it the whole psychological stuff
of a race. In particular a prolonged social use tends of itself to
make them lose their spirituality and to debase their nature as
signs, so as to make them *things* of value in themselves, which set
off mental reactions without the intervention of any significa-
tion; and the less such intervention, the more these reactions.
Many instructive observations on this point are to be found in
Jean Paulhan's "Expérience du Proverbe" (in *Commerce; cahiers
trimestriels,* Paris, Cahier V, 1924).

Victor Hugo's error was to rely on the material dynamism of
the word-*thing.* I think on the contrary that it is the duty of the
poet, while using words as the matter of his work, to react against
this tendency of the sign to transform itself into a thing, and thus
to maintain or recover by force, in the sensitive flesh of the word,
the spirituality of language. Hence an invention, a creation of
new images, which may appear obscure but is nevertheless nec-
essitated by exactness. With a courage that is sometimes absurd,
modern poetry has undertaken to purge language. In spite of
contradictory appearances and aberrant phenomena such as, only
recently, Dadaism and "free" words, poetry is heading rather in
the direction of objectivity, seeking a form of expression which
will convey without lying, and in which the mind will force the

word, with its whole weight of matter, to exercise faithful signification in the closed world of the poem.

122. Lecturing, January 7, 1668, at the Royal Academy of Painting, on Poussin's *Eliezer and Rebecca,* Philippe de Champaigne expressed regret that the Master had not seen fit to depict "the camels mentioned in Holy Writ." Lebrun thereupon replied that "M. Poussin, in a constant endeavor to purify and disencumber the subject of his paintings and to portray attractively the main action he was dealing with, had rejected any bizarre object likely to debauch the eye of the beholder and amuse it with trifles" (in Henry Jouin, *Conférences de l'Académie royale de Peinture et de Sculpture,* Paris, A. Quantin, 1883, pp. 93–94). Alas! the facile descent to the commonplace and the noble catchword was to prove only too easy; and of Poussin himself, "that philosophical painter," Delacroix could say "he was perhaps so called because he gave to the idea a little more than painting requires." ("Variations du Beau," *Revue des Deux Mondes,* July 15, 1857; *Oeuvres littéraires,* I, "Études esthétiques." *) The fact remains that the precept in itself was sound.†

Cf. this page from Nietzsche on style: "How is *decadence in literature* characterised? By the fact that in it life no longer animates the whole. Words become predominant and leap right out of the sentence to which they belong, the sentences themselves trespass beyond their bounds, and obscure the sense of the whole

* See in the *Journal* (June 6, 1851) the suggestive parallel between Poussin and Lesueur, and the very just praise of the latter.

† It may moreover not have applied too well to the case Philippe de Champaigne had in mind, for in the narrative in Genesis the camels play a part which is not simply accessory or picturesque, but essential to the main action. "And when he had made the camels lie down without the town near a well of water in the evening, at the time when women are wont to come out to draw water, he said: O Lord the God of my master Abraham, meet me today, I beseech Thee, and show kindness to my master Abraham. Behold I stand nigh the spring of water, and the daughters of the inhabitants of this city will come out to draw water. Now, therefore, the maid to whom I shall say: Let down thy pitcher that I may drink: and she shall answer, Drink, and I will give thy camels drink also: let it be the same whom thou hast provided for thy servant Isaac: and by this I shall understand, that thou has shewn kindness to my master" (Genesis, XXIV, 11–14).

page, and the page in its turn gains in vigour at the cost of the whole,—the whole is no longer a whole. But this is the formula for every *decadent* style: there is always anarchy among the atoms, disaggregation of the will—in moral terms 'freedom of the individual,' extended into a political theory: 'equal rights for all.' Life, *equal* vitality, all the vitality and exuberance of life driven back into the smallest structure, and the remainder left almost lifeless. Everywhere paralysis, distress and numbness, or hostility and chaos: both striking one with ever-increasing force as one ascends higher in the forms of organisation. The whole no longer lives at all: it is composed, reckoned up, artificial, a fictitious thing."

"Victor Hugo and Richard Wagner," wrote Nietzsche again, "they both prove one and the same thing: that in declining civilisations, wherever the mob is allowed to decide, genuineness becomes superfluous, prejudicial, unfavourable. The actor, alone, can still kindle *great* enthusiasm. And thus it is his *golden age* which is now *dawning*—his and that of all those who are in any way related to him. With drums and fifes, Wagner marches at the head of all artists in declamation, in display and virtuosity. . . ." (Nietzsche, *The Case of Wagner,* translated by A. M. Ludovici, London, Allen and Unwin, 1911.)

"The works of Hugo," wrote Delacroix in 1844, "are like the rough copy of a man who has talent: he says everything that comes into his head" (Delacroix's *Journal,* September 22, 1844).

123. *Jeremias,* I, 6. It might be said that, without being knowledge (speculative), and precisely because it is not knowledge, unless it be operative knowledge of the thing-to-be-made, art furnishes us a substitute for direct intellectual knowledge of the singular, which is the privilege of the angelic mind. Art expresses the singular not in a mental word or concept, but in the material work it makes. And by the path of the senses it leads the creative mind of the artist to an obscure experimental perception—not expressible speculatively—of the individual realities, grasped as such, in the bosom of the universal itself. "For a child," Max Jacob once said, "an individual stands alone in a species; for a man, it enters into the species; for an artist, it emerges from it." Cf. note 130.

124. Saint Thomas, *Comment. in Psalm.*, Prolog.

125. The delight of the sense itself is required in art only *ministerialiter;* that is why the artist towers so high above this delight and disposes it so freely: nevertheless it is required.

126. It is by virtue of these laws that, according to Baudelaire's remark, "seen at too great a distance to analyse or even to understand its subject, a picture by Delacroix has already produced on the soul a rich impression of happiness or melancholy" (*Curiosités esthétiques,* Salon de 1855). Elsewhere (*ibid.,* Salon de 1846) Baudelaire wrote: "The good way to determine whether a picture is melodious is to consider it from far enough off so as to understand neither the subject nor the lines. If it is melodious, it already has a meaning, and it has already taken its place in the repertory of memories."

127. To tell the truth it is difficult to determine in what precisely this *imitation-copy* consists, the concept of which seems so clear to minds which move among the simplified schemata of the popular imagination.
Is it the imitation or the copy of *what* the thing in itself is, its intelligible type? But that is an object of conception, not of sensation, something which can be neither seen nor touched, and which art, consequently, cannot directly reproduce. Is it the imitation or the copy of the *sensations* produced in us by the thing? But these sensations reach the consciousness of each one of us only as refracted by an inner atmosphere of memories and emotions, and are, moreover, eternally changing, in a flux in which all things lose their form and continuously intermingle; so that, from the point of view of *pure sensation,* it must be said with the Futurists that "a galloping horse has not four hoofs but twenty, that our bodies run into the sofas on which we sit and the sofas run into us, that the motorbus rushes into the houses it passes, and that the houses in turn hurl themselves upon the motorbus and become one with it. . . ."
The reproduction or exact copy of nature thus appears as the object of an impossible pursuit—a concept which vanishes when an attempt is made to define it. In practice it resolves itself into the idea of a representation of things such as photography or

casting would give, or rather—for these mechanical processes themselves produce results that are "false" as far as our perception is concerned—into the idea of a representation of things *capable of inducing an illusion and deceiving our senses* (which is moreover no longer a copy pure and simple but presupposes, on the contrary, an artificial faking); in short, into the idea of that naturalist *trompe-l'oeil* which interests only the art of the Musée Grevin or Madame Tussaud's.

128. Cf. Louis Dimier, *Histoire de la peinture française au XIX^e siècle,* Paris, Delagrave, 1914.

129. Ambroise Vollard, *Paul Cézanne,* Paris, Crès, 1919. "From nature," that is to say, contemplating and deriving inspiration from nature. If it were meant that it is necessary to recreate Poussin *by painting according to nature, with nature as the constituent feature,* Cézanne's dictum would deserve all the criticism it has received. "It is not by sensation you become classical, but by the mind" (Gino Severini, *Du Cubisme au Classicisme*). Cf. G. Severini, "Cézanne et le Cézannisme," *L'Esprit Nouveau,* Nos. 11, 12 and 13, 1921; Émile Bernard, "La Méthode de Paul Cézanne," *Mercure de France,* March 1, 1920; "L'erreur de Cézanne," *ibid.,* May 1, 1926.

Then again, there is the very accurate definition offered by Maurice Denis many years ago: "Remember that before being some anecdote or other a painting is essentially a plane surface covered with colors assembled in a certain order" (*Art et Critique,* August 23, 1890).

"One must not paint from Nature," said for his part Edgar Degas, that most scrupulous observer of nature (quoted by J. E. Blanche, *Propos de peintre, de David à Degas*).

"In fact," observes Baudelaire, "all good and genuine draftsmen draw according to the picture inscribed in their minds, and not according to Nature. If the admirable sketches of Raphael, Watteau and a number of others are urged against this statement, I would answer that they are only notes—very detailed, it is true, but mere notes just the same. When a real artist comes to the definitive execution of his work, the model is rather a *hindrance* to him than a help. It even happens that men like Daumier and

M. Guys, long accustomed to exercising their memories and filling them with pictures, find their main faculty upset and well-nigh paralyzed when confronted with the model and the multiplicity of details which it involves.

"A duel then takes place between the will to see everything, to forget nothing, and the faculty of memory which has acquired the habit of quickly absorbing the general color, the silhouette and the arabesque of the outline. An artist with a perfect feeling for form, but accustomed to exercise chiefly his memory and imagination, then finds himself harassed, as it were, by a pack of details, all clamoring for impartiality with the fury of a mob passionately seeking absolute equality. Every right finds itself inevitably violated, all harmony ruined and sacrificed; trivialities assume gigantic proportions, pettinesses intrude. The further the artist goes towards an impartial treatment of detail, the more the anarchy increases. Whether he be short-sighted or long-sighted, all hierarchy and all subordination vanish" (*L'Art romantique*).

130. "The artist, on the contrary, *sees:* that is to say," Rodin felicitously explained, *"his eye grafted on his heart* reads deep into the bosom of Nature" (*Rodin,* Entretiens réunis par Paul Gsell, Paris, Grasset, 1911).

It is proper to insist here on the altogether particular knowledge by which the poet, the painter and the musician perceive in things forms and secrets that are hidden to others and which are expressible only in the work—a knowledge which may be called *poetic knowledge* and which falls under the heading of knowledge through connaturality, or, as one says today, existential knowledge. Some explanations on this point may be found in my book *Frontières de la Poésie et autres essais* (Paris: Louis Rouart et fils, 1935), particularly in the chapter entitled *La Clef des chants.* Cf. also Thomas Gilby, *Poetic Experience,* London, Sheed and Ward, 1934; Theodor Haecker, *La notion de vérité chez Soren Kierkegaard,* Courrier des îles, n° 4, Paris, Desclée de Brouwer, 1934.

See note 138.

131. Baudelaire, *Curiosités esthétiques* ("Le Musée Bonne-Nouvelle").

The considerations advanced in the text make it possible to

reconcile two series of apparently contradictory expressions current among artists.

Gauguin and Maurice Denis, each a thoughtful and highly conscientious artist—among how many others in modern painting!—will tell you, for example, that "what is most of all to be deplored" is "this notion that Art consists in *copying* something" (*Théories*); "to think that Art consists in *copying* or reproducing things exactly is to pervert the meaning of art" (*ibid.*). "Copy" is here understood in the proper sense of the word—in the sense of imitation taken materially and as aiming at deceiving the eye.

Ingres, on the contrary, or Rodin, each more impassioned and of less acute intelligence, will tell you that "you must simply *copy, copy* like a fool, slavishly *copy* what you find under your eyes" (E.-E. Amaury-Duval, *L'Atelier d'Ingres*, nouv. éd., Paris, Crès, 1925); "in everything obey Nature and never try to give her orders. My one ambition is to be slavishly faithful to her" (Paul Gsell, *Rodin*). The words "copy" and "slavishly" are here understood in a very improper sense: in reality it is not a question of slavishly imitating the object, but, what is entirely different, of manifesting with the utmost fidelity, at the cost of all the "distortions" that may be necessary, the *form* or ray of intelligibility whose brilliance is apprehended in the real. Ingres, as Maurice Denis judiciously points out (*Théories*), meant to copy the Beauty *which he perceived in Nature through frequenting the Greeks and Raphael;* * he "thought he would make us copy nature," says Amaury-Duval, "by making us copy it as he saw it," and he was the first, in Odilon Redon's phrase, "to turn out mon-

* It was therefore not only a "form" spontaneously apprehended in the real, but also an artificial "ideal" unconsciously impregnating his mind and vision, that Ingres sought to manifest. This explains why Baudelaire, judging an artist's intentions by his works, attributed to Ingres principles entirely different from those the painter professed: "I shall be understood by all who have compared the different ways the principal masters have of drawing, when I say that Ingres' drawing is the drawing of a man with a system. He thinks that Nature ought to be corrected and amended; that successful, pleasing trickery, perpetrated to delight the eye, is not only a right, but a duty. Hitherto it had been maintained that Nature ought to be interpreted, translated in its unity and with all its logic: but in the works of this master there is often deceit, guile, violence, sometimes cheating and trickery" (*Curiosités esthétiques*, "Exposition Universelle 1855").

sters." Rodin, for his part, was only attacking (and how justly!) those who pretended to "embellish" or "idealize" Nature by means of aesthetic recipes, to portray it "not as it is, but as it ought to be"; and he had to admit that he *emphasized, accentuated,* and *exaggerated* in order to reproduce not only "the exterior" but "the spirit as well, which, certainly, is also part of Nature"—the "spirit," another word to describe what is here called "form."

It must, however, be observed that the "distortions" produced by the painter or the sculptor are most often the quite spontaneous result of a personal "vision" rather than the effect of deliberate calculation. By a phenomenon which the psychologists would have no difficulty explaining, they simply and steadfastly believe themselves to be copying Nature, whereas they are expressing in matter a secret which she has communicated to their souls. "If I have changed anything in Nature," said Rodin, "I was unaware of doing so at the time. The feeling that influenced my vision showed me Nature just as I copied it. . . . If I had wanted to modify what I saw and embellish it, I would have produced nothing of any value." For this reason "it may be said that all of the innovators since Cimabue," possessed with the same anxiety to interpret more faithfully, have likewise "believed they were submitting themselves to Nature" (J. E. Blanche, *Propos de peintre, de David à Degas*).

Thus in order to imitate, the artist transforms, as Töpffer said —that amiable, garrulous forerunner whose *Menus propos* contains many judicious remarks on this subject; but ordinarily he is not aware that he is transforming. This somehow natural illusion, this disparity between what the artist does and what he thinks he does, may perhaps explain the peculiar divergence between the great art of the Greco-Roman classics, so filially free in regard to Nature, and their theories, sometimes so flatly naturalist (for instance Zeuxis' anecdote of the grapes). Not that such theories, it must be admitted, prevent this art, if it relaxes its effort ever so little, from being seriously threatened by naturalism. Indeed, from Greek idealism, which claims to *copy* an ideal exemplar of Nature, the transition is all too easily made— as the author of *Théories* has fortunately observed—to naturalism, which copies nature itself in its contingent materiality. Thus

painting that seeks to induce an illusion and deceive the eye *dates back to antiquity,* as Jacques Blanche says—yes, but to the decadent periods of ancient art.

If, in this respect, mediaeval art has been safeguarded by its sublime simplicity and humility, and also by the hieratic traditions which it inherited from the Byzantines, so that *as a rule* it maintains itself at the spiritual level which a later classical art, so to speak, attains only at its summits, Renaissance art, on the contrary, allowed itself to be seriously contaminated.

Is it not strange to hear an artist of the stature of Leonardo defend painting with truly humiliating arguments? "[A] painting, representing the father of a family, which was caressed not only by the little children when still in swaddling clothes, but likewise by the dog and the cat of the household, a marvellous thing and an extraordinary spectacle to behold." ". . . I have seen a picture that deceived a dog because of the likeness to its master; likewise I have seen dogs bark and try to bite painted dogs, and a monkey that did an infinite number of foolish things with another painted monkey. I have seen flying swallows light on painted iron bars before the windows of buildings." "A painter once made a picture which made everybody who saw it yawn and yawn repeatedly as long as they kept their eyes on the picture, which represented a man who was also yawning." (*Textes choisis,* Péladan, Paris, 1907, §§ 357, 362, 363; A. Philip McMahon's translation in *Treatise on Painting,* by Leonardo da Vinci, Princeton University Press, 1956, pp. 9, 20, 22.)

Thank Heaven Leonardo *lived* painting otherwise than he thought it, although with him "the Renaissance aesthetic, *expression by the subject,* becomes definitely established," * and although it is true to say of him with André Suarès: "He seems to live only to know: much less does he live to create. . . . As long

* Maurice Denis, *Théories.* We cannot insist too much on the importance of this principle—a very simple one, but often forgotten since the Renaissance, and which Maurice Denis has made one of his leitmotifs—that *expression in art proceeds from the work itself and the means employed, not from the subject represented.* The failure to appreciate this principle, to which the image-makers of old were so spontaneously faithful, and to which their works owed at once such boldness and such nobility, is one of the reasons for the chilly decrepitude into which modern religious art has sunk.

as he is studying and observing, he is the slave of Nature. Once he begins to invent, he is the slave of his ideas: theory stifles in him the ardent play of creation. Most of his figures, although born of fire, are lukewarm, and some of them as cold as ice." *
In any event, it is ideas such as those Leonardo delighted in which, later codified by the teaching of the Academies, compelled the modern artist to react and to become reflectively conscious of his creative liberty in regard to Nature ("Nature is only a dictionary," Delacroix liked to say)—at the expense sometimes of the simplicity of his vision, which calculation and analysis put in jeopardy, to the greatest detriment of art.

In this connection we cannot insist too much on the distinction indicated above (note 95) between the artist's "vision" or, again, his invention, his *conception* of the work,—and the *means* of execution or realization which he employs.

So far as the vision or conception is concerned, simplicity, spontaneity, candor unconscious of itself, is the most precious gift the artist can have, a unique gift, a gift *par excellence,* which Goethe considered to be "demoniac," so gratuitous and beyond analysis does it seem.

If this gift makes room for some system or calculation, for some bias of "style" such as Baudelaire alleged against Ingres, or such as can be observed in certain Cubists, then ingenuous "distortion" or, rather, *transformation* through spiritual fidelity to the *form* shining in things and to their profound life, makes room for artificial "distortion," for "distortion" in the pejorative sense of the term, that is to say, for violence or deceit, and art withers to this extent.

So far as the means, on the contrary, are concerned, it is reflection, consciousness, and artifice, which are required. Between the conception and the accomplished work there is a great gap— the proper domain of art and its means—filled by an interplay of deliberate combinations which make the realization "the result of a patiently conducted and conscious logic" (Paul Valéry) and of an ever-vigilant prudence. So it is that the Venetians artificially substitute for the magic of sunshine "the equivalent magic of color" (*Théories*), and that in our day the transformations which

* *Le Voyage du Condottiere. Vers Venise* (Paris: Emile-Paul Frères, 1924).

a Picasso makes objects undergo appear as fundamentally inten-
tional.

If the "distortions" due to the artist's *vision* or conception im-
pose themselves upon him—in the very degree in which his art
is truly living—with a pure and as it were instinctive spontaneity,
there can of course be others which depend on the *means* of art,
and these are deliberate and calculated.* Many instances are
to be found in the masters, and in the greatest of them all, in
Rembrandt, of such transformations, distortions, abbreviations
and redispositions, all deliberately effected. The works of the
Primitives are full of them, because they were more concerned
with *signifying* objects or actions than representing their appear-
ances. Goethe took the occasion of an engraving by Rubens to
give a profitable lesson to the worthy Eckermann (Eckermann,
Conversations with Goethe, April 18, 1827, in *Goethes Ge-
spräche,* Bd. 3, Leipzig, 1910). Goethe shows the engraving to
Eckermann, who proceeds to relate in detail all its beauties.

" 'All these things which we see represented,' Goethe asks, 'the
flock of sheep, the cart with hay, the horses, the returning la-
borers,—from which side are they lighted?'

" 'They are lighted from our side and cast their shadows to-
wards the interior of the picture. The returning laborers, particu-
larly, are in full light, and this produces an excellent effect.'

" 'But how has Rubens brought about this beautiful effect?'

" 'By making these clear figures stand out against a dark back-
ground.'

" 'But how is this dark background produced?'

" 'By the mass of shadow cast by the group of trees beside the
figures. But how,' continued I, with surprise, 'the figures cast their
shadows towards the interior of the picture, and the group of
trees, on the contrary, casts its shadow towards us! The light
comes from two opposite sides! That's certainly absolutely con-
trary to Nature!'

" 'That's just the point,' said Goethe with the trace of a smile.
'That's where Rubens shows himself to be great and proves that

* Perhaps the proper expression in this case, as Severini observes,
would be *construction* or *reconstruction* rather than *distortion:* in any
event what is here important is the spiritual infallibility of art and
not the loose approximation of taste and sensibility.

his free spirit is above Nature and deals with her as befits his exalted aim. The double light is certainly a violent device and you can always say that it is contrary to Nature: but if it is contrary to Nature, I would immediately add that it is higher than Nature. I say that it is a bold stroke of the master, who shows with genius that art is not entirely subject to the necessities imposed by Nature and that it has its own laws. . . . The artist stands in a twofold relation to Nature: he is at once her master and her slave. He is her slave in the sense that he must work with earthly means in order to be understood; he is her master in the sense that he subjects these earthly means to his high intentions and makes them serve these latter. The artist would speak to the world through a whole, but he does not find this whole in Nature: it is the fruit of his own spirit, or, if you will, his spirit is fecundated by the inspiration of a divine breath. If we cast but a careless glance on this picture, everything strikes us as so natural that we take it to be simply copied from Nature. But it is not so. Such a beautiful picture has never been seen in Nature, any more than a landscape by Poussin or Claude Lorrain, which appears very natural to us, but which we seek in vain in reality itself.' "

Cf. Conrad Fiedler, *Ueber die Beurtheilung von Werken der bildenen Kunst,* Leipzig, Hirzel, 1876. "The artist has no need of Nature; rather, Nature has need of the artist," wrote Fiedler, in a formula which anticipates a famous dictum of Oscar Wilde. There are to be found in this little work many judicious remarks on art and operative intellectuality, and in particular on the sense of existence, the typical *Weltbewusstsein* which is bound up with the development of the peculiar faculties of the artist and which is characterized by the meeting and, so to speak, coincidence of *intuition* and *necessity*. "So a man," Goethe said, "who has been born and educated to the so-called exact sciences, will at the height of his reason not easily understand that there could also be an exact sense image, without which, after all, no art is conceivable."

132. Cf. *Summa theol.,* I, 45, 8. The capacity of matter to obey the human artist, who makes it yield effects superior to any it could give under the action of physical agents, even fur-

nishes theologians (cf. Saint Thomas, *Compendium theologiae,* cap. 104; Garrigou-Lagrange, *De Revelatione,* I, p. 377) with the most profound analogy to the *obediential potency* which is in things and souls with regard to God, and which delivers them over, in the very depths of their being, to the invisible power of the first Agent, to be raised under His action to the supernatural order or to miraculous effects. "And I went down into the potter's house, and behold he was doing a work on the wheel. . . . Then the word of the Lord came to me, saying: Cannot I do with you, as this potter, O house of Israel, saith the Lord? Behold, as clay is in the hand of the potter, so are you in my hand, O house of Israel" (*Jeremias,* XVIII, 3, 5–6).

133. Cf. Saint Thomas, *In I Sent.,* d. 32, q. I, 3, 2.

134. The ancient maxim *ars imitatur naturam,* does not mean: "art imitates nature by *reproducing* it," but rather "art imitates nature by *proceeding or operating* like nature, *ars imitatur naturam* IN SUA OPERATIONE." Thus it is that Saint Thomas applies this maxim to Medicine, which is certainly not, however, an "imitative art" (*Summa theol.,* I, 117, 1).

Let us understand in this sense Claudel's observation: "Our works and the means we use do not differ from those of nature" (*Art poétique.* 8ᵉ éd. Paris: Mercure de France, 1913).

135. Paul Claudel, *La Messe là-bas* (Paris: N.R.F., 1919).— *Sicchè vostr'arte a Dio quasi è nepote,* said Dante.

136. Quoted by Albert André in his book *Renoir* (Paris: Crès, 1919).

137. The judgment of *taste* is something altogether different from the judgment of *art:* it is of the speculative order. Taste relates to the power of perception and delight of the one who sees or hears the work; it does not by itself concern the operative intellect, and however useful the knowledge and frequentation of the things of art and of working reason * may be to its develop-

* It is from the point of view of the necessity for such information that Dürer's observation possesses an acceptable meaning: "The art of painting cannot really be judged except by those who are themselves good painters; but it is verily hidden to others, just as a foreign language is to you." Understood *simpliciter,* this remark is true of the

ment, it does not of itself imply the least shadow of the artistic *habitus* itself; it pertains to the powers of contemplation; and this is why the Greeks (the whole error of Platonism is, in my opinion, involved here) thought that it is better and nobler to be capable of enjoying the works of Phidias than to be Phidias himself. It is also why taste is such a dangerous thing for the creator —useful and dangerous and misleading for him: because it relates to the speculative intellect (and to the sense), not to the practical intellect. Many great artists had very poor taste. And many men with a perfect taste were mediocre creators—what is the music Nietzsche wrote, in comparison with his views on music?

Taste is not even a *habitus* of the speculative intellect—it has no necessary and sufficiently fixed object on which to take hold. It concerns the sense as much as the intellect, and it concerns the intellect as bound up with the exercise of the sense: no universe of knowledge is more complex and more unstable. However certain it may be in actual fact, aesthetic taste depends, not on *habitus* properly so-called, but on habitual *disposition* and cleverness, as does also the taste of the wine-taster. And it is always at the mercy of the invention—by the artist—of new types of works in which an aspect of beauty appears.

138. From this point of view the *symbolist* conception, such as Maurice Denis expounds it, seems to be not yet free of all confusion. "Symbolism," wrote Denis (*Nouvelles Théories*), "is the art of translating and *inducing states of soul* by means of relations of colors and forms. These relations, invented or borrowed from Nature, become signs or symbols of these states of soul: they have the power to suggest them. . . . The Symbol claims *to give rise straightway in the soul of the spectator to the whole gamut of human emotions* by means of the gamut of colors and forms, or let us say, of sensations, which corresponds to them. . . ." And—after quoting the following passage from Bergson: "The *object of art* is to put to sleep the active, or rather, resistant powers of our personality, and thus to lead us to a state of perfect docility in which we realize the idea suggested to us and sym-

judgment concerning the operative *habitus* itself, not of the judgment concerning the *work* made.

pathize with the feeling expressed"—Maurice Denis adds: "All our confused memories having been thus revivified, all our subconscious energies having been thus set in motion, the work of art worthy of the name creates in us a mystical state, or at least a state analogous to the mystical vision, and, in a certain degree, makes God sensible to the heart."

It is perfectly true that art has the *effect* of inducing in us affective states, but this is not its *end* or its *object:* a fine distinction, if you will, but still an extremely important one. Everything gets out of hand if one takes as the *end* that which is simply a *conjoined effect* or a *repercussion,* and if one makes of the *end* itself (to produce a work in which the splendor of a form shines on a proportioned matter) a simple *means* (to induce, in others, states of soul and emotions, to put to sleep one's resistances and to set in motion one's subconscious).

The fact remains—it's a point I think I have sufficiently indicated—that art has as its *proper effect* to cause the one who enjoys the work to participate in the *poetic knowledge* which the artist is privileged to possess (cf. above, note 130). This participation is one of the elements of aesthetic perception or emotion—in the sense that, produced immediately as a proper effect by the perception or emotion of the beautiful (considered in its essential nucleus), it redounds upon this perception or emotion, nourishes it, expands and deepens it. It is in this sense that the page from C. E. M. Joad, quoted in note 73, must be understood. *Causae ad invicem sunt causae.*

The objections that Father Arthur Little has advanced against my views, in an interesting and brilliant analysis ("Jacques Maritain and His Aesthetic," *Studies,* Dublin, Sept. 1930), oblige me to insist on this point. As my friend Father Leonardo Castellani wrote in his reply to this article ("Arte y Escolástica," *Criterio,* Buenos Aires, Sept. 10, 1931), "the critic has confused the aim of the work (*finis operis*) with the aim of the workman (*finis operantis*)"; and besides he has attributed to my positions "a restricted and exclusive meaning which they do not have."

Father Castellani has excellently shown that as a matter of fact it is the very question of the specification of *habitus* and the opposition of Scotism and Thomism concerning the intellect and

the will, which are at issue in this debate. I cannot do better than to refer the reader to Father Castellani's article.

For Father Little, it is a "communication of experience" which constitutes the *essence* of art. I do not, as he believes, exclude this communication; I do not regard it as altogether accidental and extrinsic to art; I know that it plays a capital role in the artist's activity, as in Shelley's admirable poem *One Word*. It relates, as a matter of fact, to the social essence of the human being and to the need to communicate that is natural to spirit as such, to intellect and to love—who, indeed, speaks, except to be heard? But I hold that it does not constitute the *specifying object* of the artistic *habitus*. It is, in the sense defined in this note (that is to say, for the artist, as a *condition of exercise* of primary importance, and, for the one who enjoys the work, as *proper effect* of the perception of the beautiful), an *integral element* of the artist's activity and of aesthetic emotion.

139. Cf. Aristotle, *Polit.*, VIII, 7, 1341 b 40; *Poet.*, VI, 1449 b 27.

140. *Lettres de Marie-Charles Dulac*, Bloud, 1905, letter of February 6, 1896.

141. There is no school in which one can learn "Christian art" in the sense here defined. But there can very well be schools in which one can learn *Church art* or *sacred art*, which, given its special object, has its own special conditions—and which has also, alas! a terrible need of being raised from the decadence into which it has fallen.

I shall not discuss this decadence here—too much would have to be said. Instead, let me quote these lines of Marie-Charles Dulac: "There is something I should like and for which I pray: it is that everything beautiful be brought back to God and serve to praise Him. Everything we see in creatures and creation must be returned to Him; and what distresses me is to see His Spouse, Our Holy Mother the Church, decked out with horrors. Everything that manifests her exteriorly is so ugly—she, who within is so beautiful. No effort is spared to make her look grotesque. Her body, in the beginning, was naked, delivered to the beasts;

then artists set their souls to decorating her; then vanity and finally industrial manufacture take a hand, and, thus bedizened, she is delivered over to ridicule. Here is another kind of beast, less noble than a lion and more sinister . . ." (Letter of June 25, 1897).

"They are satisfied with work which is dead. . . . They are at an ultra-inferior level, so far as the comprehension of art is concerned. I am not now speaking of the public taste: I have noticed it as early as Michelangelo and Rubens, in the Low Countries—it is impossible for me to find any life of soul in those fat bodies. You understand that I am not so much speaking of bulk, but of the complete privation of interior life—and this in the wake of an epoch in which the heart had expanded so freely, had spoken so candidly; one returned to the coarse meats of paganism, only to end finally in the indecencies of Louis XIV.

"But you know, what makes the artist is not the artist: it is they who pray. And they who pray have only what they ask for; nowadays it is never suggested to them that they should ask for still more. I firmly count on there being some lights; for considering the modern Greeks who imitate the rigid ways of long ago, the Protestants who make nothing at all and the Latins who make anything that comes into their heads, I find that in truth the Lord is not served by the manifestation of the Beautiful, that He is not praised by the Fine Arts in proportion to the graces He puts to their credit, and that it was even a sin to reject what was holy and within our reach and to take what was tarnished" (Letter of May 13, 1898).

Cf. on the same subject Abbé Maraud's essay *Imagerie religieuse et Art populaire* (published under the pseudonym of Faber; *Bibl. des lettres français*, 1914); and Alexandre Cingria's study *La Décadence de l'Art Sacré* (new and revised edition, Paris, éd. Art Catholique).

Apropos this book, which he regards as "the most thorough and penetrating study" which has appeared "on this distressing subject," Paul Claudel wrote in an important letter to Alexandre Cingria: "They [the causes of this decadence] can all be summed up in one: the divorce, unhappily consummated this past century, between the propositions of the Faith and those powers of imagination and sensibility which are pre-eminently the privilege

of the artist. On the one hand, a certain religious school, particularly in France, where the Quietist and Jansenist heresies have succeeded in sinisterly exaggerating this school's nature, has reserved, in the act of religious adherence, a too violently exclusive role for the spirit stripped of the flesh—whereas what was baptized and what is to rise on the Last Day is the whole man in the integral and indissoluble unity of his twofold nature. On the other hand, the art subsequent to the Council of Trent and generally known under the absurd name of Baroque—for which I have, like yourself, the liveliest admiration, as you well know—seems to have taken for its aim, no longer, as did Gothic art, to *represent* the concrete facts and the historical truths of the Faith to the eyes of the multitude in the manner of a great open Bible, but to *manifest* with noise, parade, and eloquence, and often with the most touching pathos, that space, vacant like a medallion, to which access is forbidden our pompously dismissed senses. And so we have saints who indicate to us by countenance and posture what is ineffable and invisible; we have the whole riotous abundance of ornamentation; we have angels who, in a whir of wings, uphold a picture that is indistinct and concealed by religious ceremony, and statues stirred as it were by a great wind from elsewhere. But before this *elsewhere* the imagination withdraws in fear and discouragement, and devotes all its resources to laying out the setting, whose essential purpose is to honor its content by quasi-official methods, which only too quickly degenerate into recipes and worn-out expedients."

After remarking that in the nineteenth century the "crisis of an ill-nurtured imagination" consummated the divorce between the senses—"which had been diverted from that supernatural world which no effort was made to render accessible and desirable to them"—and the theological virtues, Claudel goes on: "The essential spring of the creator, to wit, Imagination (or in other words the desire to procure immediately by resources peculiar to oneself and one's neighbor, with the help of elements assembled together, a certain picture of a world at once delightful, significant and rational) is thereby secretly injured, and with it the capacity to take its object seriously.

"As for the Church, in losing the envelope of Art it became in the last century like a man stripped of his clothes: in other

words, that sacred body, composed of men at the same time believers and sinners, showed itself for the first time materially before the eyes of the world in all its nakedness, in a kind of exposition and permanent translation of its wounds and infirmities. To anyone who has the heart to look at them, modern churches have the interest and pathos of a burdened confession. Their ugliness is the outward manifestation of all our sins and shortcomings, our weakness, indigence, timidity of faith and feeling, dryness of heart, dislike of the supernatural, domination by conventions and formulas, overemphasis of individual and extravagant practices, worldly luxury, avarice, boasting, sullenness, Pharisaism and bombast. But, nevertheless, the soul within remains alive, infinitely sorrowful, patient and hopeful, that soul which one divines in all those poor old women with their absurd and deplorable hats in whose prayers I have taken part for the last thirty years at Low Masses in churches and chapels throughout the world. . . . Yes, even in such ghastly churches as Notre-Dame-des-Champs or Saint Jean l'Évangéliste in Paris or the basilicas of Lourdes—more tragic spectacles than the ruins of the Cathedral of Rheims—even in these God is present: we can trust in Him, and He can trust us always to prepare for Him by our feeble personal means, in default of worthy thanks, a humiliation as great as that of Bethlehem" (*Revue des Jeunes*, August 25, 1919).

142. "Art," wrote Léon Bloy in a celebrated passage, "is an aboriginal parasite of the skin of the first serpent. Hence derive its overweening pride and power of suggestion. It is self-sufficient like a god, and the flowered crowns of princes, compared with its head-dress of lightning, are like iron-collars of torture. It will no more submit to worship than to obedience, and no man's will can make it bow before any altar. It may consent to give alms out of the superfluity of its pomp, to temples or palaces— when it is more or less to its advantage; but you must not ask it for a thimbleful over and above what is strictly required. . . .

"One may meet a few rare and ill-fated individuals who are at the same time artists and Christians, but there cannot be a Christian art" (*Belluaires et Porchers*, Paris, Delamain et Boutelleau, 1923).

Here, as he often does, Bloy goes to the extreme, the better to bring home a profound antinomy. And that this antinomy does in fact make the advent of a Christian art singularly difficult, even in a privileged spiritual line, I do not deny. Nevertheless it is not insoluble, for nature is not essentially bad, as the Lutherans and Jansenists thought. However wounded it may be by sin, especially where it is rising up—it can be cured by grace. Or do you think that the grace of Christ is powerless, that it meets an insurmountable obstacle in any one of the things, and the noblest things at that, which proceed from God, that it is incapable of setting art and beauty free, of making them docile to the Spirit of God, *ad obediendum fidei in omnibus gentibus?* God has no contrary. The intelligence of man can, and must, be given back to Him. It has only to pay the price, a higher price than Christian humanism believed. [A higher price, most certainly, than I myself believed in writing these lines, and than I can yet conceive; to tell the truth the eye of man cannot picture to itself the things of the Redemption—fortunately, to be sure, for in that event who would dare to set out on the journey? It is enough to suffer them.] If it is true that the devil is always ready to offer his services to the artist, and that connivance with evil *facilitates* many things for the artist, the fact remains that to claim with André Gide that the devil collaborates in *every* work of art, to change a *de facto* frequency into a *de jure* necessity, is a kind of Manichaean blasphemy. The hyperboles of Léon Bloy, need it be remarked, have quite a different meaning, and only tend to assert a mysterious sudden turn of fortune. (Cf. Stanislas Fumet, *Le Procès de l'Art* (Le roseau d'or), Paris, Plon, 1929; *Mission de Léon Bloy,* Paris, Desclée de Brouwer, 1935.)

Let me quote these lines from an invaluable little essay: * "Lucifer has cast the strong though invisible net of illusion upon us. He makes one love the passing moment above eternity, uncertainty above truth. He persuades us that we can only love creatures by making Gods of them. He lulls us to sleep; he makes us dream (he interprets our dreams); he makes us work. Then does the

* Raïssa Maritain, *The Prince of This World.* Translated by Gerald B. Phelan. Toronto: The Institute of Mediaeval Studies, [1933], pp. 19–21.

spirit of man brood over stagnant waters. Not the least of the devil's victories is to have convinced artists and poets that he is their necessary, inevitable collaborator and the guardian of their greatness. Grant him that, and soon you will grant him that Christianity is *unpracticable*.

"Thus does he reign in this world. In truth it seems that all belongs to him and that all must be wrested from him. Yet all has been already wrested from him; he is dispossessed (this time, without possible revenge) of the dominion he lost in the first catastrophe and regained in the Garden of Paradise. The world is saved and delivered from his hands. Yes! but on condition that the Blood of Redemption be applied to the world and *received* into souls. . . . Let it be received and all will be reborn. All that now is but the magic and the fruit of death,—art lost in lewdness, knowledge frenzied with pride, power consumed with avarice—*all that* can be reborn like man himself. New births like these have come to light along the track of all the saints and men of goodwill."

143. This divine inspiration in the natural order was expressly recognized by the ancients, in particular by the author of the *Eudemian Ethics* in his well-known chapter on Good Fortune (Bk. VII, ch. 14). Saint Thomas likewise recognizes it, in distinguishing it from the essentially supernatural inspiration proper to the gifts of the Holy Spirit (*Summa theol.*, I-II, 68, 1 and 2). Cf. my *Réponse à Jean Cocteau* (Paris: Stock, 1926), note 3; and *Frontières de la Poésie et autres essais* (Paris: Louis Rouart et fils, 1935), p. 50, note [below, n. 200—Tr.].

"The epic poets, all the good ones, utter their beautiful poems not from art, but because they are inspired and possessed. So it is also with the good lyric poets; as the worshipping Corybantes are not in their senses when they dance, so the lyric poets are not in their senses when they are composing their lovely strains. . . . A poet is a light and winged thing, and holy, and there is no invention in him until he has become inspired, and is out of his senses, and reason is no longer in him. So long as he has not attained to this state, no man is able to make poetry or to chant in prophecy. . . . One poet is suspended from one Muse, another from another; he is said to be 'possessed': for he is taken

hold of. And from these primary rings, the poets, others are in turn suspended, some attached to Orpheus, some to Musaeus, from whom they derive inspiration" (Plato, *Ion*, 534, 536; Professor Maritain's translation, as in his *Creative Intuition in Art and Poetry*, New York, Pantheon Books, 1953, p. 101—Tr.).

"He who, having no touch of the Muses' madness in his soul, comes to the doors of poetry, trusting to enter in, and who thinks forsooth that art is enough to make him a poet, remains outside, a bungler: sound reason fades into nothingness before the poetry of madmen" (Plato, *Phaedrus*, 245; Professor Maritain's translation, *ibid.*, p. 102—Tr.).

Since the powers of the unconscious, of the images and instincts of the subterranean world, have a great part to play in the inspiration of which Plato speaks, this world is worth what the soul of the poet is worth—it is all the more divine the more profound and spiritual is this soul. And nothing is more accessible to supra-human influences, to inspiration properly so-called (whether of the natural or of the supernatural order) than this fluid and violent world.

144. I do not say that in order to make work that is Christian the artist must be a canonizable saint or a mystic who has attained to transforming union. I say that, by right, mystical contemplation and sanctity in the artist are the goal to which the formal exigencies of Christian work as such tend; and I say that in actual fact a work is Christian to the extent to which—in whatever manner and with whatever deficiency it may be—there courses through the soul of the artist something of the life that makes saints and contemplatives.

These are self-evident truths, simple applications of the eternal principle: *operatio sequitur esse*—as a being is, so it acts. "That's the whole secret," said Goethe. "You must *be* something, to be able to *make* something." Leonardo illustrated this same principle by some very strange observations: "A heavy-handed painter will be heavy-handed in his work and will reproduce the flaw of his body, unless he guards himself against this by long study. . . . If he is quick to speak and vivacious in manner, so also will his figures be. If the master is pious, then his personages will have wry necks; and if he is lazy, his figures will themselves

express laziness. . . . Each of the characteristics of the painting is a characteristic of the painter" (*Textes choisis,* Péladan, Paris, 1907, §§ 415, 422).

"How does it happen," asks Maurice Denis in an address on "Religious Sensibility in the Art of the Middle Ages" (*Nouvelles Théories*), "that artists of talent whose personal faith was pure and living—artists like Overbeck and certain pupils of Ingres—produced works which hardly touch our religious sensibility?"

The answer does not appear to be difficult. In the first place, it could be that this lack of emotion proceeds quite simply from an insufficiency as regards the virtue of art itself, which is something altogether different from talent or school learning. Then, too, strictly speaking, faith and piety in the artist do not suffice for the work to produce a Christian emotion: such an effect always depends on some contemplative element, however deficient one may suppose it, and contemplation itself presupposes, according to the theologians, not only the virtue of Faith, but also the influence of the gifts of the Holy Spirit. Finally, and above all, there can be—due, for example, to systematic academic principles—obstacles, *prohibentia* preventing art from being moved instrumentally and superelevated by the soul in its entirety. For the virtue of art and the supernatural virtues of the Christian soul do not, together, suffice here—the one must also be under the influence of the others. And this takes place *naturally,* provided, however, that no alien element interferes. Far from being the result of deliberate contrivance, the religious emotion that the Primitives arouse in us is a dependent variable of the ease and liberty with which these nurslings of Mother Church allowed their souls to pass into their art.

But how does it happen that artists as devoid of piety as many of those of the fourteenth and fifteenth centuries still produced works of intense religious feeling?

These artists, in the first place, however pagan one may suppose them to have been, were far more imbued with Faith, in the mental structure of their being, than our short-sighted psychology imagines. Were they not still close to those tumultuous and passionate, but heroically Christian, Middle Ages, whose imprint on our civilization four centuries of anthropocentric culture have been unable to efface? They might indulge in the worst

facetiae, but they preserved within them, still quite lively, the *vis impressa* of the faith of the Middle Ages, and not only of the faith, but also of those gifts of the Holy Spirit which were exercised with so much fullness and liberty in the Christian centuries. So that it might be maintained without temerity that the "undisciplined pleasure-seekers" of whom Maurice Denis speaks, following Boccaccio, were in reality more "mystical" before the work to be painted, than many pious men in our dessicated times.

In the second place, the *Christian quality* begins, in fact, to degenerate in their works. Even before becoming pure humanity and pure nature in Raphael and already in Leonardo, it has ceased to be anything but sensitive grace in a Botticelli or a Filippo Lippi. It preserved its serious and profound character only in the great Primitives, Cimabue, Giotto, and Lorenzetti, or later in Angelico, who, because he was a saint, was able to infuse all the light of the interior heaven into an art that in itself was already less austere.

The fact of the matter is that one has to go quite far back into the Middle Ages, beyond the exquisite tenderness of Saint Francis, to find the purest epoch of Christian art. Where would one find better realized than in the sculptured figures and stained-glass windows of the cathedrals, the perfect harmony between a powerfully intellectual hieratic tradition—without which there can be no sacred art—and that free and ingenuous sense of the real which is proper to art under the Law of liberty? No subsequent interpretation attains, for instance, the truly sacerdotal and theological loftiness of the scenes of the Nativity of Our Lord (the Choir of Notre-Dame de Paris, the windows at Tours, Sens, Chartres, etc.—*ponitur in praesepio, id est corpus Christi super altare*), or of the Coronation of the Blessed Virgin (at Senlis), such as they were conceived in the twelfth and thirteenth centuries. (Cf. Émile Male, *L'Art religieux du XIII^e siècle en France*, 3^e éd., Paris, A. Colin, 1909; Dom Louis Baillet, *Le Courronement de la Sainte Vierge*, Van Onzen Tijd, Afl. XII, 1910.)

But art in those times was also the fruit of a humanity in which all the energies of Baptism were at work. It is certainly right to insist on the *ingenuousness* of the Primitives and to ascribe to this ingenuousness the emotion we experience in the

presence of their works. But all great art is ingenuous, and not all great art is Christian, except in hope. If the ingenuousness of the great mediaevals leads the heart to the living God, it is because this ingenuousness is of a unique quality; it is a *Christian* ingenuousness; it is, so to speak, an infused virtue of awed ingenuousness and filial candor in the presence of the things created by the Holy Trinity; it is but the peculiar imprint in art of the faith and the gifts passing into it and superelevating it.

Thanks to this religious faith the Primitive knew by instinct what modern poetry has learned in sorrow, to wit, that "the form must be the form of the mind: not the manner of saying things, but of thinking them"; and that "only reality, even well-nigh covered up, possesses the power to stir the emotions" (Jean Cocteau, *Le Rappel à l'Ordre,* Paris, Stock, 1926).

For this reason also it is in vain that Gaston Latouche tell us that the ceiling of the Chapel at Versailles strikes him as every bit as religious as the canopy at Assisi. So long as a sullen "classicist" fanaticism has not triumphed over the Christian heart, Jouvenet will remain a cipher when compared with Giotto.

Nicholas Berdiaeff maintains that a perfect classicism, that is to say, one capable of extracting from Nature an entirely happy and satisfying harmony, is impossible since the agony of Christ and the Crucifixion: according to him the classicism of the Renaissance retains without knowing it a Christian wound. I think Berdiaeff is right. But did perfect classical tranquillity exist even in Greece? A mysterious and sullen violence kept breaking in upon this dream: for in Greece too, human nature was wounded and needed redemption.

145. "As the body of Jesus Christ was born of the integrity of the Virgin Mary, so also is the song of praise rooted, according to heavenly harmony, in the Church through the Holy Spirit," writes Saint Hildegarde in the admirable letter to the Chapter of Mainz in which she asserts the liberty of sacred song. (St. Hildegarde, *Epistola XLVII,* Migne, 197, col. 221 B.)

146. It is interesting to observe that in its boldest experiments contemporary art seems to want to rejoin all that which—with regard to the construction of the work, the simplicity, frankness

and rationality of the means, and the ideographical schematiza-
tion of expression—characterizes primitive art. If from this point
of view one examines the miniatures of the *Scivias* of Saint Hil-
degarde reproduced in Dom Baillet's admirable work ("Les min-
iatures du *Scivias* conservé à la bibliothèque de Wiesbaden," first
fasc. of Vol. XIX of the *Monuments et Mémoires de l'Acad. des
Inscr. et Belles-Lettres, 1912*), one will here discover some very
suggestive analogies to certain contemporary efforts—to Cubist
perspective, for instance. But these analogies are altogether ma-
terial; the inner principle is utterly different. What the majority
of "advanced" modern artists are seeking in the cold night of a
calculating anarchy, the Primitives possessed without seeking,
in the peace of interior order. Change the soul, the interior prin-
ciple, imagine the light of Faith and reason in place of the ex-
asperation of the senses (and sometimes even of *stultitia*), and
you have an art capable of high spiritual developments. In this
sense, and although from other points of view it is diametrically
opposed to Christianity, contemporary art is much closer to a
Christian art than is academic art.

147. It goes without saying that I am taking this word "moral-
ity" not in the Stoic, lay or Protestant sense, but in the Catholic
sense, according to which the sphere of morality or of human
conduct is, in its entirety, *finalized* by the Beatific Vision and the
love of God for His own sake and above all things, and is per-
fected in the supernatural life of the theological virtues and the
gifts of the Holy Spirit.

148. The witness of a poet so ardently an artist as Baude-
laire, is on this point of the liveliest interest. His essay on *The
Pagan School*, in which he shows in vivid terms what an error
it is for man to dedicate himself to art as his final end, concludes
with the following page:
"The intemperate desire for form leads to monstrous and un-
known disorders. Absorbed by the fierce passion for the beauti-
ful, the droll, the pretty, the picturesque—for there are degrees—
the notions of what is proper and true disappear. The frenzied
passion for art is a cancer which eats up everything else; and,
as the out-and-out absence of what is proper and true in art is

tantamount to the absence of art, the man fades away completely; excessive specialization of a faculty ends in nothing. I understand the rage of the iconoclasts and the Mohammedans against images. I admit all the remorse of Saint Augustine for the overpowering pleasure of the eyes. The danger is so great that I excuse the suppression of the object. The folly of art is on a par with the abuse of the mind. The creation of one or the other of these two supremacies begets stupidity, hardness of heart, and unbounded pride and egoism . . ." (Baudelaire, *L'Art romantique*).

149. Saint Thomas, *Sum. theol.*, II-II, 169, 2, ad 4. In this connection the well-known text of Saint Thomas may also be recalled, where, commenting on the Philosopher's *Ethics*, he points out, following Aristotle, that it belongs to the domain of political science, in its capacity as architectonic science, to *order* the "practical sciences," such as the mechanical arts, not only in regard to the exercise of these sciences, but also in regard to the very determination of the work (thus it orders the artisan who makes knives, not merely to use his art, but also to use it in such or such a manner, by making knives of such and such a kind): "for both of these are ordered to the end of human life." Politics also orders the speculative sciences, but only in regard to the exercise of these sciences, not in regard to the determination of the work; for though it prescribes that some shall teach, and others learn, geometry—"such acts, in so far as they are voluntary, having in fact a relation to the matter of morality, and being capable of being ordered to the end of human life"— it does not prescribe to the geometrician what he must conclude concerning the triangle, for "this does not belong to the domain of human life and depends only on the nature of things" (*Comment. in Ethic. Nicom.*, I, 2).

Saint Thomas does not speak explicitly here of the fine arts, but it is not very difficult to apply these principles to them, observing that they participate in the nobility of the speculative sciences through the transcendence of their object, which is beauty —so that no *politicus* can interfere with the laws of beauty— but that they nevertheless remain, by their generic nature, arts, "practical sciences," and that on this score all that the work includes of intellectual and moral values normally falls under the

control of the one who watches over the common good of human life. Moreover Aristotle adds that it belongs to Politics to use for its own ends the noblest arts, such as Military Art, Economics, and Rhetoric.

150. *Met.,* XII, 10, 1075 a 15; Saint Thomas' *Commentary,* lect. 12. Cf. *Summa theol.,* I-II, 111, 5, ad 1.

151. "The good of the army is more in the Commander than in order: because the end is higher in goodness than those things which are ordered to the end; and the order of the army is ordered to the good of the Commander which is to be realized, that is to say, the will of the Commander in the obtaining of victory" (Saint Thomas, commenting on the passage cited from Aristotle. Ed. Cathala, § 2630).

152. "It is by being national that a literature takes its place in humanity and assumes meaning in the concert. . . . What is more Spanish than Cervantes, more English than Shakespeare, more Italian than Dante, more French than Voltaire or Montaigne, Descartes or Pascal; what is more Russian than Dostoievsky—and what is more universally human than these men?" (André Gide, "Réflexions sur l'Allemagne," in *Nouvelle Revue Française,* 1er Juin et 1er Août 1919.)—"The more a poet sings in his genealogical tree, the truer is his singing" (Jean Cocteau).

153. Saint Thomas, *In II Sent.,* d. 18, q. 2, 2.

154. *Summa theol.,* I-II, 30, 4.

155. *Summa theol.,* II-II, 35, 4, ad 2. Cf. *Eth. Nic.,* VIII, 5 and 6; X, 6.

156. *Summa theol.,* I-II, 3, 4.

157. "In fact, all other human operations seem to be ordered to this one [contemplation], as to an end. For, there is needed for the perfection of contemplation a soundness of body, to which all the products of art that are necessary for life are directed. Also required are freedom from the disturbances of the passions—this is achieved through the moral virtues and prudence—and freedom from external disorders, to which the whole

program of government in civil life is directed. And so, if they are rightly considered, all human functions may be seen to subserve the contemplation of truth" (*Summa contra Gent.*, III, 37; Vernon J. Bourke's translation in *On the Truth of the Catholic Faith: Summa contra Gentiles,* Bk. III, Pt. I, New York, Hanover House, 1956, p. 124).

Such a teaching—whose noble Aristotelian approach attains a peculiar quality of serene and refined irony in Saint Thomas, for he knew well that in concrete existence the goal of "all other human operations" is not an intellectual and philosophical contemplation crowning an altogether harmonious humanity, but a contemplation of love superabounding in mercy, a redemptive love at work in a wounded humanity—such a teaching, I say, enables one to appreciate the essential opposition, in the very order of ends, which separates the Christian body politic from the body politic of modern "humanism," which is entirely orientated towards practice, "production" and "consumption," not towards contemplation.

It is strange that a man like Wilde had understood that "while, in the opinion of society, Contemplation is the gravest sin of which any citizen can be guilty, in the opinion of the highest culture it is the proper occupation of man" ("The Critic as Artist," *Intentions,* New York, Brentano's, 1905, pp. 169–170). Yet the unhappy man was convinced that "we cannot go back to the saint," and that "there is far more to be learned from the sinner"—which is a gross absurdity. "It is enough that our fathers believed," thought Wilde. "They have exhausted the faith-faculty of the species. . . . Who, as Mr. Pater suggests somewhere, would exchange the curve of a single rose-leaf for that formless intangible Being which Plato rates so high?" (*ibid.,* p. 171). The βίος θεωρητικός of which he boasted could therefore be only the stupidest and most lying caricature of contemplation—to wit, aestheticism—and he was compelled to exert all his energies to install his soul in this sham counterfeit of intellectual life. But in vain. According to an irrevocable law which I have explained elsewhere,* it was inevitable that, not passing to the love of God, he should sink to the love of things below, under the influence

* "Grandeur et Misère de la Métaphysique," in *Les Degrés du Savoir.*

of his beloved Greeks, and become that terrible instrument of the devil which has so long been the scourge of modern literature.

158. *De Div. Nomin.*, cap. iv.

159. Exodus XXXV, 30–35.

160. *Summa theol.*, I-II, 53, 3. "When therefore a man ceases to use his intellectual *habitus,* strange fancies, sometimes in opposition to it, arise in his imagination; so that unless these fancies are in some way cut off or kept back by frequent use of the *habitus,* the man becomes less fit to judge rightly, and sometimes is even wholly disposed to the contrary; and thus the intellectual *habitus* is diminished or even destroyed by cessation of act."

161. *Ibid.*, 52, 3.

162. Jean Cocteau, *Le Coq et l'Arlequin,* 1918 (*Le Rappel à l'Ordre,* Paris, Stock, 1926)— "Shelter well your virtue of making miracles, for 'if they knew you were a missionary, they would tear out your tongue and your nails.' "

163. Hence so many conflicts between the Prudent Man and the Artist, concerning, for instance, the representation of the nude. In a beautiful study of the nude, one man, concerned only with the subject represented, sees only animality—and becomes rightly apprehensive for his own animality and that of others; another man, concerned only with the work itself, sees only the formal aspect of beauty. Maurice Denis (*Nouvelles Théories*) points out in this regard the case of Renoir, and he rightly insists on the beautiful pictorial serenity of his figures. But this serenity of the work did not exclude, in the painter himself, complicity or connivance and a lively sensuality of vision. (And what would have to be said if it were a question, no longer of Renoir, but of that great fauna-workman Rodin?)

However the case may be with this particular problem, concerning which the Middle Ages were severe and the Renaissance was excessively lax (even in the matter of Church decoration), the fact remains that in a general way and considered in itself only Catholicism is capable of truly reconciling Prudence and Art, because of the universality, the very *catholicity* of its wisdom,

which embraces the whole of reality: this is why Protestants accuse it of immorality and humanists of rigorism, thus bearing witness, symmetrically, to the superiority of its point of view.

As most men are not educated to appreciate art, Prudence is right in being apprehensive of the effect on the masses of many works of art. And Catholicism, which knows that evil is found *ut in pluribus* in the human species, and which, on the other hand, is obliged to have concern for the good of the multitude, must in certain cases deny to Art, in the name of the essential interests of the human being, liberties of which Art is jealous.

The "essential interests of the human being" must be understood not only in relation to the passions of the flesh, but in relation to the material of all the virtues, and, first of all, to the rectitude of the mind—not to mention the interests of art itself, and the need it has of being protected by the disciplines of religion against the dissolution of all that is in man.

No doubt it is difficult to preserve the just measure in these matters. At all events, to fear art, to escape from it and to make others escape from it, is certainly no solution. There is superior wisdom in trusting the powers of the mind as much as possible. Catholics of our day should remember that only the Church has succeeded in educating the people to beauty, while protecting them against the "depravation" for which Plato and Jean-Jacques Rousseau hold art and poetry responsible. The spirit of Luther, Rousseau or Tolstoy has no place among us: if we defend the rights of God in the order of moral good, we defend them also in the order of intelligence and beauty, and nothing obliges us to walk on all fours for the love of virtue. Every time he finds in a Christian environment a contempt for intelligence or art, that is to say, for truth and beauty, which are divine names, we may be sure that the devil scores a point.

I do not overlook the necessity for prohibitive measures. Human frailty makes them indispensable—it must be protected. It is nevertheless clear that, however necessary they may be, prohibitive measures remain by nature less efficacious and less important than robust intellectual and spiritual nourishment, enabling minds and hearts to resist *vitally* every morbid principle.

As for the liberty of the artist with regard to the subjects he depicts, it seems that the problem is, as a rule, poorly stated, be-

cause one forgets that the subject is only the matter of the work of art. The essential question is not to know whether a novelist can or cannot depict such or such an aspect of evil. The essential question is to know *at what altitude* he is prepared to depict it and whether his art and his heart are pure enough and strong enough for him to depict it without complicity or connivance. The more deeply the modern novel probes human misery, the more does it require superhuman virtues in the novelist. To write Proust's work as it needed to be written would have required the inner light of a Saint Augustine. The opposite occurs, and we see the observer and the thing observed, the novelist and his subject, rivalling each other in a competition to degrade. From this point of view, the influence André Gide has exercised on French letters, and the exaggeration in which he indulges in his latest works, must be regarded as very characteristic.

I have just mentioned the novel. Unlike other literary forms, the novel has as its object not a thing-to-be-made that would possess its own beauty in the world of *artifacts,* and of which human life furnishes only the elements, but human life itself to be moulded in fiction, as providential Art moulds human life in reality. The object it must create is humanity itself—humanity to be formed, scrutinized and governed like a world. Such seems to me to be the distinctive characteristic of the art of the novel.*
(I am speaking of the modern novel, of which Balzac is the father, and which Ernest Hello, in an essay in other respects quite declamatory, has shown to be fundamentally opposed to the novel such as antiquity knew it, the latter being above all a voyage into the marvellous and the *ideal,* a release of the imagination.)

One can therefore understand the necessity for integrity, authenticity and universality in the novelist's realism: only a Christian, nay more, a mystic, because he has some idea of *what is in man,* can be a complete novelist (not without risk, for he needs an *experiential knowledge* of the creature; and this knowledge can come from only two sources, the old tree of the knowledge of evil, and the gift of Understanding, which the soul

* Cf. Henri Massis, *Réflexions sur l'art du Roman* (Paris: Plon, 1926); Frédéric Lefèvre, *Georges Bernanos* (Paris: La Tour-d'Ivoire, 1926).

receives with the other gifts of grace . . .). "There is not," said Georges Bernanos speaking of Balzac,* "a single feature to be added to any one of those frightful characters, but he has not been down to the secret spring, to the last recess of conscience where evil organizes from within, against God and for the love of death, that part of us the harmony of which has been destroyed by original sin. . . ." And again: "Take the characters of Dostoievsky, those whom he himself calls *The Possessed*. We know the diagnosis the great Russian made of them. But what would have been the diagnosis of a Curé of Ars, for instance? What would he have seen in those obscure souls?"

164. Cf. *Summa theol.*, I-II, 66, 3; II-II, 47, 4.

165. Cf. *Summa theol.*, I-II, 66, a. 3, ad 1. "But that the moral virtues are more necessary for human life, does not prove that they are nobler *simpliciter*, but only in this particular respect; indeed, the speculative intellectual virtues, from the very fact that they are not ordered to anything else, as the useful is ordered to the end, are nobler. . . ."

166. *Eth. Nic.*, X, 8; cf. *Summa theol.*, II-II, 47, 15.

167. *Summa theol.*, I-II, 66, 5.

168. Cf. the observations of the learned theologian, Father John G. Arintero, O.P., in his treatise *Cuestiones misticas* (Salamanca, 1916); also, and above all, Father Garrigou-Lagrange's *Perfection chrétienne et contemplation* (Saint-Maximin, 1923).

169. John of Saint Thomas, *Curs. theol.*, I P., q. XXVII, disp. 12, a. 6, § 21. Plotinus taught, on the contrary, that to engender is a sign of indigence. "He who does not aspire to engender is more completely self-sufficient in beauty; if one desires to produce beauty, it is because he is not self-sufficient, and because he thinks he will gratify himself more by producing and engendering in beauty" (*Enneads*, III, 5). This aspect of indigence, which is bound up with transitive activity, is the ransom we have to pay for our condition as material beings, but it does not—and this is the error of neo-Platonic metaphysics—essentially affect

* Frédéric Lefèvre, *op. cit.*

the generative fecundity itself, which, in the immanent activity
proper to life—and all the more so the higher and more imma-
terial is this life—is, above all, superabundance. We are here
touching the very root of the opposition between neo-Platonism
and Christianity, between Plotinus and Saint Thomas: on the
one hand, the primacy of existence and the generosity of being;
on the other, the primacy of essence and a false barren purity.

170. Max Jacob, *Art poétique,* Paris, 1922.

171. Since the time when these lines were written, Cocteau
has given us *Orphée* and then *La Machine Infernale,* both great
dramatic works.

172. Raymond Radiguet's *Le Bal du Comte d'Orgel* (Paris:
Bernard Grasset, 1924).

173. Criticism, on the contrary, while drawing its inspiration
from philosophical principles—which is always good, but dan-
gerous—remains on the level of the work and of the particular,
without however being itself operative or making any creative
judgment, but rather judging from without and after the event.
Wilde, therefore, made a grave mistake in placing the critic
above the artist, although he could have invoked the testimony
of Plutarch, who says somewhere, if my memory does not fail
me: "Who then, given the choice, would not rather enjoy the
contemplation of Phidias' works than be Phidias himself?" Cf.
above, note 137.

174. Some critics have reproached me in a friendly manner
for not having mentioned the Spanish and Jesuit Baroque which
they rightly admire. But there are much greater examples,
whether of Byzantium or of the Far East, which I have not used
either.

175. See also, on related questions, my *Réponse à Jean
Cocteau* (1926) and the essay published in the first *Courrier
des Iles* (1932).

176. John of St. Thomas, *Curs. Theol.* (Vivès, t. III), q. XV,
De Ideis, disp. 1, a, 1, § 13. "Many people see perfectly and
know some artifact, e.g., a house or a statue; and natural things

also are perfectly well known by many people. And yet they do
not have the *idea* of these things, because they are not artisans
and still less are they makers of natural things. An *idea,* on the
contrary, is a form that is a *making* exemplar of the thing
known."

177. "For a truth of this kind is one of the boundaries of
this world: it is forbidden to take up your abode there. Nothing
so pure can coexist with the conditions of life." Paul Valéry,
Preface to Lucien Fabre's *Connaissance de la Déese* (Paris:
Société littéraire de France, 1920).

178. All things (like intelligence and art) that touch the
transcendental order and consequently find themselves realized
in the pure state in God and "by participation" in created sub-
jects involve an antinomy of this kind. In the very measure in
which they tend (with a tendency that is inefficacious, but none-
theless real) to the fullness of their essence *considered in itself*
(transcendentally) *and in its pure formal line,* they tend to go
beyond themselves, to exceed the limits of their essence *con-
sidered in a created subject* (with the specific determinations
which belong to it there), and at the same stroke to escape from
their *conditions of existence.*
 Thus the intellect tends in man, in whom it is *reason,* to re-
join the perfection of its essence transcendentally understood,
and by that very fact to go beyond both its limits as reason and
its conditions of existence in the subject. Hence the angelist
swoon—when grace does not intervene to superelevate nature—
into a "pure intellection" which is then a mystical suicide of
thought.

179. " 'Poetry is Theology,' says Boccaccio in his commentary
on the *Divina Commedia.* Ontology would perhaps be the better
word, for poetry inclines above all to the roots of the knowledge
of Being." Charles Maurras, Preface to *La Musique Intérieure,*
Paris, B. Grasset, 1925.

180. Cf. Pierre Reverdy, *Nord-Sud,* Nos. 4, 5, 8, 13.

181. Even those who today draw inspiration from Rimbaud do
not so much continue his poetry in the line of art as transpose

it into the line of moral life and action. The influence of Lautréamont, which here mingles with that of Rimbaud, likewise concerns the sphere of moral and metaphysical life more than the sphere of art. Apropos *Chants de Maldoror,* it is not without profit to observe that Léon Bloy, as long ago as 1887, proclaimed in *Le Désespéré* (Paris: G. Crès et Cie, 1913) the historic importance of these "good *tidings* of *damnation,*" noting in them "one of the least ambiguous signs that the modern generation had been brought to bay at the extremity of everything." It is Bloy who has spoken of Lautréamont in the profoundest manner (in an article written in 1890 and reprinted in *Belluaires et Porchers.*)

182. Cf. St. Thomas, *Summa theol.,* I, 19, 1, ad 3.

183. Paul Claudel, "Introd. à un poème sur Dante," *Correspondant,* September 10, 1921.

184. This sentence is borrowed from a line of the French poet Mallarmé: "tel qu'en lui-même enfin l'éternité le change" (such as into himself at last eternity changes him). [Translator's note.]

185. The phrase *submissiveness to the object,* which is very clear as far as science is concerned, easily becomes obscure in reference to art. For the formal object of art is not a thing to which to conform, but a thing to be formed. To say that art must be submissive to the object is therefore to say that it must be submissive to *the object to be made as such* or to the right rules of operation thanks to which this object will truly be what it ought to be. (Academicism with its recipes, pseudo-classicism with its clichés and its mythology, Wagnerism with its worship of effect, all fail in this submissiveness.)

Materially speaking—that is, if one no longer considers the formal object of art but its material object, or that reality an image of which it causes to enter the work—submissiveness to such an object will have to be understood in a thousand different ways, and according precisely to the formal object of the artist in each particular case. In the case of the novel it is fair to reproach Flaubert—with Cocteau—for his *style as starting-point,* or—with Ghéon—for *indifference to the subject.* In the

case of the prose poem such as Max Jacob has defined it, it is, on the contrary, the very construction of the poem that constitutes the whole object of the art, and the subject must intervene only in a wholly indirect and material manner.

186. Arthur Rimbaud, *Une saison en enfer* (Paris: Br. Poot et Cie, 1914).

187. Apollinaire, "Zone," *Alcools* (Paris: Mercure de France, 1913).

188. "In order therefore to simplify things, let us call this fluid 'poetry,' and 'art' the more or less felicitous exercise by which one domesticates it." Jean Cocteau, *Le Rappel à l'Ordre* ("Le Secret Professionel").

189. I am by no means thinking here of the pursuit of pure poetry in Mallarmé's sense, of poetry that would be *pure art,* and which "would result, by a kind of *exhaustion,* from the progressive suppression of the prosaic elements of a poem." (Paul Valéry, in Frédéric Lefèvre, *Entretiens avec Paul Valéry*, Paris, La Livre, 1926.) I am thinking rather of the pursuit of the *poetic spirit* in the pure state, that is to say, of something altogether different and ever so much more profound, a whole metaphysical region to be explored.

190. Jean Cocteau, *Le Rappel à l'Ordre* ("Le Secret Professionel"; "Picasso"). Cf. Pierre Reverdy, *Pablo Picasso* (Paris: N.R.F., 1924).

191. Art begins with intelligence and free choice. The spontaneous welling up of images, without which there is no poetry, *precedes and nourishes* the activity of the poet; and doubtless— it is good to insist on this—this welling up is never the result of premeditation and calculation. Even when the mind, by the highest point of an in some way supra-conscious emotion, solicits it and orientates it, the mind receives it as it were passively, suffering this flow of images, feelings and words which are discharged into it. But the mind does so in order that it may control this flow, stop the passing gifts thus sent, accept them freely or choose among them, in a word, pass judgment on them.

192. André Breton, *Les Pas perdus* (Paris: N.R.F., 1924).

193. Demonologists know well that every *passive state into which a man puts himself* is a door open to the devil.

194. Jean Cocteau, *Orphée* (Paris: Delamain, 1928).

195. More's martyrdom does not exempt them all from this reproach. But if More was the object of a special grace, it may also be that he had always looked at things in a higher light. Cf. Daniel Sargent's *Thomas More* (New York: Sheed and Ward, 1933).

196. The unconcealed and palpable influence of the devil on an important part of contemporary literature is one of the significant phenomena of the history of our time. Léon Bloy imagined a moment when "the true Beelzebub" would make his entrance and, parodying Hugo, declare, "in a voice that would imply magistracy of the lower depths": *Gentlemen, you are every one of you possessed.* It is already time, in any case, to call the attention of exorcists to cases of *demonic possession in literature,* assuredly one of the most grimacing species of possessed.
[In an essay on "The Modern Mind" (*The Use of Poetry and the Use of Criticism,* London, Faber and Faber, 1933), T. S. Eliot observes that the question to which attention is called in this note may seem impertinent but deserves to be raised; and he even promises us to study it some day: "With the influence of the devil on contemporary literature I shall be concerned in more detail in another book." There's a book that we shall read with exceptional interest! (1935).]

197. Cf. Raïssa Maritain, *Le Prince de ce Monde.* Paris: Desclée de Brouwer, 1932.

198. The history of the theatre offers a particularly striking example of this, as Henri Ghéon observed in his lectures at Vieux-Colombier, and also Gaston Baty in his book *Le Masque et L'Encensoir; introduction à une esthétique du théâtre* (Paris: Bloud & Gay, 1926).

199. Max Jacob, *Art poétique,* Paris, 1922.

200. Cf. Paul Claudel, "Réflexions et Propositions sur le vers français, Parabole d'Animus et d'Anima," *Nouv. Rev. Franc.*, October and November, 1925 (reprinted in *Positions et Propositions,* Paris, Gallimard, 1928); Claudel explained this fable and limited its meaning in a letter to Father de Tonquédec (*Etudes,* October 20, 1926). Strictly speaking, it is scarcely defensible except when related to the particular case of the conflict between the soul and lower reason engaged in the tumult and traffickings of the world.

On poetic inspiration, see also *Art and Scholasticism*, note 143. —In a very remarkable passage T. S. Eliot writes: "To me it seems that at these moments, which are characterized by the sudden lifting of the burden of anxiety and fear which presses upon our daily life so steadily that we are unaware of it, what happens is something *negative:* that is to say, not 'inspiration' as we commonly think of it, but the breaking down of strong habitual barriers—which tend to re-form very quickly. Some obstruction is momentarily whisked away. The accompanying feeling is less like what we know as positive pleasure, than a sudden relief from an intolerable burden. I agree with Brémond, and perhaps go even further, in finding that this disturbance of our quotidian character which results in an incantation, an outburst of words which we hardly recognize as our own (because of the effortlessness), is a very different thing from mystical illumination. The latter is a vision which may be accompanied by the realisation that you will never be able to communicate it to anyone else, or even by the realisation that when it is past you will not be able to recall it to yourself; the former is not a vision but a motion terminating in an arrangement of words on paper." (T. S. Eliot, *The Use of Poetry and the Use of Criticism,* pp. 144–145.) The fact remains that the question of knowing from whence, or from whom, this breaking down of barriers derives continues to exist. A new sense can be given to Plato's statements in the *Ion* and the *Phaedrus;* they nevertheless remain valid.

201. Léon Bloy, *La Femme Pauvre,* Paris, Mercure de France, 1921 (first published 1897).

202. *Ephes.,* V, 3.

203. In practice, printing and the modern processes of distribution, by jumbling the diversity of publics more and more into the same amorphous mass, run the risk of rendering almost insoluble a problem already singularly difficult.

204. "When one looks on the man one judges the work, when one looks on the work one judges the man. Imagine, if one of them is good, what the other could be." Pierre Reverdy, *Self Defense:* Critique—Esthétique, [Paris], 1919, p. [17].

205. Cf. Henri Massis, "Littérature et Catholicisme," *Réflexions sur l'art du Roman,* Paris, Plon, 1926.

206. Plotinus, *Enneads,* I, 4.

207. Max Jacob, *Art poétique,* Paris, 1922.

208. Nietzsche. *Le cas Wagner* (Paris: Mercure de France, 1914).

209. "Saint Theresa of Lisieux says: *'To all the ecstasies I prefer sacrifice.'* Poets should have these words tattooed on their hearts." Jean Cocteau, *Lettre à Jacques Maritain* (Paris: Delamain, 1926).

210. Oscar Wilde, *De Profundis* (New York and London: G. P. Putnam's Sons, 1909), pp. 57, 55.

211. Paul Claudel, "Lettre à Alexandre Cingria sur la décadence de l'art sacré," *Revue des Jeunes,* August 25, 1919.

212. Guillaume Apollinaire, "Les Collines" (*Calligrammes*). Apollinaire also said:

> *C'est de suffrance et de bonté*
> *Que sera faite la beauté*
> *Plus parfaite que n'était celle*
> *Qui venait des proportions.*

213. Julien Lanoë, "Trois siècles de littérature," *La Ligne de Coeur,* June 25, 1926.

214. Raïssa Maritain, *La Vie donnée,* Paris, Labergerie, 1935.

Index

231